CHRISTOPHER ALLEN studied for his Maitrise ès Lettres in France, and obtained his PhD on ' The Tradition of Classicism and Academicism in 17th-century France' at the University of Sydney, Australia. He has since been Visiting Lecturer at the Collège de France in Paris, and he now teaches at the National Art School in Sydney. He is the author of *Art in Australia* in the World of Art series, and has collaborated on a critical edition of a key text of French 17th-century painting theory, Charles-Alphonse Dufresnoy's *De arte graphica*.

D0113163

Thames & Hudson world of art

This famous series provides the widest available range of illustrated books on art in all its aspects.

If you would like to receive a complete list of titles in print please write to:

THAMES & HUDSON
181A High Holborn
London WC1V 7QX

In the United States please write to:

THAMES & HUDSON INC.
500 Fifth Avenue
New York, New York 10110

Printed in Singapore

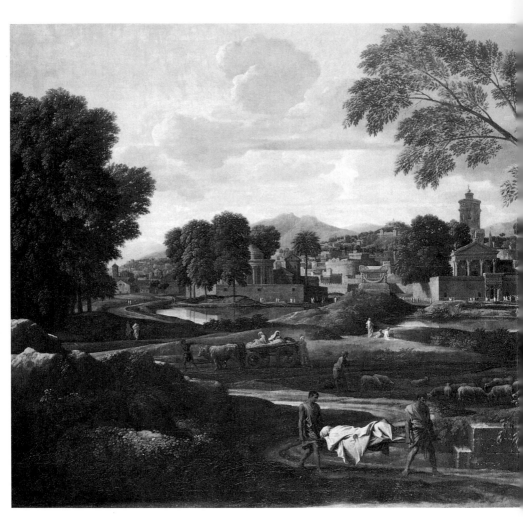

1 **Nicolas Poussin**, *Landscape with the Funeral of Phocion*, 1648

Christopher Allen

French Painting
in the Golden Age

182 illustrations, 79 in color

Thames & Hudson world of art

For Michelle
qui ne néglige rien

First published in paperback in the United States of America in 2003 by
Thames & Hudson Inc., 500 Fifth Avenue, New York, New York 10110

thamesandhudsonusa.com

Library of Congress Catalog Card Number 2003101349
ISBN 0-500-20370-9

Printed and bound in Singapore by CS Graphics

Contents

Acknowledgments

There are many people to thank in a project of this nature. I am particularly grateful to Professor Jacques Thuillier for the exceptional opportunity to work with him at the Collège de France between 1994 and 1996. His assistant, Madame Corinne Maisant, was endlessly helpful to me. I am also very grateful to Professor Jean-Claude Boyer, who among many kindnesses invited me to speak at conferences in Paris in 1996 and 2000, and who read the present book in its first complete draft. Both at the Collège and subsequently, I have listened to papers by, and often enjoyed illuminating conversations with, such learned scholars and curators as Marc Fumaroli, Francesco Solinas, Pierre Rosenberg, Sylvain Laveissière, Olivier Bonfait, Alain Mérot, Gilles Chomer, Colette Nativel, Thierry Bajou, Emmanuelle Brugerolles, Sylvain Kerspern, Françoise Létoublon, who also kindly invited me to speak at the University of Grenoble, and many others. Needless to say, I have also learnt more than I can say from their publications, as well as those of Bernard Teyssèdre, Dominique Brême, Jean-Luc Gautier-Gentès and others listed in the short bibliography. I would like to acknowledge the staff of the Bibliothèque Nationale, and especially of the Réserve. I also want to thank the dear friends in Paris who have made my many stays there so pleasant over the years: Cécile Poutignat and the late Alain Poutignat, their son Fabien and his wife Bénédicte.

In Australia, I am indebted to the late Professor Kevin Lee for his generous support, and to my friends Frances Muecke and Yasmin Haskell, my colleagues in the new edition of Dufresnoy's *De arte graphica* that we are currently completing. I am especially grateful to Frances Muecke for reading the first full text of this book. I would also like to thank Margaret Sankey and Stephen Gaukroger of the University of Sydney for their advice and invitations to take part in colloquia. At the National Art School, I have benefited from the expertise of several colleagues who share my interest in the 17th century: Michael Hill, Jacques Delaruelle, Alex Trompf, Jethro Lyne, and especially Arthur Lawrence, who was particularly generous in helping me in areas both of research and of teaching.

At Thames & Hudson, I am grateful to Nikos Stangos, who commissioned the Australian volume in this series almost a decade ago and then entrusted me with a second. Thanks also go to Wendy Gay, Karolina Prymaka and Celia Falconer. Above all, this book has been improved by its editor, Emily Lane, whose criticism is as acute as it is witty and courteous.

Finally, I would like to thank my mother and father for the constant support, both moral and material, which has contributed to all my undertakings for many years. This book is dedicated to my wife, Michelle Hiscock, who has helped me understand the work of the painter from the inside.

Note The ancient divinities and other literary figures are generally given their Latin rather than Greek names, since this is how they were almost always known in the 17th century.

2 **Eustache Le Sueur,**
A Gathering of Friends, c. 1640 (detail)
The artist shows himself in his early twenties with a book of drawings, seated before his easel. (For the complete painting, see ill. 90.)

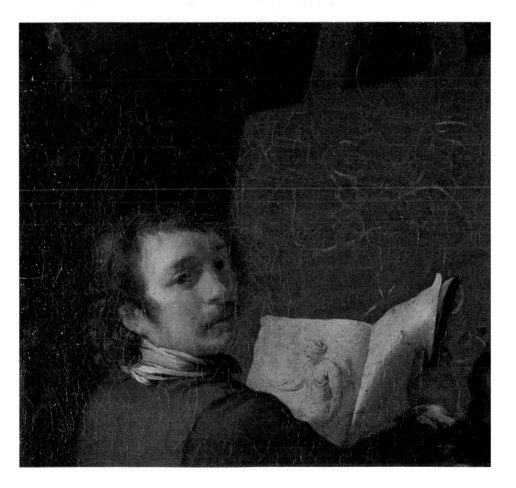

Introduction

*La novità nella Pittura non consiste principalmente nel soggetto non
più veduto, ma nella buona, e nuova dispositione e espressione, e così
il soggetto dall'essere commune, e vecchio diviene singolare, e nuovo.*

(Novelty in Painting does not consist principally in a subject never
seen before, but in good and new composition and expression, so that
the subject, from being common and old, becomes singular and new.)

Poussin, in Bellori, *Vite de' pittori*, 1672

It may seem strange that there has never been a volume devoted
to the painting of the French 17th century in the World of Art
series. The period has always been indisputably the *grand siècle*
of French history, producing not only an astonishing collection of
poets, playwrights and philosophers, but also such quintessentially
French institutions as the Académie Française, the first government
body specifically charged with the supervision and regulation of
an aspect of national culture, in this case the French language.

Similarly, no charting of the history of 17th-century painting
can ignore the central place of the French school. Two of the
very greatest figures of the time are French: Nicolas Poussin
and Claude Gellée, known as Claude Lorraine. Just as importantly,
the mainstream of early modern art, which had flowed through
Italy for over two hundred years since the beginning of the
Renaissance, is diverted to Paris in the second half of the 17th
century. Although Rome remains the great school of painters,
Italy never regains leadership of the tradition.

And yet the fact remains that French painting of this time is
far less well known than contemporary Dutch art, for example,
whose relation to the mainstream is in many ways more tangential.
The first reason for this apparent anomaly is that the mainstream
itself has become unfamiliar to today's audiences, who are more
at home with Monet or Matisse than with Raphael or Poussin.

This is compounded by the suspicion that if the mainstream did indeed divert to Paris, it was only to stagnate there; for after all, not one of the supreme artists of the century – Rubens, Rembrandt, Velázquez, Poussin himself – actually worked in Paris for any length of time.

Such lack of sympathy with the aims of the central tradition of early modern art, fostered by the prejudices of modernism (dislike of 'literary' subject-matter, preference for abstract decorative values), has also been an obstacle to an integrated understanding of the French school, both in its successes and in its shortcomings. Thus there has been a tendency to segregate Poussin and Claude and even Valentin de Boulogne on the grounds that they are essentially Roman. And the 'Naturalists' La Tour and the Le Nain brothers, rediscovered in the 20th century and generally popular, have so often been presented as refugees from a dominant academic conformism that they have done little for a broader appreciation of the school as a whole. As I shall try to show, when all of these figures are brought back together and replaced in the framework of the artistic concerns of their time, French 17th-century painting emerges as an aesthetically rich and intellectually substantial field of study.

Even twenty years ago this book would have been much more difficult to write, for the useful materials were scanty: a few modern studies on the most prominent figures and a certain number of primary sources, such as the 17th-century biographies written by André Félibien (1619–95) and Roger de Piles (1635–1709) or the documents published by French scholars in the 19th and early 20th centuries, including the invaluable minute-books of the Academy. But this state of affairs has been completely changed since the 1960s, largely thanks to the patient efforts of Professor Jacques Thuillier of the Collège de France, as well as other distinguished contemporaries such as Pierre Rosenberg of the Louvre and a younger generation of scholars, whose work has produced an accelerating curve in the growth of our knowledge of the period and of its principal figures.

Jacques Thuillier was associated with Anthony Blunt in the first great Poussin exhibition of 1960, and his preferred instrument of research has always been the monographic exhibition with a comprehensive catalogue. After Poussin there followed Le Brun (1963, with Jennifer Montagu), La Tour (1972, with Pierre Rosenberg), Le Nain (1978), La Hyre (1989 with Pierre Rosenberg), Vouet (1990) and Bourdon (2000), to name some of the most significant. Among the next generation, Alain Mérot

has produced the definitive work on Le Sueur (1987) and Jean-Claude Boyer is preparing his study of Mignard for publication. Following in their wake, a spate of catalogues and monographs has appeared even on quite minor individuals. And the scholars I mention here do not in any way exhaust the list of those who have made valuable contributions to the field.

Thuillier directed his own researches and those of others towards the monograph and the catalogue (including catalogues of museum collections) because he knew that his first priority was to recover the *œuvres* of the many artists who had drifted into partial or complete oblivion. France, as he has often said, has been extraordinarily destructive of her own artistic heritage: the losses to civil war, mob violence and the casual vandalism of changing fashion have in certain cases amounted to the totality of an artist's work. What little has survived has often lost its attribution, so that some once-celebrated names can no longer be matched to a single painting. Poussin had made a similar observation: beautiful things are no sooner completed in France, he wrote, than considered of no further account, and indeed his countrymen 'often take pleasure in destroying them'.

Thuillier's method therefore combined the art of connoisseurship with the close study of published and archival sources in order to reconstruct the life and work of his subjects. He was suspicious of Wölfflin's formalist analysis of great stylistic categories such as 'Classic' and 'Baroque', and also of Anglo-German iconographic studies, both of which he felt could distract from the fundamental and urgent task of reconstruction. He was no less wary, however, of the French weakness for insubstantial 'theoretical' improvisations, and was very critical of intellectuals who ventured into the field of art history without the requisite knowledge of the material.

The work of reconstruction initiated by Professor Thuillier, while not (as he would be the first to insist) complete, has nonetheless utterly transformed our knowledge of the field. Where once the non-specialist might have to form an opinion of a secondary figure from a single photograph in a general history, now the whole extant work may be available in a handsome catalogue; and museums have followed suit, devoting far more space to hanging their French 17th-century paintings. The recovery of this second rank of artists has, in turn, brought lesser figures into a degree of visibility. The artists who now figure as single images in general histories are usually very minor indeed. In fact a new problem has arisen, which is a reluctance,

3 **Nicolas Poussin**,
The Death of Sapphira, 1652–54
Poussin abstracts the figures
to concentrate attention on
the meaning of the story, which
comes from Acts 5: 1–10. When
members of the new Christian
community were selling their
property and donating the proceeds
to the Church, Ananias and his
wife Sapphira both lied about the
amount of money they had raised.
The sin Peter reproves them for
is not avarice, but lying to the
Holy Ghost, which constitutes
abuse of the Logos – the Word,
or Divine Reason. Peter first
challenges Ananias, who falls dead;
the same happens to Sapphira
when she in turn lies a few hours
later – for the Logos is also the
principle of life itself. The
background figures show, in
counterpoint, the usually positive
action of the Logos: St Peter heals
a paralytic (Acts 3: 1–8).

in some cases, to discriminate between painters of manifestly different quality. Particularly at the end of the century there are a number of individuals whose work is historically interesting, but of limited significance as art. History must ultimately be informed by critical evaluation.

The present state of knowledge both permits and arguably calls for a general and synthetic historical essay such as the present book. We know enough about the most important figures to make certain generalizations, and indeed we need to stand back from the vast amount of material now available and see if any shape can plausibly be found in it. Because the most serious work has been done in monographs and catalogues, we have to see if there are larger currents in which these individuals can be situated. I do not believe that historical events are simply random. There are indeed random or aleatory events in human experience, but there are others that are in some sense necessary, and others again that are voluntary in nature, acts of human will. The *course* of events is therefore neither entirely predictable nor entirely unpredictable, neither wholly impersonal nor wholly personal, and yet there are detectable pathways in any period. Those who are on the pathway do not know where it is going to end; we have that

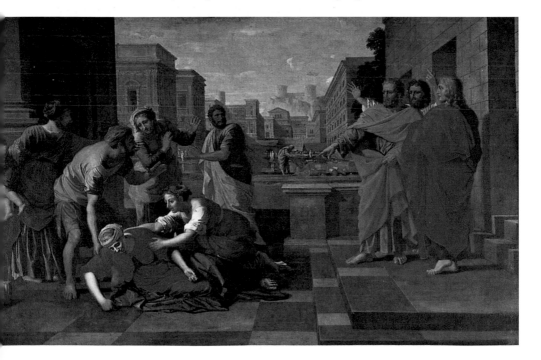

advantage over them, but it is only an advantage if we recognize the end as the end of a pathway.

There are many ways in which a field of study such as French 17th-century painting may be divided up – by genre or region, by generation or patronage – but such divisions are external: finding a direction is an internal matter. It requires a theoretical framework that will accomplish what is etymologically the task of theory – to help us see the material more clearly. After the theoretical inflation of the end of the 20th century, however, historians may well be suspicious both of formalist matrices and of sociological or semiological paradigms: experience has shown that theory can be cumbersome, and instead of illuminating the material, too often projects onto it a set of foregone conclusions.

In contrast, the theories that had currency during the period itself can be a useful starting-point. It is true that any contemporary theory, as the consciousness of the corresponding practice, is never fully adequate to the realities of that practice. We may not have the conceptual tools to articulate what we are actually doing, and sometimes what we think we are doing, or believe we should do, is inconsistent with what we are actually doing. The historian, once again, has the advantage both of hindsight and of an independent, observer's viewpoint. If they are combined with sympathy and historical imagination, they may allow us to understand the aspirations and ideas that regulate practice. The aim, in other words, is to reach past the psychological or personal phenomenon of intention and to define the more impersonal intentionality which is the impetus of a tradition.

There is ample material for such an approach to early modern painting, in theoretical treatises from Leon Battista Alberti in the 15th century to Giovanni Battista Bellori and Charles-Alphonse Dufresnoy in the 17th and finally Sir Joshua Reynolds in the second half of the 18th. Such material was largely inaccessible to the 20th-century mind, however, because its axioms ran so contrary to those of modernism. To understand the art of the 17th century, we must appreciate that its highest aspiration – which effectively governs its passion for picturing the world – is the depiction of humanly and religiously important stories. This is what Alberti calls (in Latin) *historia*, and what is later known as 'history painting'.

It is important to understand what this highest genre of painting entailed, because it has become relatively unfamiliar to audiences today. History painting is not necessarily concerned with subjects from ancient history, and even less with contemporary political events. The word refers merely to story-

telling, and the stories told are more often than not from the scriptures – Old or New Testament – or from mythology, for which the most commonly used text was Ovid's *Metamorphoses*, the 'painter's bible'. The history painter is not expected to make up a new story, but to bring to life one that is already known to the viewer. And what was often called the Grand Manner or *le grand goût* naturally came to be considered the supreme genre because it contains all the others: landscape, still life, animal painting and to a lesser extent genre and portrait painting are all subsumed into the art of pictorial narrative. Conversely, it is from this central category that they eventually emerge as independent practices.

It is the prestige of history painting that accounts for the central place of the figure in the Western tradition, even if human bodies also appear in the subordinate categories of genre and portraiture. Stories can only be told with figures. But what sort of thing is a figure? It is not simply the rendering of any particular human body. Anyone who looks at Poussin's *Death of Sapphira* [3], to take a particularly clear example, can see at once how very abstract his figures are. They are obviously informed by a thorough understanding of the workings of the body, both in attitude and in facial expression, but there are none of those idiosyncratic features or accidental details that characterize a real body. It is clear they have not been copied from any given model. This often comes as a surprise to viewers today, because modernism claimed for itself the credit for emancipating art from 'copying' appearances. In fact artists hardly ever based a figure directly on a model, which was but an aid in creating the painted figures in a composition, particularly with regard to anatomical structure. If Caravaggio's naturalism was felt at the time to be both new and to some extent shocking, it was because it was so unusual to see painted figures that appeared to be drawn directly from particular models. One of the most common questions in Renaissance and later art theory is the process by which these painted figures are produced: whether by selection and combination from particular models, by direct intuition of the essential form of the body, or by some combination of the two. The process by which empirical experience is synthesized with an abstract 'idea' of the body is often referred to in later writing as 'idealization'.

The figures in a history painting are thus fictional, artificial bodies, designed as the players in a painted drama. A writer creating a character – as distinct from a biographer giving an account of a real person – is highly selective and specifies only those things that serve the telling of the story: details of appearance, personality

and history are included to help explain the fictional personage's actions. In the same way, everything that enters into a history painting, including the conception of each of its individual figures – and here the relevant contrast is with the portrait – is governed by the economy of the narration. The difference is very apparent in 15th-century painting, where the two categories are often combined. Pictures in which donors and their families are depicted surrounding a Nativity, for example, show how impossible it is to confuse the features of a portrait and those of an invented figure. How strictly the principle of economy is applied varies from one place and time to another (Veronese's enormous feast pictures, criticized by the Venice Inquisition for an excess of irrelevant incident, represent one extreme). But even rigorous observance does not necessarily result in a lack of variety or imagination: Poussin's *Rebecca at the Well* [47] is strict in its focus on the subject, but rich and varied in the telling of the story. And that is because the telling of a story is not a mechanical but a poetic problem: not a matter merely of conveying the sequence of events, but above all of evoking their significance.

History painting thus depends centrally on the subject. The process by which an artist makes a picture out of a subject is known, in a term borrowed from the theory of rhetoric, as *invention*. This concept comes to include not only the articulation of dramatic relationships between the figures in the story, but also everything else that pertains to its composition, as Sir Joshua Reynolds (1723–92) explains: 'The invention of a painter consists not in inventing the subject, but in a capacity of forming in his imagination the subject in a manner best accommodated to his art, though wholly borrowed from poets, historians, or popular tradition. For this purpose he has full as much to do, and perhaps more, than if the very story was invented: for he is bound to follow the ideas which he has received and to translate them (if I may use the expression) into another art. In this translation the painter's invention lies; he must in a manner new-cast the whole, and model it in his own imagination … here begins what in the language of painters is called *invention*, which includes not only the composition, or the putting the whole together, and the disposition of every individual part, but likewise the management of the background, the effect of light and shadow, and the attitude of every figure or animal that is introduced or makes a part of the work.'

Invention, as Reynolds shows, has nothing to do with making up a new story. On the contrary, it presupposes the existence

of a collection of subjects with which the intended viewers of the painting are familiar. Painting, as Victorian genre pictures amply demonstrate, is not a good medium for conveying a completely 'new' story, and in any case novelty is not a virtue in itself. Good subjects need to be substantial, poetically resonant and culturally shared, for the stories of a people map their imaginative world. They must be capable of eliciting the kind of intellectual and emotional engagement which I want to call *belief*. That

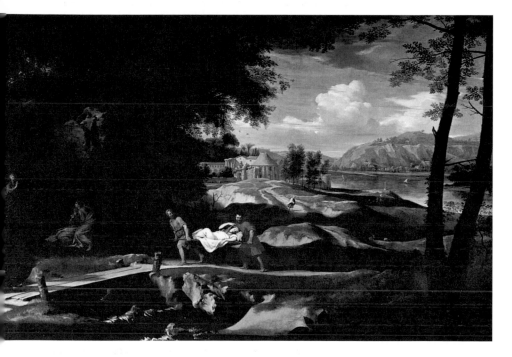

4 **Philippe de Champaigne**, *Miracles of St Mary the Penitent*, 1656. This is one of four paintings made for the apartment of the Queen Mother, Anne of Austria, at the Val-de-Grâce in Paris, the Benedictine convent she had founded. Each is devoted to the story of a penitent harlot and each evokes a time of day: here the obscure Mary who is the niece of St Abraham is seen praying for a sick woman at midday, while another is brought on a litter – a quotation from Poussin's *Funeral of Phocion* (ill. 1).

engagement does not have to amount to accepting the stories as being literally or factually true, but the stories we are talking about claim another kind of truth. The viewer must be willing to suspend disbelief and enter into the world of meaning evoked by the painting. It is an imaginary world in the strongest sense, in which, as in the mythical universe of the Greeks, there is room to accommodate literalism and allegorization, scepticism and mysticism, pathos and humour. The loss of such references and such belief in 20th-century art was clearly part of the crisis of modernism, but we shall see that the problem goes back much further into the *ancien régime* itself.

It is in this perspective that the art of landscape can best be understood. As its subject is the natural environment within

which we live, landscape is inherently concerned with the response to a world that transcends the self. The pleasure we take in nature is in the mind's expansion beyond the claustrophobic and mirrored chamber of self-consciousness; it is the recognition of an ontological reality beyond subjectivity. Landscape painting may therefore be considered in a fundamental sense as religious, and it naturally appears, in a complementary role, in the background of Renaissance pictures. Significantly, one of the first artists to take a greater interest in landscape for its own sake was Leonardo da Vinci, whose own world-view seems to have been more pantheistic than strictly Christian. The painting of views of the countryside evolved in Venice and in the North, but only emerged as both an autonomous and a serious genre in Italy in the first half of the 17th century. I would suggest that it could not develop fully as long as the field of religious experience was monopolized by Christian faith. It was in that more complex century – a time of religious revival but also of scepticism and even the beginnings of atheism – that landscape became the vehicle for a less specific religious sensibility, often combined with mythological or even scriptural themes, although these were now represented by small figures that no longer determined the meaning of the whole picture. Later, of course, landscape assumed an enormous importance in periods that were even less intimately shaped by Christianity, such as the British 18th and 19th centuries. Britain, indeed, relied even more heavily on the art of landscape because puritan iconoclasm in the 16th and 17th centuries had severed her connection with the Renaissance tradition of narrative and religious painting. The British experience was, in this crucial respect, very different from the French.

My theme in this book is the effort by French painters in the 17th century to assimilate the tradition of history painting which had been formed in Italy and acclimatize it in their own land. Renaissance art had been imported into France in the 16th century, but only in the form of Mannerism, and the religious wars at the end of the century had left French painting in a very reduced state. The wreckage of Mannerism was scattered around the northern countries, but in Rome it had been abandoned in favour of Caravaggio's naturalism, or the Carracci's new synthesis of the High Renaissance heritage. Most young painters of any ambition knew they had to reach Rome and reconnect with the mainstream of contemporary painting: some absorbed the more limited lesson of Caravaggio, others set themselves to the arduous task of mastering the central tradition of history painting.

A few of these painters stayed in Rome, but many went back to France and began to practise and teach what they had learnt. Some brought back, or indirectly assimilated, forms of naturalism; and their attempts to extend the possibilities of an inherently limited language produced some of the most remarkable and distinctive works of French painting in this period. With the return of Simon Vouet to Paris in 1627 after a long stay in Rome, a fluent, Carracci-derived history painting style was available in France for the first time, and it became enormously successful. Vouet trained a new generation of artists who in turn reacted against what was too facile in his manner and – encouraged by Poussin's example in Rome and his brief stay in Paris (1640–42) – established the first coherent French style of history painting. In 1648 this generation formed the Academy, which in due course was put to work by Louis XIV and Colbert as part of the State cultural apparatus. It seemed that artists were being treated with munificence, but there was a high price to pay. The Sun King was henceforth the all-consuming centre of attention. As his brilliance dimmed, French painting at the end of the century was left in a state of disorientation and exhaustion.

I hope this book will show that the French 17th century is both a crucial moment in the story of modern painting and a time from which many lessons can be drawn. It is also, of course, a period that has made a permanent contribution to the way we think, write and experience the world. This broader context of philosophy and literature is vital to an understanding of the development of French painting and is discussed where it is useful. In general I have sought to concentrate on the main current of events: I have sacrificed some minor individuals, and only mentioned others, like the engraver Jacques Callot, in passing; but I have tried to show how the genres of landscape, still life and portraiture can be understood in relation to the central themes and concerns of the time. The new format of the World of Art series has allowed me to focus on the broad themes in the body of the text, while consigning detailed discussion of the pictures to the captions. I have taken full advantage of this resource in the hope of making the images as accessible as possible.

Chapter 1 From Mannerism to Naturalism

At the end of the 16th century, after years of religious war, the Protestant king of Navarre Henri IV assumed the French throne, converted to Catholicism and issued the Edict of Nantes (1598), guaranteeing the security of the Protestants. He set about rebuilding an economy and a political structure ravaged by war and the opportunism of the nobility. Efforts to strengthen the power of the central government were brought to a temporary halt by his assassination in 1610 and the Regency that ensued, but were resumed with even greater forcefulness by Cardinal Richelieu [79], prime minister under Louis XIII. The deaths of Richelieu at the end of 1642 and of Louis early in 1643 led to a second Regency and a further period of instability, known as the Fronde (1648–53). However, Richelieu's successor Cardinal Mazarin steered the nation through this period until his death in 1661 and the beginning of the personal reign of Louis XIV (1638–1715) [155], who was to find a brilliant minister in Jean-Baptiste Colbert [114]. Inexorable political centralization was accompanied, gradually, by an increasing State involvement in the management and funding of all the arts. In the first decades of the century, it would have been nearly impossible to imagine the wealth and social standing that painters would one day enjoy, the seriousness with which their work would be discussed, or the interest the State would have in artistic training and administration.

When the young Nicolas Poussin (1594–1665) came to Paris from Les Andelys in Normandy in 1613, French painting was at a low ebb. He had watched the late Mannerist Quentin Varin (c. 1570–1626) execute a commission for the church of his native town in the previous year [5], and must have shown him some of his own drawings, since Varin encouraged the young man to pursue his interest in art. Varin, though now barely remembered, was as good as any artist of the time [11]. They were few and on the whole mediocre, while the art of painting itself was considered by many to be little better than a trade. It is not surprising that aspiring French artists almost without exception set off for Rome,

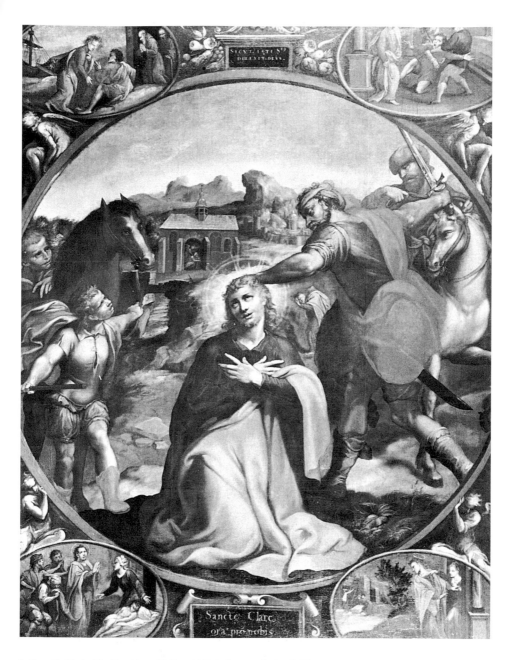

5 **Quentin Varin**, *The Martyrdom of St Clare*, 1612. In the central scene St Clare, first Bishop of Nantes in the 3rd century, is about to be decapitated; subsidiary episodes include his arrival in Brittany, his refusal of a courtesan's advances, and miraculous healings. Poussin, at the age of seventeen or eighteen, watched Varin paint this picture, and it has even been suggested that the young man on the far left, behind the horse, may be a portrait of him.

6 **Toussaint Dubreuil**, *Cybele awakening Sleep*, before 1602. Painted for the Château Neuf of St-Germain-en-Laye, this is an episode from Pierre de Ronsard's epic the *Franciade* (1572). The poet imagines that France, like Virgil's Rome, was founded by refugees from Troy – in this case by Hector's son Astyanax, renamed Francus. Dubreuil shows Cybele, a goddess favourable to the Trojans, visiting Sleep and asking him to bring dreams to the various characters.

where art was held in high esteem and supported by a sophisticated public of collectors, scholars and connoisseurs. Above all, Rome was the epicentre of their tradition: it was the home of the great models of ancient and modern art, and the focus of the most vital contemporary activity.

The painters of the first quarter of the 17th century in France were belated Mannerists, practising variants on what had by now become an international and eclectic style, or perhaps more accurately a jumble of styles. Elements of the original Italian Mannerism (in the versions of Pontormo, Bronzino, Parmigianino, Beccafumi, etc.) had been combined with others from the Netherlands and the School of Prague, and with the style that had been developed by the Italians Rosso, Primaticcio and Niccolò dell'Abbate in 16th-century France, the School of Fontainebleau. These, together with other more recent Italian tendencies, were the influences that shaped the work of the Second School of Fontainebleau – the collective denomination for the group of artists who worked for Henri IV around the turn of the century – and their successors in France, as well as the late flowering of Mannerism in Lorraine, which was then still an independent state. All of these artists were working after the rejection of Mannerism by the new generation in Italy: Michelangelo Merisi da Caravaggio (1573–1610) and Annibale Carracci (1560–1609), together with his brother Agostino (1557–1602) and cousin Ludovico (1555–1619). The Carracci, especially, in renewing the understanding of the

Renaissance tradition, had laid the foundations for all subsequent 17th-century history painting.

Mannerism in general was not well suited to the genre of history painting because it refused to subordinate the parts to the whole, and particular effects to overall meaning. This had already been true of both Schools of Fontainebleau, in which the picture space was usually dominated by large figures, decorative or tortured as the case might be, but always drawing attention to themselves and to the cleverness or elegance of their poses, while anatomical accuracy was neglected and the meaning of the composition often obscure. Although Toussaint Dubreuil (1561–1602) seems to cling to such elements of realism and Classical harmony as he could derive from his predecessors [6], Ambroise Dubois (1542/43–1614) epitomizes the affectations of late Mannerism in a work like *The Baptism of Clorinda* [7], while Martin Fréminet (1567–1619) joins heavy-handed imitation of Michelangelo's musculature with extremes of contrapposto, illusionistic architecture and foreshortening in the ceiling of the Chapel at Fontainebleau. Such works are crowded with stylistic tricks assembled with little thought of coherence. Facial expressions and bodily gestures are inconsistent, and all too often the figures look like a troupe of amateur actors each trying to

7 **Ambroise Dubois**,
The Baptism of Clorinda, 1601–6. The subject is from Tasso's *Jerusalem Delivered* (12: 65–69): Tancred, a Christian knight, has unwittingly wounded the Amazon Clorinda, who has been fighting on the side of the Saracens. As she lies dying, she begs for Christian baptism. Tancred is seen twice, in the background fetching water from a stream in his helmet, and in the foreground administering the sacrament.

upstage the other. It is little wonder that the mature Poussin later insisted that the expression of the subject should govern and unite all aspects of a painting, from the choice of composition, lighting and colour to the attitudes and interrelations of the figures.

On the other hand, it would be wrong to underestimate the importance of both Schools of Fontainebleau in opening the French visual arts to the poetic treasure-house of ancient literature. Like most areas of 16th-century culture in France, the painting of the time is a mixture of the naïve and the sophisticated,

8 **Georges Lallemant**, *The Adoration of the Magi*, c. 1630. The sobriety in the attitude and type of the Virgin reflects a development away from Mannerist extremes, although the painting as a whole lacks narrative and expressive focus. Seized in the Revolution from an unidentified church in Paris, it was attributed to Claude Vignon until 1937.

of the unripe and the overripe: an inevitable outcome when the beginning of the French 'Renaissance' was informed by the ending of the Italian. Deliberate difficulty and a love of the recondite are part of Mannerist culture, and in France these tendencies are combined with the indiscriminate enthusiasm of those who are discovering a new world for the first time. Great Homeric subjects and the myths that were generally familiar from Ovid's *Metamorphoses* are mingled with material from late or obscure sources. All this abundance, like that of the language itself, would need to be rigorously cut back in the following century, and yet the French imagination had been durably transformed and enriched.

Most of the painters of the Second School of Fontainebleau had died by the time Poussin came to Paris, and the most important

studio in the capital was that of a Mannerist from Lorraine, Georges Lallemant (c. 1575–1636). He is often mentioned as an early teacher of Poussin, but Poussin's close friend and first biographer, Giovanni Pietro Bellori (1613–96), the most important Italian art theorist of the mid-17th century, refers to Lallemant merely as an artist 'di poco talento' – of little talent. As Bellori would have had no reason to know of Lallemant except through Poussin's recollections, the evidence does not suggest that the latter had much regard for him even as a novice. And yet

9 **Claude Vignon**, *The Adoration of the Magi*, 1624. Vignon was born in Tours; widely travelled, he was acquainted with leading artists in England and Holland as well as in Italy, and well known as an expert and valuer as well as a prolific painter.

Lallemant was still enjoying considerable success, and would continue to do so until his death, almost a decade after Vouet's return in 1627. *The Adoration of the Magi* (c. 1630) [8] was painted at the height of his career. Lallemant evidently knew how to please an aristocratic clientèle that did not take painting very seriously as an art but loved exotic romances and masques and fancy dress. The eclectic Claude Vignon (1593–1670) appeals to a similar taste for colourful costume and for picturesque effects – in his case, especially painterly bravura – in his treatment of the same subject (1624) [9]. After more than a decade in Rome, Vignon was back in Paris by the beginning of 1623 and was prolific during the 1620s and 1630s, once again even after the return of Vouet. In spite of his personal success, however, his style was not sufficiently coherent to exert anything like the influence that Vouet would achieve.

Bellori tells us that the young Poussin was fortunate enough to meet a scholarly member of the Regency court, Alexandre Courtois, who had a collection of 16th-century prints after Raphael and Giulio Romano. The story is a reminder of how important engravings had become by this time, and how they had changed the transmission of influence and the access to what had already become a canon of modern masters. At the same time, we know that Poussin saw at least one recent and impressive painting in Paris, *The Last Supper* (1618) [10] by the Flemish artist Frans Pourbus the Younger (1569–1622). Pourbus was mainly a portraitist, but he had spent many years in Mantua (some of them coinciding with Rubens' stay in that city) and would have had ample opportunities to study both Renaissance and contemporary Italian painting. *The Last Supper* is so far superior to any other picture painted in Paris at the time, in spatial organization, in figure drawing and in the coherent expression of the subject, that it is not surprising to learn that Poussin was impressed by it. To the admirers of Lallemant, it must have seemed too sober; but it does appear to have had an influence on Quentin Varin, whose own *Wedding Feast at Cana* (c. 1620) [11] was painted very soon afterwards.

10 **Frans Pourbus the Younger**, *The Last Supper*, 1618. Pourbus' *Last Supper* is a late work, a rare example of a history painting in the career of an artist who devoted himself mostly to portraits. No other painter in Paris possessed a comparable artistic culture in 1618, and the composition must have made a strong impression. It was the high altarpiece of St-Leu-St-Gilles, where it remained, much admired, until the Revolution.

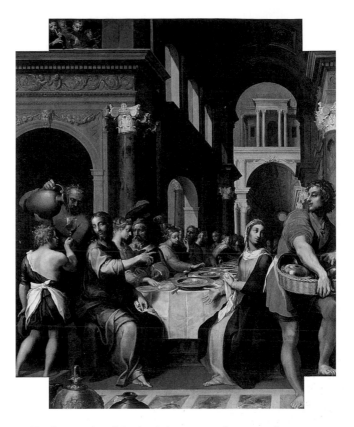

11 **Quentin Varin**, *The Wedding Feast at Cana*, c. 1620. This large composition, which illustrates Christ's first miracle according to St John's Gospel (2: 1–11), was commissioned for the high altar of St-Gervais in Paris, subsequently dismantled in the Revolution. The continuity of Varin's style since the pictures at Les Andelys (ill. 5) is clear, but no less so is his development over the intervening years.

The few works of this kind that were to be seen in Paris, however, like the paintings by Raphael and others then at Fontainebleau and the engravings in the collections of amateurs, must only have made young artists more anxious to reach Rome. When Poussin left towards the end of 1623 young Frenchmen had been making the pilgrimage for over three decades. But a cultural metropolis, as we shall see when we return to Poussin in the next chapter, is not an easy environment for a beginner. Rome was full of artists from all over Italy and Europe; although the opportunities were many, competition was also intense and a small number of established artists gained most of the important commissions. If a young man was exceptionally talented and came to the notice of a powerful patron, he could go far; otherwise it was easier to settle for a comfortable living practising one of the minor categories, like landscape (before it was ennobled by Claude and Poussin) or genre.

Genre painting – scenes of ordinary life with no particular narrative subject – is particularly important for French artists

in this period. It became the vehicle for ambitions that they could not satisfy by any other means, and the best of them raised it to a level not seen before or since, with the exception of Chardin in the following century. But contrary to the modern commonplace that the *peintres de la réalité* are some kind of popular alternative to the academic tradition, the work of these artists cannot be understood without appreciating the primacy of history painting. Moreover, the painting of 'reality' was a reaction not against an academic art that had yet to evolve, but against the vapidity of late Mannerism. The most immediate antidote to Mannerism's failure to study nature was Caravaggio's striking, almost sensational reliance on the particular model – what was referred to even in the 17th century as 'naturalism'. And this was the basis for the various forms of genre that flourished after Caravaggio's death, from the drinkers and smokers of his disciple Bartolommeo Manfredi (1580–1620/21) to the small and picturesque peasant and gypsy subjects painted, from around 1630, by the Dutch artist Pieter van Laer (1592–1642). Van Laer was known as Bamboccio (literally, a marionette) because of his misshapen body, and paintings of this type, whether by the artist himself or his imitators, were known as *bambocciate*, or in French *bambochades*.

The language of history painting, as we have seen, is grounded in the study of nature, but is essentially abstract and artificial: it seeks a general understanding of the workings and proportions of the body, as well as the conventions by which it has been represented, in order to allow the painter to construct the artificial bodies that will be the actors of his painted dramas. It is a far more complicated way of thinking than that which is embodied in naturalistic painting, entailing the assimilation and internalization of a tradition as well as manual skill and attention to the model. The naturalists, who based their work on particular bodies (even when they repeated or copied their models or those of others), could never proceed from this starting-point to a truly abstract figural language. They could, however, achieve a kind of abstraction if not by construction, then by a process of reduction or subtraction. And this is the secret of some of the greatest achievements of French 17th-century painting.

The lesson of Caravaggio was thus much easier to understand than that of the Carracci, and was consequently the one that most of the first wave of French artists learnt during their stay in Rome. Eventually, as a simplified version of the style spread through France and the Netherlands (with artists like Baburen, Ter Brugghen and Honthorst), it was possible to assimilate it without

12 **Valentin de Boulogne**, *Allegory of Rome*, 1628. Rome is personified in the central figure, who is shown wearing the castellated crown of Cybele. Her shield bears the crossed keys of St Peter and the papal tiara. On the left of the composition, Father Tiber leans on the symbolic urn of a river god, accompanied by Romulus and Remus and the she-wolf that nursed them. The other river god has been identified as the Arno, with the lion of Florence, representing the home town of the Barberini family (the painting was commissioned by Cardinal Francesco Barberini). A single model appears to have posed for both of these figures, and is quite likely the same one who, a couple of years earlier (but with whitened beard), had been the elderly miser in *The Four Ages of Man* (ill. 14). Valentin wittily emphasizes the striking naturalism of his river gods by basing their attitudes (especially that of the Tiber) on the colossal Roman *Tiber* and *Nile* statues that Michelangelo had set up on the Capitoline Hill. The rather odd lion is very similar to the one Valentin included in the *St Mark* at Versailles some years earlier; evidently neither was painted from the life.

actually going to Rome at all. It was not in general the style of large public commissions, but of smaller pictures for the art market. Nevertheless, it is important to note that although *Bambocciate* were never taken seriously as high art, the naturalism of Caravaggio was not itself condemned in an unqualified way.

Attitudes hardened progressively over the course of the century, and Bellori was far more indulgent in his judgment of Caravaggio around 1640 than he became two decades later; but even in his life of Caravaggio (1672) his assessment remains nuanced.

Earlier still, in the 1620s, the young Poussin could be 'discovered' in Paris by the celebrated poet Giambattista Marino (1569–1625), who had been a friend and admirer of Caravaggio and had written an epitaph on his death in 1610. An ambitious artist like Simon Vouet, who will be discussed in Chapter 3, could pass through a Caravaggesque phase before developing the mature style he was to bring back to France. And the case of Valentin de Boulogne (1591–1632) demonstrates that it was still possible to build a serious career in Rome on a Caravaggesque foundation, at least up until the time of his premature death. Valentin is sometimes considered more of an Italian than a French painter, but that seems wrong in view both of the singular importance of the naturalist current in French art and of his own particular sensibility. It is, however, important to consider him in the Roman context before discussing those artists who brought varieties of naturalism back to France, and especially the greatest of them all, Georges de La Tour.

Valentin was born in Coulommiers (the surname, which was also his father's, appears to come from the city of Boulogne in Normandy) and may have arrived in Rome as early as 1611. Little is known of his early years, but around the mid- or later 1620s he came to the notice of Cardinal Francesco Barberini (1597–1679), nephew of Pope Urban VIII, and perhaps even more importantly to that of the Cardinal's secretary, the famous connoisseur Cassiano dal Pozzo (1588–1657). It is indicative of the pluralism of Roman taste that Cassiano was also, and at exactly the same time, the patron of Poussin (who was about three years younger than Valentin and had arrived in the Holy City in 1624), and indeed their patrons seem to have set up a kind of contest between the two young artists. The Cardinal commissioned an *Allegory of Rome* from Valentin (1628) [12] not long after the completion of Poussin's *Death of Germanicus* (commissioned by him late in 1626 and delivered in January 1628) [34]. Each was then given the opportunity for an important public commission, an altarpiece for one of the side-chapels at St Peter's itself. Poussin's *Martyrdom of St Erasmus* [35] was completed in 1629, and Valentin's *Martyrdom of SS. Processus and Martinian* [13] in 1630. The contest seems to have had the desired effect, as the German artist and writer Joachim von Sandrart (1606–88) later recalled the vigorous debate that

13 **Valentin de Boulogne**,
The Martyrdom of SS. Processus and Martinian, 1629–30. Processus and Martinian were Roman soldiers, two of the gaolers of Peter and Paul in the Mamertine Prison. Converted to Christianity, they helped the leaders of the Church to escape, but were later put to death in their turn. There is a certain similarity between Valentin's composition and that of Poussin's *St Erasmus* (ill. 35), completed several months earlier. The two saints are being stretched on the rack, while a young thug prepares to break their bones with an iron bar and a very Caravaggesque angel descends from heaven with the palm of martyrdom.

arose when the two pictures were seen side-by-side. The partisan, Sandrart says, tried to assert the superiority of one or the other, while the judicious agreed that Poussin was superior in expression and invention, and Valentin in *Natürlichkeit*, strength and harmony of colour. The cultivated Roman public, which had experienced the rivalry of Domenichino (1581–1641) first with Guido Reni (1575–1642), and then with Giovanni Lanfranco (1582–1647), would have enjoyed this new *paragone*.

From the perspective of even slightly later taste, the *Allegory of Rome* [12] is a very strange picture. The figure of Father Tiber, the direct transcription of a middle-aged man's body with hirsute

14 **Valentin de Boulogne**, *The Four Ages of Man*, 1626. Valentin's four ages speak of the transience of human life, not only by juxtaposing its beginning and end – the boy who has let the bird of life fly from the cage and the old man who consoles himself with wine and wealth – but by evoking the movement from one stage to the next. Thus Valentin shows the young man roused from his romantic absorption in a love song, and in contrast the victorious soldier falling asleep over his book. We might speculatively suggest that the youth is a self-portrait. If the artist was born in 1591 and this picture is correctly dated to 1626, Valentin would be painting himself at thirty-five – Dante's 'middle of the path of our life' – a hypothesis consistent with the picture's emphasis on transition.

chest, would have been inconceivable – indecorous in allowing trivial detail to distract the viewer from significance. The figure of Rome herself looks suspiciously like one of Caravaggio's young models in fancy-dress. In other words, this 'allegory' has all the external appearances of being a genre painting. But the whole composition is painted with great strength and confidence, and above all Valentin evokes a mood of mysterious solemnity, with undertones of expectancy and apprehension, and a dominant note of youthful determination in the central figure.

It is this sensitivity to expression that differentiates Valentin's work from lesser Caravaggesque artists such as Manfredi. For the minor naturalists and genre painters, expression remains a disconnected and anecdotal affair – smirks and grimaces, superficial reactions to incidents and events depicted. Certain early Caravaggesque paintings by Vouet exhibit this in an extreme form, for instance *The Fortune Teller* (c. 1618; Ottawa, National Gallery). The concern for expression as the co-ordinated and coherent account of the meaning of an event is central to history painting, and occupies a prominent place in contemporary art theory, as we shall see in the next chapters. If the essential starting-point of painting is invention, expression is the

15 **Valentin de Boulogne**,
The Judgment of Solomon, 1628–30.
Solomon has to adjudicate
between two mothers: the child
of one has died, and both claim
the survivor (I Kings 3: 16–28).
He orders that the child be
divided between them. As the
soldier is about to carry out the
command, one woman clings to
the child, while the other yields
him, rather than see him killed.
The king recognizes that she is
the true mother and stops the
soldier with a gesture and a word,
looking straight into his eyes.
Solomon is depicted as young, for
this is the first trial of the wisdom
that he has just asked of God.

articulation of that invention into forms which are intelligible to
the viewer; and if naturalists or those artists later called Baroque
are censured, it is because they replace true expression with,
respectively, trivial detail or rhetorical flourishes.

The importance of expression in Valentin's work is thus a sign
of his higher ambitions, and is no doubt the reason that his work
was appreciated by so thoughtful a man as Cassiano dal Pozzo.
It is also a French characteristic, as I have suggested, to attempt
higher things through genre subjects. Like the *Allegory of Rome*,
Valentin's *Four Ages of Man* (c. 1626) [14] shows him achieving all the
things usually expected of genre – precise observation of models,
a wealth of anecdotal detail, and (what is sometimes forgotten)
virtuoso painting of fabrics and armour and other still-life details
– but this painting too has an allegorical sense, and once again
derives its greatest power from the gravity and melancholy
expressed in various ways by the four figures in the composition.

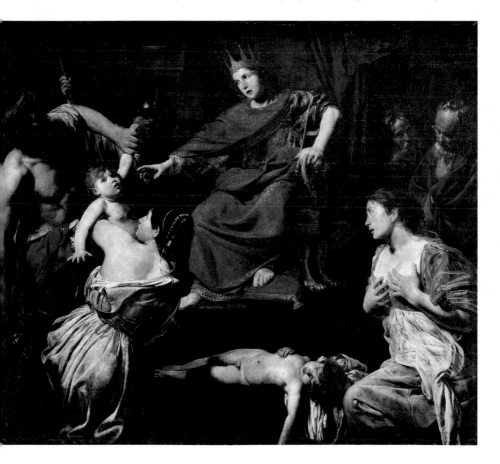

In the later *Judgment of Solomon* (1628–30) [15], Valentin adapts his genre figures to the performance of a true history subject, in which the emphasis is overtly on expression.

Similar qualities are apparent to a lesser degree in some of the minor French naturalists, many of whom returned to France and were active in the provinces. Thus Nicolas Tournier (1590–1639) spent some years in Rome, where he was influenced by Caravaggio, Manfredi and Valentin, before returning to France and establishing himself in Toulouse by 1632. His *Gathering of Revellers* [16] is a virtual copy of a painting by Manfredi, although comparison shows that he has made some attempt at a more considered treatment of expression: the figure on the right looking at us, in particular, has been given a dreamy, melancholy air absent from the original, and brought into closer harmony with the figures of the two young men. The picture is still anecdotal compared to Valentin, but it is more interesting than its model. His *Deposition* (c. 1635) for the church of St-Etienne in Toulouse [17] owes much to the *Pietà* by Andrea Camassei (1602–49) in S. Maria della Concezione in Rome (c. 1631), but is characteristically at once stiffer, more naturalistic and less rhetorical in its treatment. The connection with Camassei may

16 **Nicolas Tournier**, *A Gathering of Revellers*. This painting is a version of Manfredi's *Drinking and Musical Party* (Los Angeles County Museum of Art), but certain variations speak of a different sensibility. The young man in the centre looks much more French than Italian, and above all the figure on the right turned towards us has lost his original coarseness, and become gentle and melancholy.

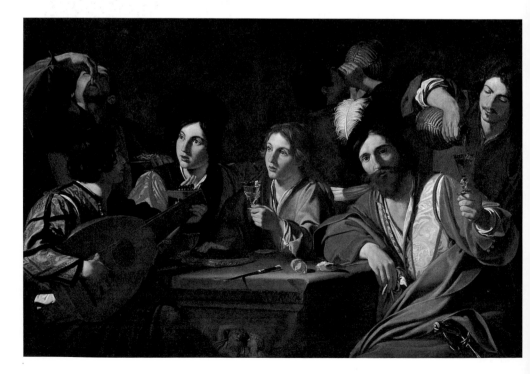

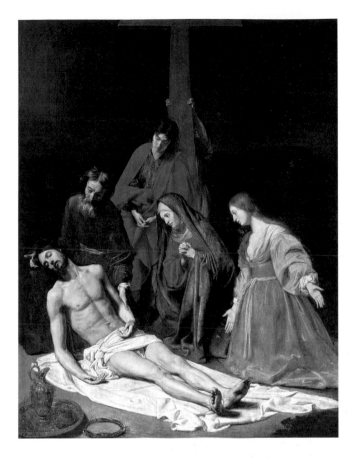

indicate that Tournier, who was in the south of France by 1627, returned to Rome around 1630–31 before settling in Toulouse.

Tournier's altarpiece, much admired in recent years, leads us to a further reason for the success of naturalism among French painters. There was a great revival of religious feeling in France in the first half of the century, which was accompanied by a campaign of rebuilding and expanding and by a wealth of commissions for artists. St François de Sales published his *Introduction à la vie dévote* (*Introduction to the Devout Life*) in 1608, Cardinal Pierre de Bérulle founded the French Oratoire, following the example of St Filippo Neri in Rome, in 1613 (by 1629 there were sixty-one houses), and St Vincent de Paul established the first modern charitable institutions for the poor. All of these initiatives shared a certain characteristic French concern for realistic spiritual practice integrated into the fabric of modern life, moderate, down-to-earth and sincere rather than ecstatic in tone.

To some degree in conflict with this native French spirituality was that of the Jesuits. The order was hated as an ultramontane force and suspected fifth column of Spain by many elements within the French Church and the highly educated legal and administrative patrician class, the *noblesse de robe*. The Jesuits had been virtually driven out of France by the end of the 16th century, but they were restored by Henri IV in 1603, from which time they adroitly aligned themselves with the monarchy and the centralist cause. The Jesuits also established the Company as the providers of the best school education of the time, first with the Collège de la Flèche in the Loire region (where Descartes went to school) and then in Paris itself from 1618 – when Louis XIII overrode the Parlement's prohibition – with the Collège de Clermont in the rue St-Jacques, later the Collège and today the Lycée Louis-le-Grand. Intellectual and political opposition to the Jesuit doctrine came especially from another and very French movement that will be further discussed in Chapter 4, the Jansenists.

The spirituality of the Jesuits was naturally more attuned to the contemporary styles of painting in Rome, where the highly disciplined order had its headquarters. For a long time, indeed, the French thought of the Baroque as 'le style jésuite'. The more home-grown variety of French spirituality, however, retained throughout the century a certain affinity with the directness and plainness of naturalism. As in the work of Caravaggio, the emphasis is on the mystery of the divine presence manifesting itself in the midst of our everyday experience; but whereas Caravaggio dramatizes the irruption of the transcendent into a base material world, the French sensibility is more attuned to tranquil immanence. Apart from Tournier, other provincial painters who fall into this category include Jean Boucher (c. 1575–1633?) in Bourges, who was the first master of Pierre Mignard, Guy François (c. 1578–1650) in Le Puy, and Philippe Quantin (c. 1600–1636) in Dijon. Boucher spent time in Rome around the year 1596, although he was back in his home town by 1598. He evidently assimilated the anti-Mannerist currents in the Rome of those years, both naturalistic and classicizing, even though he left before either Caravaggio or the Carracci had executed their most influential works. The down-to-earthness of French religious sensibility seems to favour a reconciliation or combination of both tendencies in his work, as can be seen in his 1610 *Nativity* [18]. Similarly Guy François worked in Rome – but significantly, a decade or more later than Boucher – with Guido Reni and Carlo Saraceni before returning to Le Puy. It is striking

18 **Jean Boucher**, *The Nativity*, 1610. The work was probably commissioned by
the Governor of Berry, and has almost always remained in the Cathedral of Bourges.
The artist has included portraits of the donors in the doorway on the right, as well
as a self-portrait in the figure on the left carrying a sheaf; the strap of his sack tells
us that this is a true portrait of Jean Boucher at the age of thirty-five.

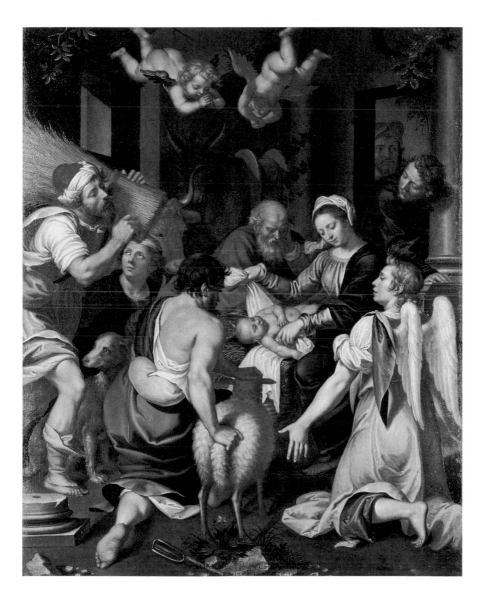

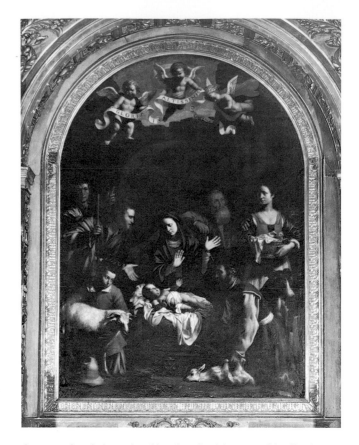

19 Guy François, *The Adoration of the Shepherds*, 1621. This was commissioned for the main altar of the Chapel of the Virgin in the Jesuit College of Le Puy, in Auvergne. (François executed a number of other works for the Jesuits, both before and after.) The composition, although self-consciously symmetrical, is much more sophisticated than Boucher's (ill. 18), and is animated by a diagonal line of four hands – a device learnt from Caravaggio.

20 Philippe Quantin,
The Annunciation. In this unusually tall altarpiece, a Caravaggesque angel links the sober earthly plane, with its homely chair and basket, to a vision of God the Father and a cascade of little angels which are very far from Caravaggio's inspiration.

that a work as balanced and lucid as the *Adoration of the Shepherds* (1621) [19] that he painted for the Chapel of the Virgin at the Jesuit College in Le Puy could be produced in Auvergne at a time when painting in Paris was still dominated by extravagant Mannerists like Lallemant. And as we will see, elements of the Fontainebleau aesthetic persisted in the capital later than might be expected. Quantin, who was born in Dijon, probably travelled to Rome as a young man before returning home by 1622; in any case he too appears to have learnt much from the works of Caravaggio and Saraceni [20].

For a few years, then, French painting was actually more up-to-date in the provinces than in Paris. But the situation in the capital was to change dramatically in the later 1620s. Vouet's return in 1627 and its consequences will be discussed in Chapter 3. Around the same time, the three brothers Le Nain arrived from Laon; the eldest, Antoine, was admitted to the Painters' Guild in 1629. The Le Nain family, like other French naturalist painters, fell into virtual

oblivion at the end of the 17th century, and were only brought back to general attention in the 20th century. The consequence of long neglect is that very little is known about their individual lives and careers, and most frustratingly to art historians, it is impossible to be certain which of the three is the author of any given picture or group of pictures in a fairly large and very diverse corpus.

Antoine and Louis were born around 1600, Matthieu around 1607. In spite of their Guild affiliation, the three brothers joined the new Academy of Painting and Sculpture when it was set up in 1648; Antoine and Louis, however, died later in the same year, while Matthieu lived on for almost three decades, dying only in 1677. Even with this enormous disparity of life-spans, it is not possible to attribute any pictures with certainty to the last thirty years of Matthieu's life. All the signed pictures bear the family name alone, while all the dated pictures are from the period 1641–47, when all three brothers were alive. The problem is further complicated by the fact that a large proportion of the brothers' production was destroyed by the deliberate vandalism of the French Revolution (including everything they left in their home town of Laon). There have, nonetheless, been many attempts to attribute different categories of work, some authors, for example, giving the small family groups to Antoine, the substantial peasant genre subjects to Louis, and the contemporary

21 **Antoine, Louis and Matthieu Le Nain**, *Bacchus and Ariadne, c.* 1629–30. Ariadne, the daughter of Minos, had helped Theseus kill the Minotaur and escape from the labyrinth, but he abandoned her on the island of Naxos on his journey home. Bacchus, on his own triumphal return after becoming a god in India, came upon Ariadne, fell in love with her, and made her his consort. The Le Nain interpretation of the theme is quaintly precious, like the romances that were popular at the time. The subject was probably inspired by Blaise de Vigenère's translation of Philostratus (illustrated edition 1614), and elements are drawn from Primaticcio at Fontainebleau.

genre pieces to Matthieu. More recently, it has been suggested that the brothers deliberately produced different categories of work under the common brand for distinct clientèles. Considering how punctilious the Guild of Painters was in regulating the activities of their profession in Paris, it was probably also more convenient to operate as a single firm than to obtain two further Guild memberships.

Whatever the truth about the attributions, it seems that the brothers started by producing religious and mythical subjects, such as the early *Bacchus and Ariadne* (c. 1629–30) [21] which is still visibly in the tradition of Fontainebleau mythological painting, before moving towards a naturalistic idiom. The reason for this change was no doubt that they were being driven out of business by Vouet, whose new Italian style was incontestably a superior vehicle for the history painting they had been attempting. Unlike Vouet, the brothers had not been to Italy and had not been properly trained in the art of painting; they could not imitate or compete with the abstraction of his style, but they could follow the practitioners of *bambocciate* in a style that could be learnt simply by close observation of the everyday world. Of course their paintings are more complex and more ambitious than that. In the first place they avoid the triviality that is common in genre and especially in some Dutch and Flemish work. The Le Nains' peasants are never coarse, repellent or ridiculous. On the contrary, they are treated with dignity and compassion, although without sentimentality. The compositions are characterized by contemplative stillness, even solemnity.

Venus in Vulcan's Forge [22], a work signed and dated 1641, probably marks the near-conclusion of the transition from the early mythologies to genre, for Venus still belongs to the earlier period, while Vulcan is already changed into a Caravaggesque blacksmith. The two young men in the background are wholly naturalistic, and the one who turns around to stare at the goddess is not only a man looking at a woman, but a tradesman of Paris in 1641 gazing in wonder at a being who does not belong to time or place at all. He tends to attract our attention, but the real focus is on the encounter of husband and wife, which is in contrast strangely indirect and reticent.

Once again we encounter that emphasis on expression which marks the higher ambitions of French genre painters. The incomplete metamorphosis into genre that is here taking place before our eyes also makes this hard to overlook. But expression is handled with greater assurance in a later reworking of the

22 **Antoine, Louis and Matthieu Le Nain**, *Venus in Vulcan's Forge*, 1641. Venus is the mother of Aeneas by the Trojan prince Anchises. As Virgil relates, she comes to ask Vulcan to make her son a new set of arms (*Aeneid* 8: 370–453). The episode is based on Thetis' request to Hephaestus (Vulcan) in *Iliad* 18 on behalf of her son Achilles, but in Virgil's poem the situation is complicated, for Venus is Vulcan's unfaithful wife. Nonetheless, Vulcan will be overcome by her seduction, and after going to bed with her, will fulfill her request.

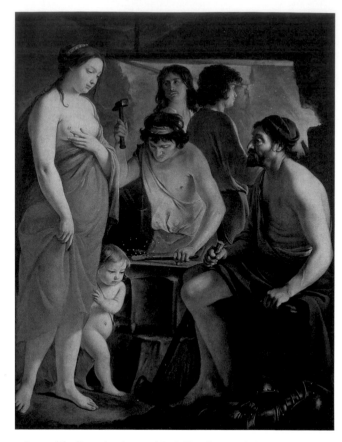

23 **Antoine, Louis and Matthieu Le Nain**, *The Forge*, mid-1640s. This important painting was saved from destruction during the French Revolution when it was confiscated from the Comte d'Angivilliers and entered what became the Louvre museum, where it kept the Le Nain name alive during the 19th century.

24 **Antoine, Louis and Matthieu Le Nain**, *Peasant Family*, c. 1645–48? The greatest painting of the Le Nain brothers remained completely unknown, in the Château de Marmier where it had perhaps hung since the 17th century, until the Marquis' auction in 1914. It was acquired in 1915 by the Louvre and soon became one of the most famous images of the French 17th century.

subject, *The Forge* (mid-1640s) [23]. The figure of Vulcan is replaced by that of the elderly father, the young man looking at the goddess has become the young blacksmith glancing out at us, and Venus has become his wife, standing behind him and also looking out at the viewer. Whereas the first picture exhibits a certain confusion between historical and anecdotal levels of expression, in the later composition the alert but weary look of the young man, the patient gaze of the wife, and the faraway, dreamy stare of the old blacksmith all tell a common story of labour and life and the passing of generations.

The masterpiece of the Le Nain brothers is the *Peasant Family* in the Louvre [24], presumably painted in the late 1640s. It is the culmination of their efforts to raise genre to the dignity of history, and it shows them assimilating something of the new Classical rigour that developed in Parisian history painting in the decade following Poussin's visit (1640–42). The clear placement of the

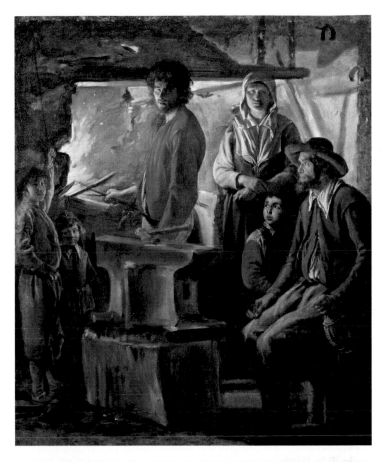

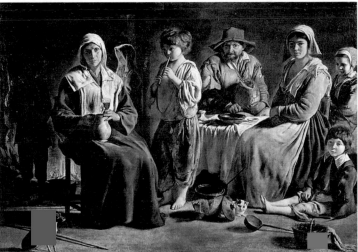

25 **Antoine, Louis and Matthieu Le Nain**, *La Tabagie*, 1643. A *tabagie* is a smoking party. Such occasions must have involved drinking as well, but this is an oddly sober assembly: there is not a glass in sight, although two bottles stand in a tub in the foreground, and one man has fallen asleep on the table. The man standing on the far left may be speaking, while the others are silent. The young man on the right and the black servant both look out at us, but with very different expressions.

figures on a spatial stage, the strong composition closed by the figures of mother and daughter turned inwards at either side, are all Classical in flavour. And yet this is not really a Classical space: the ample foreground only draws our attention to the disconcerting fact that there is not enough room for the adult figures to stand up. Clearly the artist has not conceived the space as one in which an action or *historia* is to take place: the emphasis is rather on stillness and intimacy, and one may recall Pascal's almost contemporary observation that most of the evils of our lives come from our inability to sit still in our room. Le Nain's peasants seem indeed free of the *inquiétude*, the restlessness that Pascal deplores, although – significantly – this is precisely the quality we sense in the group of smart young men portrayed in *La Tabagie* (1643) [25].

The *Peasant Family* has intrigued viewers and writers because it seems at once obvious and mysterious, and attempts have been made to read hidden meanings into its iconography. The

strangeness perceived in the picture, however, is the result of that elevation of genre to the seriousness of history, even if, as we have seen, the subject is not to be confused with a history subject. The essence of the transformation lies in the avoidance of anything trivial or gratuitous, and the marshalling of every element in the composition, from the actions of the figures to the animals and the still-life details, in the interests of expression, precisely as Poussin did in his quite different range of subject-matter. The focus of that expression is the quiet dignity and simplicity of the family, which the bread and wine lead us to understand as deriving from the effect of immanent grace.

The other French artist who extended the idiom and material of naturalism and raised it to unprecedented heights was Georges de La Tour (1593–1652). The unique sensibility of his work derives from his pursuit of an increasingly rigorous abstraction, in order to concentrate more and more precisely on the expression of his religious subject-matter. As we have seen, however, the constructive abstraction of history painting cannot be derived from the singular model which is the premise of naturalism, and La Tour is the supreme example of a subtractive or reductive abstraction. The result, incidentally, is much more obviously 'abstract' to modern eyes than the artificial figures of Poussin.

Georges de La Tour, like Lallemant and above all Claude, was actually a native of Lorraine, which had escaped the horrors of religious war at the end of the 16th century and was in consequence more prosperous and more culturally sophisticated than France at the beginning of the 17th. He probably spent some time in Italy between 1613 and 1616 before establishing himself in the city of Lunéville, where he became a wealthy citizen. The early part of his career belongs to the last brilliant period in the history of the Duchy, which was invaded by Richelieu and annexed to France in 1630. The following decade was marked by successive disasters: war, plague, and the great fire of Lunéville in which the artist's house was burnt. The horrors of war were commemorated in a series of engravings, *Les Grandes Misères de la Guerre*, by Jacques Callot (1592/93–1635). Nonetheless, La Tour accepted the French occupation and was in Paris in 1638–39, where he presented Louis XIII with a painting of St Sebastian (the original of which is lost) and was made Peintre Ordinaire du Roi (Painter-in-ordinary to the King), a title which was in itself largely honorific, although it included the right to a lodging at the Louvre. It appears too that La Tour sought this honour in order to shore up quasi-noble privileges and fiscal exemptions previously granted

by the Duke of Lorraine. He was not the isolated provincial artist
that is sometimes imagined, idiosyncratic and out of step with
contemporary taste; his work was certainly highly individual, but
it is clear that it was collected by important patrons, including
the French governor in Nancy and the King himself.

La Tour's work falls broadly into two categories, sometimes
simply characterized as day and night pictures. In the first and
earlier group (to around the mid-1630s), the subjects are
Caravaggesque: scenes of fortune-telling or card-sharping [26]
which allow him to represent groups of glamorously dressed
young men or women together with ruffians or gypsies, or in
a more serious vein figures of aged and wrinkled men in the
personages of St Jerome or some other appropriate character.
There are magnificent pictures in this period, like the *St Thomas*
(c. 1632) [27] with its harsh expression of suffering and endurance,

27 Georges de La Tour,
St Thomas, c. 1632. Thomas, the
apostle who doubted, now looks
grimly set in his faith. The spear
alludes to his own death in India,
but also to the spear that wounded
Christ in the side – the very wound
into which Christ made Thomas
put his hand to convince himself
that his master had truly risen
from the dead (John 20: 24–29).
The work was known from
1950, but not exhibited until its
acquisition by the Louvre in 1988.

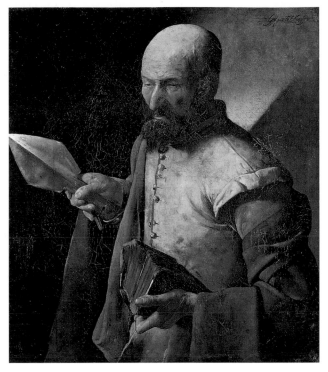

and the extraordinary still-life detail of the book which is like a
metaphor of the man, grown old in the service of the Word.

La Tour's greatest paintings, however, are mostly the later
nocturnes, such as *Christ in the Carpenter's Workshop* (c. 1640) [30],
The Penitent Magdalene (c. 1642–44) [32] and *The Newborn Infant*
(c. 1648) [31]. The incidental detail and the surface realism of the
early pictures have been pared away and even iconography is
almost eliminated. Candle- or torch-light not only dramatizes the
narrative, but further simplifies forms and tonal construction. Like
the masterpieces of the Le Nain brothers, but to an even greater
extent, these are works whose laconic integrity has provoked the
commentary of critics. Their power derives from the immediacy
of direct observation, concentrated by extreme reduction; it is not
a formula that could be adopted or extended by anyone else. It is
itself the final point of a development, but in La Tour's hands it is
the perfect medium for the tangible, almost sculptural expression
of an essentially intangible and spiritual experience.

That La Tour is a religious artist is not in doubt; and although
his personality was extremely different from that of Caravaggio,
his development followed a similar path from early virtuosity in

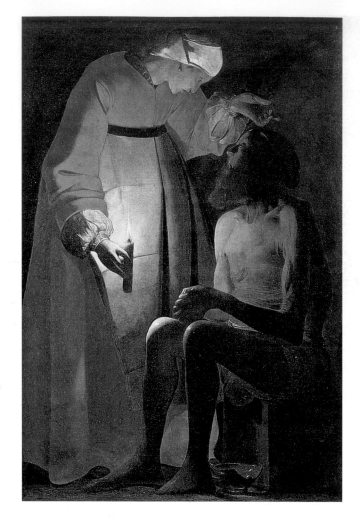

28 Georges de La Tour,
Job and his Wife, c. 1632–35. The
massive figure of Job's wife towers
over her unfortunate husband,
chiding him for refusing to give in
to the disasters God has allowed
Satan to visit upon him as a test
of his faith. In the first stage of his
trial, Job had lost his wealth and
his children. Now he is stricken
in his own body. 'Then said his
wife unto him, Dost thou still
retain thine integrity? curse
God, and die' (Job 2: 9).

execution, minute observation of the model, and irony in subject-matter to deep seriousness and urgent intensity in the last period. Although La Tour or his workshop often produced variants of his compositions, the great paintings are each distinct acts of meditation. *Job and his Wife* (*c.* 1632–35) [28] – a work that seems to belong to the transition from the earlier to the later period – evokes the misery of the just man unaccountably abandoned by God. The *St Sebastian tended by St Irene* [29] is a monumental picture of martyrdom and pious care, while *Christ in the Carpenter's Workshop* [30] is a meditation on the humble world into which the Redeemer chose to be born. The restraint of *The Penitent Magdalene* [32] makes Charles Le Brun's almost contemporary

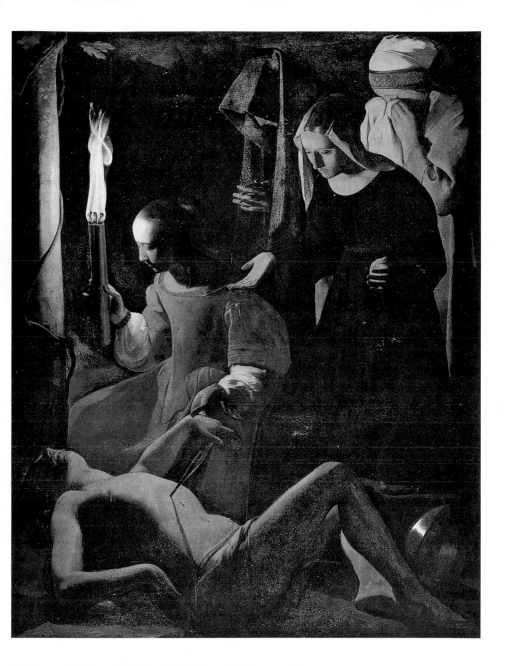

29 **Georges de La Tour**, *St Sebastian tended by St Irene*, 1649. The composition
recalls that of Caravaggio's *Deposition*, with its diagonal sweep of figures and play
of hands. As usual, however, La Tour is much quieter and more sober. This painting
was probably commissioned by the city of Lunéville as a gift to the Governor,
La Ferté. It was only discovered in 1945; there is another version in Berlin, but
this is now recognized as the original.

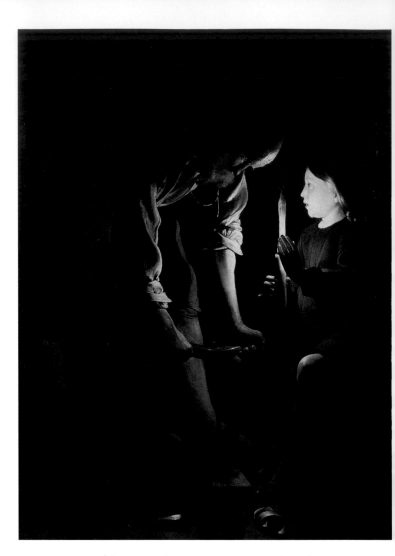

30 **Georges de La Tour**, *Christ in the Carpenter's Workshop*, c. 1640. La Tour re-uses the compositional format of *Job and his Wife* (ill. 28), with the large figure of Joseph arching over the top of the canvas and meeting the smaller figure of Jesus. Now, however, it serves for a tender encounter between the elderly father and the young boy, in one of La Tour's most memorable uses of the masked candle-flame.

treatment of the same subject appear overwrought and even hysterical [107]. It is significant that Le Brun, who did not have a very deep religious sensibility, conceives of repentance as a paroxysm of anguish, while La Tour understands it as a process of inner transformation. His Magdalene is already inhabited by grace, whose appearance in the world is the subject of *The Newborn Infant* [31]. Once again, we encounter a characteristically French spirituality, attuned to the presence of the divine in this world, not to the pursuit of inaccessible transcendence.

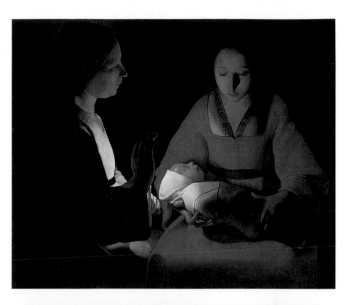

31 Georges de La Tour,
The Newborn Infant, c. 1648.
This famous painting is a Nativity
stripped of its iconography, reduced
to the bare relation of mother and
child, and to the intense, deep sleep
of the infant. In fact the maternal
theme is doubled: the young
mother is herself little more than
a girl, in turn watched over by her
own mother, St Anne, who holds
the candle.

32 Georges de La Tour,
The Penitent Magdalene, c. 1642–44.
The candle flame in La Tour's
nocturnes is generally covered,
but here is it is naked, leading us
to share the absorption of the
Magdalene as she stares into its
intense brilliance. In spite of the
scourge that lies on the table, her
penitence is less a mortification
of the flesh than a forgetting of
the self in the experience of the
divine. All of this is anchored
in a composition of irrefutable
simplicity: the main line of her
body follows the curve defined
by placing a compass-point at
the top right-hand corner of the
painting and rotating the short
side of the rectangle downwards
onto the long side.

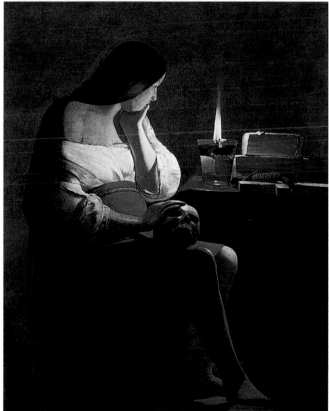

Chapter 2 Rome: History and Landscape

The most important artists discussed in the previous chapter reacted against the prevailing Mannerism of the beginning of the century by resorting to naturalism, but then strove to raise genre to the seriousness of history. This chapter, in contrast, will be largely concerned with the man who most thoroughly understood the tradition of history painting, Nicolas Poussin (1594–1665) [33]. Or perhaps we should more properly say – since a tradition is also an aspiration or a horizon – that Poussin is the artist who most fully realized the potential of history painting. He is a 'classic' in the specific sense in which T. S. Eliot applies the term to Virgil: the artist who consummates the art he practises and leaves no loose ends for his successors to pick up. Poussin, the painter of the tradition, is thus unexpectedly almost as inimitable as La Tour, whose work was a brilliant and solitary exception.

That Poussin should have achieved so much – born in a small town in Normandy, growing up in an unpropitious time and place, more or less self-taught in the art of painting and not reaching Rome until the age of thirty – is quite remarkable. It illustrates, however, the nature of true vocation: an instinct for the path, implicit in the work of one's predecessors, that leads beyond oneself to greater and more impersonal things. Poussin's career is also the most brilliant example of a certain relationship between French and Roman painting (and art theory) in the 17th century: Rome possessed a unique cultural weight, but France had a new and sharp edge. It is the combination that makes Poussin not only the best French artist of the 17th century, but also the best Italian. Claude Lorraine's greatness derives from a similar hybridization, and on a smaller scale the same holds true of Valentin, who was the most substantial of Caravaggio's followers.

It may seem strange that Rome, and indeed Italy, could not produce another painter of Poussin's stature in the 17th century. But although Rome was the epicentre of the great tradition of history painting, all was not well in its practice. To understand why this was the case, it is necessary to recapitulate briefly the

historiography of early modern art. From Vasari's point of view, writing his *Lives of the Artists* in the middle of the 16th century, the arts had been lost in the fall of the Roman empire, and had been gradually recovered, in three stages, in the course of the Renaissance. The High Renaissance marked the full restoration of the three daughters of *disegno* – painting, sculpture and architecture – to the glory they had enjoyed in Antiquity, and as a Mannerist himself, Vasari suggested that his hero, Michelangelo, had actually surpassed the Ancients.

After the reaction which set in at the end of the 16th century, the Mannerist episode came to be regarded as a relapse into decadence, requiring a new restoration, which was effected by Annibale Carracci together with his brother Agostino and cousin Ludovico. Annibale's greatest monument in Rome was the ceiling of the Galleria Farnese (1597–99), which became as essential an object of study to young painters as the Vatican frescoes of Raphael and Michelangelo. The Carracci method of working and teaching corresponded closely to the general method of history painting already outlined: like Raphael, only more systematically, they used live models not as the direct objects of copying, but as a means to understanding the form and workings of the body, and always with a view to the imaginative transformation of those real bodies into artificial painted figures. That process of transformation was in turn guided by the study of ancient sculpture and modern painting (a canon was defined, based on four great masters: Raphael, Michelangelo, Titian and Correggio, to whom Annibale himself was subsequently added). The aim of this process was, once again, to generate figures that would be suitable vehicles for the expression of the subject in a history painting.

From the beginning, however, there were artists and patrons for whom this ideal was too rigorous. A celebrated and endlessly repeated anecdote that goes back to Annibale's own lifetime (1608) made the point that one of his pupils, Domenichino, was more attentive to expression than another, Guido Reni. The master had given each of the younger artists a scene from the martyrdom of St Andrew to paint in S. Gregorio Magno in Rome. When they were finished, Annibale watched an old woman showing the paintings to her grandchild. The pair admired Guido's work in silence, but when they turned to Domenichino's *Flagellation*, the old woman started to comment on the attitudes and expressions of the figures; and thus Annibale knew that Domenichino's painting was more truly effective in conveying its story. This anecdote was probably recalled in the light of the later

quarrel between Domenichino and another of the Carracci pupils, Lanfranco, which was raging at the very time Poussin arrived in Rome in 1624. Lanfranco had wrested from Domenichino the important commission for the dome of S. Andrea della Valle (1621–25), and left his rival to paint the pendentives (1624–28). Not content with that victory, Lanfranco then put it about that one of Domenichino's masterpieces, *The Last Communion of St Jerome*, was largely copied from an earlier version of the same subject by Agostino Carracci. This charge of outright plagiarism, at a time when intelligent imitation and adaptation were standard practice, was quite exceptional. Lanfranco went so far as to have his pupil François Perrier engrave the Agostino composition so that all could see for themselves.

At the same time other quarrels were brewing. Gianlorenzo Bernini (1598–1680) sculpted his *Apollo and Daphne* in 1622–25 and became Architect of St Peter's in 1629; neither his sculpture nor his architecture was to be taken seriously by Bellori, who later pointedly omitted him from his collection of twelve artists' biographies, the *Vite* (1672). Pietro da Cortona (1596–1669) was making a name for himself with a series of frescoes at S. Bibiana (1624–26) and would soon paint the extravagant ceiling at Palazzo Barberini (1633–39), designed to rival the more sober *Divina Sapienza* (*Holy Wisdom*) ceiling only just completed (1629–33) in an adjacent room by his rival, Andrea Sacchi (1599–1661), pupil of another orthodox disciple of Annibale, Francesco Albani (1578–1660). The rivalry between Sacchi and Cortona at Palazzo Barberini turned into an important debate at the Academy of St Luke in 1636.

The two camps that increasingly emerge from these various quarrels and rivalries can be broadly characterized as Classical and Baroque. Ultimately these stylistic labels may be understood as embodying alternative metaphysical perspectives. For our present purposes, however, they can be more simply and precisely characterized. The Classical party is the one that takes history painting seriously. It considers *invention*, as we have seen, to be the heart of painting, and expression the governing principle in realizing the subject in paint. All the formal qualities associated with Classicism – clarity of composition and narration, accuracy of drawing, and distinctness of colour and light – are valued because they contribute to the economy of expression. In contrast, the Baroque party is in general more attached to large-scale decorative values; they pay lip-service to expression, but in practice they reduce it either to a sensational psychological

33 **Nicolas Poussin**, *Self-portrait*, 1649–50. Painted at the insistence of Poussin's friend Paul Fréart de Chantelou, who wanted to complete his fine collection of the artist's work with an image of the man himself. The allegorical figure in the painting in the background is the Genius of Painting; the third eye, on her tiara, probably stands for what Chantelou's brother, Fréart de Chambray, referred to as *l'œil de l'esprit*, the eye of the mind.

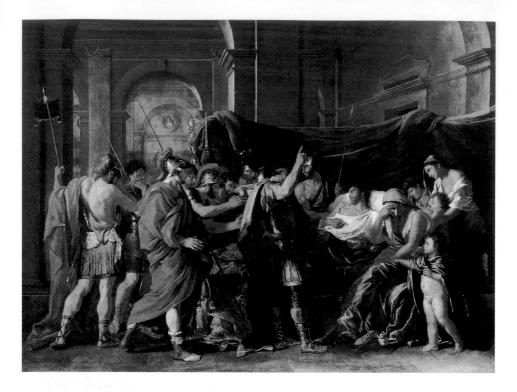

34 **Nicolas Poussin**, *The Death of Germanicus*, 1627–28. In this picture, privately commissioned by Cardinal Francesco Barberini late in 1626, Poussin worked in an unprecedentedly Antique mode. The story is from Tacitus (*Annals* 2: 71–72). Germanicus (15 BC–19 AD) was the adopted son of Tiberius, but the Emperor, jealous of his military successes, had him poisoned in Antioch. Before dying, Germanicus addresses his friends, who are seen vowing to avenge him, while his wife Agrippina mourns.

phenomenon or to a superficial code of facial and bodily movement. Dramatic decorative effect remains their first priority.

It is necessary to define these issues with some precision because they are vital to an understanding of Poussin's development as an artist and the fundamental choices he made in his career. They are also indispensable to an understanding of the later development of painting in France itself: for the painters of Versailles, like the Classical artists of Rome in Poussin's time, would be torn between their aesthetic ideals and the demand for Baroque decoration. The artists that Bellori particularly admired – Domenichino, the sculptor Francis Duquesnoy (1594–1643), Sacchi – almost all experienced difficulty with invention and completed very little work, while their Baroque rivals were prolific. Lanfranco's attack on Domenichino's alleged poverty of invention was, we can now appreciate, particularly malicious. Bellori's defence, of course, is on the grounds of superior expression, and Poussin too remarked, with this controversy in mind, that originality in art does not derive from a subject never before represented, but from 'buona, e nuova dispositione e espressione' – good and new composition and expression.

The only Classical painter, in fact, who did not suffer from this kind of paralysis was Poussin, who on the contrary worked consistently, with an unmatched quality of invention, for almost forty years after his establishment in Rome. This achievement was only possible because Poussin understood the nature of the dilemma that faced his contemporaries, and made the strategic decision to withdraw from the field of large-scale decorative painting altogether. Working exclusively in the format of easel pictures, which he could execute without assistants, and selling them to an Italian and French *clientèle* of connoisseurs who held him in high regard, Poussin could be almost entirely free to pursue his own artistic concerns.

Such freedom was not achieved all at once, although a certain determined independence can be divined in his work from the very beginning. It is often pointed out that he was not a prodigy

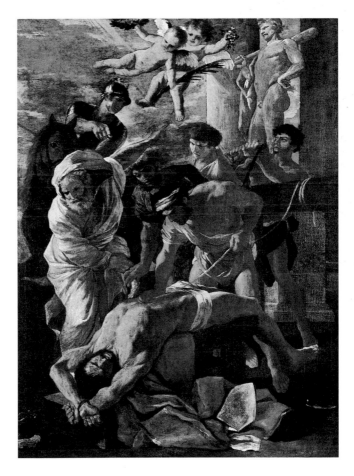

35 **Nicolas Poussin**,
The Martyrdom of St Erasmus, 1628–29. Commissioned as an altarpiece for St Peter's in Rome by Cardinal Francesco Barberini, this painting required the young Poussin to adopt a Baroque manner which was not really suited to his talents. He was also unhappy at being placed effectively in competition with Valentin (see ill. 13).

Erasmus, Bishop of Antioch, was put to death by the Emperor Diocletian in 303 AD. In the Middle Ages the legend arose that he had had his intestines wound out on a winch, as is shown here. Although the execution seems well under way (the Roman officer at the back urges the executioner to turn the winch harder), the priest still enjoins Erasmus to give up his faith and worship the statue of Hercules. This hero, who usually stands for virtue in humanistic painting, is in this case represented as a swaggering bully with a sneering expression on his face.

in any conventional sense, but prodigies can only arise in a generally flourishing environment. The genius of the young Poussin is apparent in his pursuing an art of which he could only actually see for himself tantalizing vestiges. Ignoring the fashions dominating contemporary practice, he found, as we have seen, a few clues at Fontainebleau, in the work of Quentin Varin [5, 11], of Toussaint Dubreuil [6]; in Pourbus's impressive but isolated *Last Supper* [10]; and then in prints after Raphael and Giulio Romano. Poussin did have the advantage of being better educated than most of his

36 **Nicolas Poussin**, *The Death of Adonis*, 1626–27. Venus loves Adonis and tries to dissuade him from going to the hunt, but he refuses to listen and is killed by a boar (Ovid, *Metamorphoses* 10: 719–735). Mourning him, she pours nectar over his body and he is turned into the anemone. The attitude of Adonis is strikingly like that of a dead Christ painted by Poussin at around the same time (Munich, Alte Pinakothek).

fellow artists in France, for he had probably attended a Jesuit college for a time. This association may explain the commission he received from the Company in 1622, for six paintings (now lost) celebrating the canonization of their new saints, Ignatius Loyola and Francis Xavier. These works attracted the attention of the poet Marino, who took Poussin into his own house towards the end of the same year, commissioned a series of drawings after Ovid, and then encouraged the young painter to follow him to Rome. Poussin may have left Paris in the autumn of 1623, wintering in Venice before arriving in Rome early in 1624. A few weeks later, Marino left for Naples, where he died in the following year.

The first few years in Rome were hard, although thanks to Marino's introductions, Poussin enjoyed some important connections from the start. Most valuable to his material well-being and intellectual development was no doubt Cassiano dal Pozzo, whose library, collections and 'paper museum' of drawings after Antique sculptures and archaeological objects as well as natural history were known around Europe. Poussin was already familiar with Ovid, and Cassiano helped him to broaden his

37 **Nicolas Poussin**, *The Kingdom of Flora*, 1631. Apollo, standing for the fiery Logos or Divine Reason, guides the chariot of the sun through the heavens, giving life to the world of nature – of earth and water – below. There Poussin has collected the mythical figures who die and are transformed into flowers: Ajax falling on his sword (he becomes a hyacinth), Clytie looking up at the sun (she becomes a sunflower: cf. ill. 160), Narcissus gazing into a pool, Hyacinth wounded in the head, Adonis wounded in the thigh (he becomes an anemone: cf. ill. 36), and the couple Crocus and Smilax – with Flora in the centre scattering flowers.

understanding of the religious, philosophical and historical dimensions of mythological subjects. But Rome also offered Poussin – accustomed to working from such scanty materials in Paris – a bewildering wealth of examples. Apart from the treasures of Antiquity, he was able to study Raphael's frescoes for the first time, as well as those of Annibale Carracci. He drew in the studio of Domenichino, Annibale's most serious-minded pupil. His admiration for Domenichino's *Flagellation* is even said to have converted other young artists who had previously preferred Guido Reni's competing *St Andrew led to Martyrdom*.

But it was also in Rome (and of course in Venice, if he did indeed stop there on his way south) that Poussin came to know the work of Titian, an artist he had not been able to study properly in Paris. He found in Titian's *Bacchanals* a painterly language of figures in a landscape that was ideally suited to his developing subject-matter, and allowed him to progress beyond the simple but poetic compositions of his earliest work in Rome, such as *The Death of Adonis* (1626–27) [36]. On the whole, it is a manner derived from Titian that characterizes the work of the

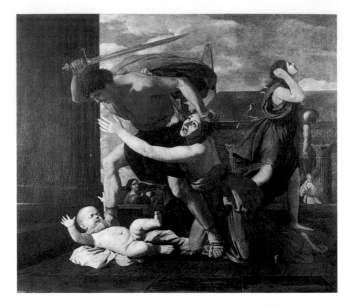

38 **Nicolas Poussin**, *The Massacre of the Innocents*, 1627–28. When the Magi failed to return to tell him where they had found the new King, Herod had all the male infants of Bethlehem slaughtered as a precaution. The Holy Family, however, had slipped away into Egypt and would only return on Herod's death. Instead of the usual crowd scene, Poussin seems to have thought that it would be more logical to imagine a house-by-house search, and also more dramatic to focus on a single killing. The three main figures are a re-thinking of a group in Raphael's *Massacre of the Innocents* (drawn for engraving by Marcantonio Raimondi).

later 1620s, although Poussin's tone is always more elegiac than sensual, and the themes of the paintings already foreshadow a philosophical thinking that will become clearer in later years.

But Poussin was aware that large commissions were dominated by the Baroque painters. For a short time around the end of the decade, he was willing to experiment with different styles for his various clients and commissions. We have seen that his friend and patron Cassiano was also the secretary of Cardinal Francesco Barberini. When Cardinal Barberini personally commissioned *The Death of Germanicus* [34] in 1626, Poussin produced the most strictly Classical, or more accurately Antique, composition that he had ever painted. But when the same Cardinal, pleased with this work, invited him to paint the *Martyrdom of St Erasmus* altarpiece (1628–29) [35] for St Peter's, Poussin knew that what was required was something quite different, especially as the task had originally been allocated to Pietro da Cortona. He appears to have incorporated some of Cortona's ideas for the composition, while typically giving them greater coherence. Neither the scale of this project, however, nor the subject suited Poussin's temperament; the competition set up with Valentin was even less congenial (p. 28), and he was discouraged by the work's reception.

At the same time that he was working for the Cardinal, Poussin painted his starkly dramatic *Massacre of the Innocents* (1627–28) [38], in which he turned for inspiration to one of Raphael's designs made for engraving by Marcantonio Raimondi. His single group is

derived from, but completely reconstructs, the group on the right in Raphael's design. In attempting this subject, Poussin was also engaging in a less public kind of competition with Guido Reni, whose own *Massacre* (1610) was considered a masterpiece. It is thus not surprising that Poussin's spatial layout suggests that he has been studying Domenichino's compositions in the St Cecilia frescoes in S. Luigi de' Francesi (1615–17).

Poussin's disappointment at St Peter's precisely echoed the kind of frustration that Domenichino himself had experienced in trying to compete with the Baroque artists on their own terms. Unlike some of his predecessors and contemporaries, however, Poussin recognized the futility of the attempt, and turned decisively in another direction. Seen in this light, *The Kingdom of Flora* (1631) [37], which is a collection of his favourite mythological characters, is like a declaration of independence from Church commissions and patron-politics: the affirmation that he can devise his own painterly world, drawing on far older and deeper sources than the Church's catalogue of minor martyrs. At the same time, *The Plague at Ashdod* (1630–31) [39], which once again refers directly to a design by Raphael (*The Plague of the Phrygians*, also known as the *Morbetto*), shows

39 Nicolas Poussin, *The Plague at Ashdod*, 1630–31. The subject is from I Samuel 5: 1–12. The Philistines have seized the Ark of the Covenant and placed it in the temple of their idol Dagon. The idol's statue is miraculously cast down and broken, while a terrible plague breaks out in the city, which is infested with rats. Poussin has captured the confused agitation of the stricken population. In the centre is a group adapted from Raphael's print of *The Plague of the Phrygians*: a man bends down, holding his nose, to stop an infant suckling at the breast of its dead mother.

40 **Nicolas Poussin**, *The Adoration of the Golden Calf*, 1633–34. Moses descends from the mountain where he has been communing with God, bearing the tablets of the Ten Commandments. But the people of Israel have grown impatient. Aaron has collected their jewelry and made them a golden calf to worship (Exodus 32: 1–6). Furious, Moses – seen in the background – breaks the tablets before destroying the idol.

The main group of three dancers in the foreground has been adapted (and reversed) from the *Bacchanal before a Herm* (London, NG). The animation has a similar cause – the worship of a deity of nature – but the expression is subtly changed: the principal male figure, in particular, who is happily inebriated in the *Bacchanal*, here looks grim and apprehensive.

Poussin's determination to return to the central Classical tradition of Raphael and Annibale and to develop a style incomparably more solid and substantial than anything that a Pietro da Cortona, for example, could achieve: Poussin deliberately set a new standard of drawing, of composition, and of expression that would prove impossible to match.

Coincidentally, both *The Kingdom of Flora* and *The Plague at Ashdod* were purchased by Fabrizio Valguarnera in 1631. He was a Sicilian adventurer who had stolen a quantity of diamonds in Spain and was endeavouring to launder the money in Rome by buying paintings. He was caught, Poussin had to testify at the trial, and Valguarnera died in prison the following year, no doubt poisoned. Although it must not have been pleasant for Poussin to be involved in these events, they are evidence that his paintings were already considered valuable and marketable objects. Poussin's career during the remainder of the decade follows an ascending curve of success and self-confidence. He takes on large and important subjects from the Old Testament – like *The Adoration of the Golden Calf* (1633–34) [40] – and ancient history – *The Rape of the Sabines* (1634 [41] and a further version in 1637). By the middle of the

41 **Nicolas Poussin**, *The Rape of the Sabines*, 1634. In the early days after its foundation, the city of Rome was short of women. Romulus invited the neighbouring Sabines to a feast, and at his signal – he is seen upper left lifting his red cloak – each man seized a Sabine woman. The union of the two tribes would produce the people of Rome.

The group of the soldier carrying off a girl on the left recalls a similarly placed pair in Cortona's *Rape of the Sabines* a decade earlier, and draws the viewer's attention to the much greater expressive intensity of Poussin's version. Poussin painted this, his first essay at the subject, for the Maréchal de Créqui, French Ambassador to the Holy See.

decade, his fame had reached Paris and Cardinal Richelieu (1585–1642) had ordered a series of three – or four, according to Bellori – *Bacchanals* to go with the mythologies by Mantegna, Perugino and Lorenzo Costa that had once adorned the *studiolo* of Isabella d'Este in Ferrara. The Este pictures, together with the new Poussin compositions, were mounted in the Cabinet du Roi at the Cardinal's château at Richelieu in Poitou. This prestigious commission was an opportunity for Poussin to return to subjects he had originally approached through the language of Titian, and which he now depicted in his new style. The three works were conceived as celebrations of three figures associated with the fertility of the earth: *The Triumph of Pan* [42], *The Triumph of Silenus* (London, National Gallery) and *The Triumph of Bacchus* (Kansas City). The resulting pictures are among his least appealing, however, because the hardness of the style – in the painting reproduced, built upon an extraordinary grid of diagonals – does not marry well with the gaiety of the subjects, and because, prompted no doubt by the importance of the commission (and perhaps also by doubts about the artistic sophistication of his compatriots), he has given the works an excessive level of finish.

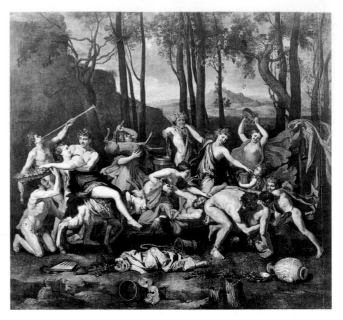

42 **Nicolas Poussin**, *The Triumph of Pan*, 1636. This is one of the *Bacchanals* ordered by Richelieu for his château in Poitou, where it was to hang in the Cabinet du Roi with paintings from the *studiolo* of Isabella d'Este at Ferrara. Although traditionally known as the triumph of Pan, the true subject of this picture is probably the triumph of Priapus, the phallic god: the term in the centre has a red face, which is one attribute of Priapus, while the other and more obvious one is discreetly veiled by the draperies of a nymph.

The attitude of the satyr lifting a drunken companion, on the right, is derived from a drawing after Raphael. That figure in its turn is probably a permutation of an attitude used by Raphael to anchor the left side of the fresco of *The Battle of Constantine* (Vatican): a man kneeling on his left leg with the right extended, and the back turned to face the viewer. The composition was drawn by Rubens and the attitude loosely adapted for the left-hand figure in his *Miracles of St Ignatius Loyola*. It became an intrinsic part of Poussin's compositional language and is closely followed for the kneeling shepherd in *Et in Arcadia Ego* (ill. 44). The ultimate classical prototype of this attitude, which all of these painters could have known, may have been a large antique marble vessel carved with reliefs (the Torlonia Vase) which had been set up as a fountain in the Cesi gardens in Rome.

In 1639 he completed *The Gathering of the Manna* [43] for Paul Fréart de Chantelou (1609–94), who would be a friend, collector and correspondent until the end of Poussin's life (see p. 103). This complex painting represents the culmination of Poussin's ambitious history subjects in the 1630s, and yet as in some other works of this period, its large number of relatively small figures, although divided into several groups (as prescribed by Classical theory when a subject demands many figures), lack a central focus. The number of figures allowable in a composition had been one of the topics hotly debated at the Academy of St Luke in 1636, the Classical party maintaining that in painting as in tragedy, it was preferable to employ few actors rather than many. Poussin was certainly involved in these discussions, and it is interesting to see that from this time onwards he begins to limit the number of figures in his pictures. Thus *Et in Arcadia Ego* (1638–40) [44], one his most celebrated poetic meditations, has only four large figures clustered around the tomb, each one carefully constructed to occupy and unify the pictorial space, with many limbs parallel to the picture plane. Even in larger historical subjects painted after these years, the number of figures is restricted compared to *The Gathering of the Manna*, and Poussin demonstrates his increasingly strict sense of a Classical composition ultimately derived from the Raphael of the Sistine tapestries (Cartoons, 1515–16, London, V&A).

43 Nicolas Poussin, *The Gathering of the Manna,* 1637–39. After Moses had led the people of Israel out of Egypt, they were miraculously fed by God with manna, a mysterious substance which fell on the ground like dew and had to gathered each day and eaten fresh (Exodus 16).

This painting, commissioned by Chantelou, was the subject of a *conférence* at the Academy by Charles Le Brun, who identified both the different expressions of the figures and their sources in ancient statuary – no doubt taking his cue from Poussin, whose well-known remark about 'reading' his pictures was made with reference to this work. There are also borrowings from Raphael, such as the woman on the right, adapted from a figure on the left in the fresco of *The Expulsion of Heliodorus.* The man on the extreme right repeats the attitude of the half-kneeling satyr in ill. 42.

Richelieu was not content to commission paintings from Poussin: Chantelou and his brother, Roland Fréart de Chambray (1606–76), were sent to Rome to bring him back to Paris. Poussin's very success led to what was to prove the last real challenge to his independence. In 1640 he was virtually forced into returning to France, where he was accorded the title of Premier Peintre (First Painter) of Louis XIII and put to the completely uncongenial work of decorating the immense Grande Galerie of the Louvre, a task in which he was kept busy making designs for a team of assistants, and during which he was constantly interrupted by demands for paintings, as well as frontispieces for books and other distractions (this period of his life will be considered in the following chapter). In addition he had to put up with the violent resentment of many of the local painters.

In the autumn of 1642 Poussin returned to Rome, ostensibly to bring back his wife and the rest of his household; but the deaths of Richelieu in December and of Louis XIII in May 1643 effectively freed him from any obligation to return to Paris. From then on, his reputation further enhanced by a royal appointment best enjoyed *in absentia* and his economic position fortified by a new circle of

44 **Nicolas Poussin**, *Et in Arcadia Ego*, 1638–40. Three shepherds and a sheperdhess read the inscription on a tomb. The Latin could mean 'I too dwelt in Arcadia', and thus be taken as the voice of the dead person; but it is more plausibly translated 'Even in Arcadia, I am': the voice of Death, declaring his presence in this idyllic place. The tone, however, is not one of shock or even surprise, much less desolation, but of contemplation. The female figure is probably the personification of Reason (she is hardly a shepherdess).

45 **Nicolas Poussin**, *Sacraments*, I: *Ordination*, 1638–40
see overleaf

46 **Nicolas Poussin**, *Sacraments*, II: *Ordination*, 1647
see overleaf

French collectors, Poussin's independence was unassailable. By the mid-1640s even a wealthy collector might have to wait 'many, many years', in the words of a contemporary, to obtain a painting from Poussin. His portrait for his friend and patron Chantelou (1649–50) [33] speaks of his proud autonomy.

The periods immediately before and after the stay in Paris are marked by the two great cycles of the *Sacraments*, the first for Cassiano dal Pozzo [45] and the second for Chantelou [46]. The idea of painting a series based on this subject was in itself highly original, and testifies at the same time to Poussin's desire to create a monumental artistic work, even though he had forsaken the conventional avenues of monumental art. The *Sacraments* demonstrate the depth both of Poussin's archaeological studies (the early Church was still part of the ancient world) and of his own philosophical meditations, of which more will be said later. Poussin knew, however, that 'sacrament' was the Latin equivalent of the Greek 'mystery', and that the seven Christian Sacraments were essentially ceremonies of spiritual initiation. This is the aspect that evidently particularly concerns him in the first series, in most of which a figure in the background can be seen leaving the space of the composition (in the interior scenes, usually going out of the room and into a more brightly lit one). Some of these

on p. 65

45 **Nicolas Poussin**, *Sacraments*, I: *Ordination*, 1638–40. The first set of Sacraments was done for Cassiano del Pozzo. This composition is indebted to Raphael's Sistine tapestry design *Feed my Sheep* (with the motif of Christ's giving the keys to St Peter), but also suggests a relation between the teachings of religion and those of philosophy. The figures in the grove behind may be intended as philosophers; the one at the far left who has his back to Jesus and walks out of the composition, reading a book, looks very much like Socrates.

46 **Nicolas Poussin**, *Sacraments*, II: *Ordination*, 1647. In the second set of Sacraments, painted for Chantelou, Christ delivers his command to Peter in an elaborate architectural setting, the most mysterious element of which is a pillar with a giant letter E. This is commonly interpreted as standing for *Ecclesia*, the Church, but is more likely an allusion to the E at Delphi, the subject of an essay by Plutarch. Poussin would probably have been drawn to the hypothesis that it is an address to the divinity (in Greek), effectively 'thou art' – a parallel with God's absolute 'I am' in Exodus 3: 14.

right

47 **Nicolas Poussin**, *Rebecca at the Well*, 1648. Abraham sends his servant Eliezer to find a wife for his son Isaac. Approaching the city of Nahor, and seeing the girls at the well, Eliezer prays for a sign: that the destined wife should offer him and his camels water. When Rebecca does so, he explains his mission and offers her a gift of jewelry (Genesis 24: 10–22). The subject was a type of the Annunciation, and for Poussin too it evokes the solemn but joyful reception of the Word (which is fire) by the nymph-like girls, guardians of the complementary element of water.

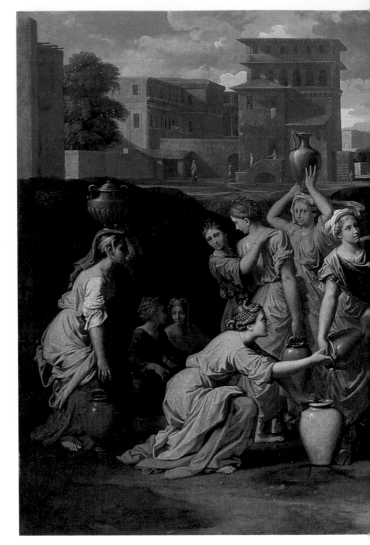

figures suggest that the illumination of the Sacrament may also be attained by philosophical means. In the second series – painted for Chantelou, who had originally requested copies of the Cassiano works – Poussin is even more concerned with archaeological erudition and more solemn in tone [46], but also more discreet in his treatment of the spiritual significance of the ceremonies.

In the *Sacraments* and in his subsequent work, Poussin's style became more severe in some respects, but also more confident. There is none of the over-finishing sometimes found in the mid-

1630s. Poussin's engagement with the compositional and dramatic achievement of Raphael's designs for the Sistine tapestries is manifest. His sense, too, of the meaning and expressive tone of his subjects is now absolutely certain: *Rebecca at the Well* (1648) [47], *The Judgment of Solomon* (1649) [48], *The Death of Sapphira* (1652–54) [3], and so many others, are like dramas in which every character's role is fully understood and integrated into the moral sense of the whole. Thus in *Rebecca at the Well*, often cited later as a touchstone of 'expression générale', all the figures are focused on the encounter of Rebecca and Eliezer, but they are themselves

actors in an event whose significance transcends their personal interests and even their understanding. Rebecca is being chosen, and is offering herself, to be the wife of Isaac; she will become the mother of Jacob, whose name will later be changed to Israel. The subject of the picture is not the psychological experience of the individual figures, but their participation in the unfolding of destiny.

These paintings are like plays, too, in the stage-like construction which reflects Poussin's way of working from small wax figures, which he would set on a peg-board, light artificially and draw with ink and wash to establish his compositions. But these theatrical constructions are only partly representative of the later work, because one of the most important developments in Poussin's painting after the return from Paris is his increasing concern with landscape, and more broadly with nature as the scene of his painted stories. The great pair of *Phocion* paintings (1648) [1, 49], the *Landscape with Orpheus and Eurydice* (c. 1650) [50], the *Calm* [51] and the *Storm* (Rouen, Musée des Beaux-Arts), both of 1651, *The Exposition of Moses* (1654) [55], *Bacchus consigned to the Nymphs* (1657) [56], the *Landscape with Orion* (1658) [52], all testify to the central place of nature in Poussin's thinking.

Poussin's determined independence would in itself justify a particularly attentive study of the subjects that he chose to paint.

But even setting aside all consideration of his career, the subject-matter is unsurpassed in its originality and coherence. This last quality is sometimes obscured by attempts to interpret the iconography of a single picture in isolation, or even to discuss different categories of subject separately. Poussin's subject-matter does indeed develop throughout his life, and the heroic or divine love stories of the early paintings, tinged with melancholy, give way to solemn themes from scripture and history and then finally to the more subtle and resonant poetry of the last decades. And yet to anyone who looks seriously at Poussin's work it is apparent that all his pictures belong to an evolving system of painterly reflection, and that all the subjects treated at any given point in that evolution are likely to be related. In fact Poussin draws his subjects from three main sources: the Old Testament – mostly stories of Moses; the New Testament – the stories of Christ and of some of the Apostles; and Classical mythology, to which we could add a number of exemplary lives of Stoic heroes and of historical events.

It is often asked whether Poussin was a Christian. He certainly treats the Christian stories he deals with as vehicles of some

49 **Nicolas Poussin**, *The Ashes of Phocion*, 1648. The life of Phocion (402–318 BC) is told by Plutarch. He was an upright general unjustly condemned to death by the Athenian people. His body was ordered to be cremated outside Athenian territory, but his loyal wife collected the ashes and brought them home. This picture and its companion piece (ill. 1) were painted for the Lyons silk merchant Serisier. They were still in his collection in 1665 when Bernini saw them and famously said, tapping his forehead, 'Il signor Poussin è un pittore che lavora di là…': Signor Poussin is a painter who works from there...

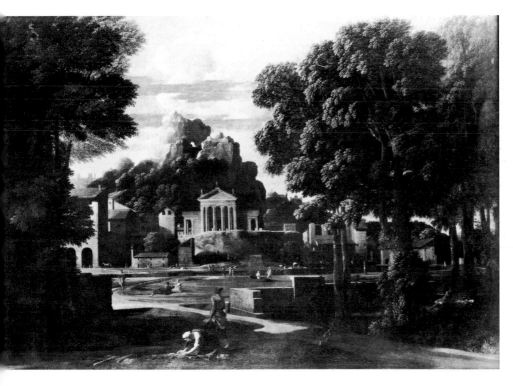

50 **Nicolas Poussin**, *Orpheus and Eurydice*, c. 1650. Poussin's version of the story is taken from Virgil (*Georgics* 4), but is told in highly compressed and allusive form. Eurydice falls, bitten by the snake, while Aristaeus (who was pursuing her in Virgil) merely glances over his shoulder at her. The smoking castle in the background and the river hint at the underworld. Aristaeus is assimilated to Hades, and the basket of flowers recalls the rape of Persephone. Orpheus is seen on the right as though already singing for the liberation of Eurydice in the infernal regions. The great mass of shadow in the foreground is thus at once the darkness that overtakes Eurydice in her death, and the darkness overcome by Orpheus' song. The mythical Thracian poet is the embodiment of the magical power of the Word over Nature itself.

essential truth. He seems, however, to take the Hebrew and Classical stories equally seriously, and in this respect goes further than the more common intellectual syncretism that considered Hebrew and Classical wisdom as a partial foreshadowing of things fully revealed in Christianity. Poussin appears to have regarded all three categories of subject-matter as possessing a comparable, and perhaps complementary, truth. The key to his thought, as has long been recognized, is Stoicism. This philosophical system had appeared in the turbulent and cosmopolitan Hellenistic world as a formula for personal moral survival, and it had been revived in the later 16th century in a similar time of political and moral crisis.

Stoicism teaches that virtue is the only good, and indeed the only thing over which we have any control. The world, and our external lives, are subject to ineluctable determinism. The wise man is the one who fully understands this and consequently cultivates detachment both from pleasure and from pain, striving to maintain an inner equilibrium. These moral qualities are directly evoked in the paintings which deal with heroes or martyrs of Stoicism – Phocion [1, 49], Eudamidas or Diogenes – and the ideal of inner peace is alluded to metaphorically in the still bodies of water that appear in so many of Poussin's pictures.

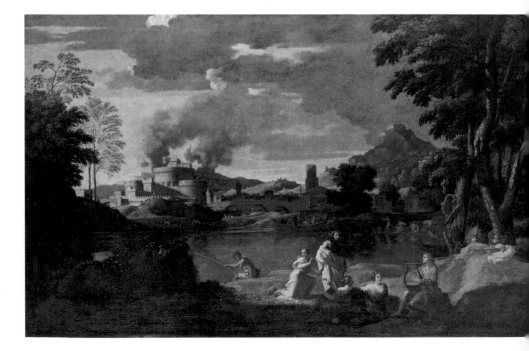

51 **Nicolas Poussin**, *Landscape with a Calm*, 1651. Poussin painted this picture for Jean Pointel – one of the new French patrons that he acquired during his stay in Paris in 1640–42 – together with a companion piece, *The Storm*. The painting is extremely finely composed within the formal matrix of the rectangle, evoking peace and stability. The sense of tranquillity is enhanced by an unusual clarity and luminosity. There is a single, tantalizing note of dynamism in the leaping horse on the left.

The cosmology of Stoicism (derived from the pre-Socratic philosopher Heraclitus) is less commonly understood, but is essentially related to its ethics, both as a closely parallel theory and as the justification of the doctrine of determinism. In brief, the world is made up of two principles: Logos, 'the Word' (as in the opening of St John's Gospel), which is Divine Reason, and is conceived as a kind of fire; and base matter, which is associated with the elements of water and earth. When the Logos descends to dwell in matter, Nature comes into being (or more accurately *becoming*). This natural world is governed by determinism, but because that determinism is founded in Logos or Reason, the course of things is essentially reasonable; and that is why the mind, in apprehending the reasonableness of necessity, will naturally accept it.

Even Poussin's early mythologies allude to such a cosmology: *The Kingdom of Flora* [37] is a picture of Nature in which the Logos – in the person of Apollo driving the chariot of the Sun – gives life to a lower world of earth and water. The world of nature is full of deaths and rebirths: a collection of Ovidian figures who die and are changed into flowers. Several are elsewhere the subjects

52 **Nicolas Poussin**, *Landscape with Orion*, 1658. This famous painting was made for the banker Michel Passart and once belonged to Sir Joshua Reynolds. Its rare and apparently enigmatic subject alludes to the Neo-Stoic doctrine that the soul is produced out of water, like a mist, by the action of the sun: the fiery Logos brings our soul into being, but it is at first a blind thing, opaque because of its watery nature. To approach the Logos more closely will dispel the opacity, but with it also our individual existence: enlightenment entails extinction. Here the soul is figured by Orion, the blind giant (with his guide Cedalion on his shoulders); Diana, waiting in the clouds with bow and arrows, signifies death.

of individual pictures, like Adonis [36] or Narcissus: these are meditations on sadness and the consolation found in understanding the cycle of natural life, for the order of nature is composed of endless change. Later the reflection on these themes grows deeper and more complex. *Bacchus consigned to the Nymphs* [56] shows us the divine child – the deity who personifies the world of nature – brought down from the realm of fire and welcomed by the watery nymphs into their shady grotto (Poussin is certainly thinking of the divine infant in Virgil's fourth Eclogue whose birth will bring the return of the Golden Age). Next to this event – in a completely original juxtaposition – is once again the expiring figure of Narcissus, suggesting that the death of the man is somehow a necessary correlative of the birth of the god. Another late painting, the *Landscape with Orion* [52] – in which the blind giant is walking towards the rising sun to be healed but also to meet his death – has a similar theme.

Paintings like these take philosophical reflection to the verge of mysticism. The story of Bacchus consigned to the nymphs draws our attention, moreover, to a subject which visibly brings together the three parts of Poussin's religious or mythological thinking. A large number of pictures deal with the infancies of Christ, Moses [53, 55], Bacchus, and occasionally other figures, such as Jupiter [54]: they are images of the Logos entering the

world, of the Word becoming flesh. All of these infancies are threatened (Christ's parents must flee the Massacre of the Innocents, Bacchus' mother is consumed to ashes before his birth and he is carried in the thigh of his father Jupiter, Pharaoh orders the children of the Hebrews to be put to death and Moses' parents have to resort to exposing him on the waters of the Nile), for there is some principle of resistance to the Word. The two series of *Sacraments* are concerned with the knowledge of or initiation into the Logos. Other works, like *Orpheus and Eurydice* [50], or in a very different way *The Death of Sapphira* [3], deal with the action of the Logos in the world.

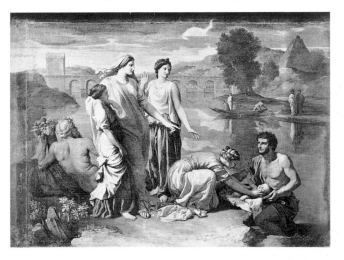

53 **Nicolas Poussin**, *The Finding of Moses*, 1638. The infant Moses, exposed on the waters of the Nile (see ill. 55), is rescued by the daughter of Pharaoh. The symbolism of death and rebirth is echoed by the figures crossing the river in the opposite direction, in the background.

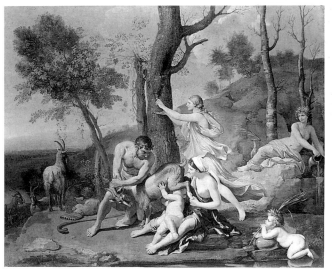

54 **Nicolas Poussin**, *The Nurture of Jupiter, c.* 1636–37. Jupiter's father, Saturn, devoured all the children his wife bore, until she tricked him into swallowing a stone in swaddling clothes in place of her son Jupiter. The infant was brought up by nymphs on the island of Crete, fed on wild honey and goat's milk. In due course Jupiter (seen here suckled by the goat Amalthea) overthrew his father to become the chief of the Olympians.

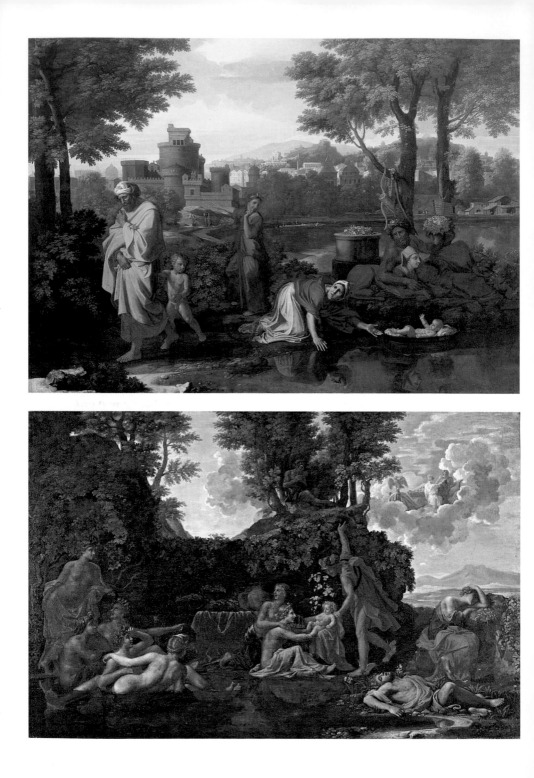

Poussin is unique in the numinous presence with which he endows his Classical gods; there is nothing like it in Rubens, for whom the same divinities are treated either allegorically or anecdotally. And he conceives his other subjects with no less imaginative intensity. Poussin epitomizes the kind of belief that the artist must have in his subjects, which is not necessarily the same thing as orthodox piety. He believes that his subjects are pregnant with meaning; that they are actually something like a language of symbols through which complex ideas can be articulated. Poussin considers his mythical or scriptural subjects as a vehicle of poetic thought, while so many Baroque and later artists treat them simply as a convenient allegorical shorthand. But Poussin was in many ways the last great artist in the Renaissance tradition; the progress of the scientific revolution would make it much harder for his French successors to read the world in the same symbolic manner, and ultimately to take the subjects of history painting as seriously as he did.

The most important French painter in Rome apart from Poussin was his friend Claude Gellée, called Claude Lorraine after his native land. Recent research suggests that Claude was born around 1604 or 1605, slightly later than the traditional date of 1600, near Nancy, and after early travels to Rome and Naples, followed by a return to Nancy, finally settled in Rome in 1626, where he remained until his death in 1682. Like Poussin, Claude's early influences were Mannerist. He assimilated the landscape formulas of Paul Bril (1554–1626) and Adam Elsheimer (1578–1610), two Northern painters living in Rome. In Bril's manner, a Northern feeling for nature was combined with schematically simplified lessons drawn from Leonardo and the painters of the High Renaissance, so that a typical landscape had a brown foreground with a dark back-lit tree, a green middle ground and blue mountains in the distance. Elsheimer had added to the general Mannerist landscape a new sensitivity to poetic effects of light and atmosphere. Claude learnt from these artists and from his teacher Agostino Tassi (c. 1580–1644), who specialized in architectural perspectives, but soon went far beyond them, raising the whole genre of landscape to a new level of seriousness.

Like Poussin again, only at an earlier age, Claude established himself as an independent artist, supported by a group of patrons, although in his case they were both wealthier and more aristocratic. His reputation was so well established by the mid-1630s that he is supposed to have been plagued by forgeries and pastiches of his

57 **Claude Lorraine**, *Landscape with a Shepherd*, c. 1630–37. This is an early work from before the period when Claude recorded his compositions in the *Liber veritatis*. It is a simple and yet sophisticated painting, a poetic invention full of the mood of Virgil's *Eclogues*, in which every element plays its part – the house and the temple, the cattle and the birds, the winding pathway and the suggestion of music.

paintings, including one famous incident when the young Sébastien Bourdon, later a prominent painter in Paris, is said to have seen a half-finished picture in his studio, gone away and painted his own version of the same composition and sold it as an original. Claude's solution was to keep a special album, the *Liber veritatis* or 'book of truth', in which he entered drawings of virtually every composition that he produced for the rest of his life, so that his career is exceptionally well documented from 1637 to his death. A study of this register and comparison with extant pictures shows, not surprisingly, that Claude painted many more and smaller works in the earlier part of his career, and that in the later years he painted fewer, taking more time over each, and that almost all of the last pictures have been preserved.

Most of Claude's landscapes were based on the scenery of the Campagna, the countryside around Rome, and many beautiful drawings survive as records of his study of this natural environment.

Occasionally paintings will include identifiable motifs, like the *Pastoral Landscape with the Temple of the Sibyl at Tivoli* (c. 1644) [58] or the *Landscape with Shepherds – the Ponte Molle* (1645) [59]. But even in such cases, the study of a real view was only a first step in making a painting. Claude's elevation of landscape to a new dignity and seriousness is achieved by virtue of the same principle that the history painting tradition applies to figures: he did not make unfounded and fanciful views like the Mannerists, nor did he simply reproduce any particular scene he came upon in his drawing expeditions. Just as the history painter used the study of the live model to construct the figures of his painted narratives, Claude studied nature in order to produce an artificial poetic world. Thus there is a direct parallel between Claude's transformation of his material and the process often known as idealization. This is in itself highly original, if we consider that the important mid-16th-century Venetian theorist Ludovico Dolce had believed that idealization was only applicable to the human figure: 'The painter must therefore strive not only to imitate, but to surpass nature. I say surpass nature in one thing; for as to the rest it is miraculous not only when we equal, but even when we approach her. And that one thing is to demonstrate through art, in a single body, all the perfection of beauty that nature can barely show us in a thousand ...'

But the analogy can be taken further, for not only are individual trees, hills or bodies of water modified to play their part in his composition: Claude's landscapes derive their authority from the evident fact that an idea of the whole has preceded the elaboration of the parts. The composition is conceived first, and the various elements in it are called forth to realize this vision. What Claude's contemporary Charles-Alphonse Dufresnoy called 'l'économie du tout-ensemble', the 'economy of the whole', is the most distinctive feature of Claudian landscape. It is what most radically separates such landscapes both from those naturalistic views which are essentially portraits of a particular place, and from what came to be known as the *paysage composé*, a category of picturesque landscapes in which elements of natural observation are put together with imaginary ruins and other motifs [93].

Such priority of conception is precisely what Poussin means when he speaks of the *pensée* or 'thought' of his paintings – or what is more usually characterized as *invention*. But invention was almost axiomatically associated with the genre of history painting. It is true that Leonardo had used the term much more freely, but few of Poussin's and Claude's contemporaries would have thought

58 **Claude Lorraine**, *Pastoral Landscape with the Temple of the Sibyl at Tivoli*, c. 1644. Painted for Michel Passart, the patron of Poussin (see ill. 52). The Sibyl of Tibur was an ancient Roman oracle, consecrated like others by the Christians because she was supposed to have revealed the birth of the Saviour to Augustus.

As usual with Claude, elements of a real site are reconfigured in the interests of composition. In this picture, the long side is equal to the diagonal of the square on the short side (as in the modern A4 sheet of paper); the two swains on the left are situated on that diagonal.

of invention in connection with landscape: we have seen that Sir Joshua Reynolds, more than a century later, still considered it to be essentially the 'translation' of a story into pictorial form. Félibien, later in the 17th century, does mention invention in connection with landscape, but casually and in passing. Indeed the English painter and draughtsman Alexander Cozens (1717–86) is perhaps the first to apply the term explicitly and deliberately to landscape, in a short book with the significant title *A New Method of assisting the Invention in Drawing Original Compositions of Landscape* (1785 or 1786). Cozens writes, in a passage that contradicts Dolce but is perfectly applicable to Claude: 'Composing landscapes by invention, is not the art of imitating individual nature; it is more; it is forming artificial representations of landscape on the general principles of nature, founded in unity of character, which is true simplicity …'

What kind of landscape does Claude invent? It is usually described as pastoral, bucolic or Arcadian: the kind of fictional world populated by shepherds [57] and shepherdesses and other rustics that was invented by the Hellenistic poet Theocritus in

his *Idylls*, refined in Virgil's *Eclogues* and more recently adjusted to modern taste and morals in Sannazaro's *Arcadia*. The original Arcadia was a remote part of the Peloponnese associated with the cult of the god Pan. The poetic and imaginary place of the same name was an essentially happy and harmonious natural environment, whose denizens appeared to be mainly preoccupied with love and poetry. Arcadia was conceived as something like a surviving enclave of the Golden Age, and thus all the more poignantly shadowed by ineluctable death (as in Poussin's *Et in Arcadia Ego* [44]). Only a few of Claude's paintings are specifically Arcadian in subject-matter, but they do have in common a view of nature as welcoming and accommodating. In his foregrounds and middle grounds he creates a space that is open and flat enough to be hospitable and yet sufficiently varied in its rises and declivities to retain the viewer. It is a space to dwell in and to travel through with pleasure. It is also a space which opens out, in the background, into infinity: Claude loves to let the eye stretch out into the furthest distances of mountains and sky, or of the horizon on the sea.

59 **Claude Lorraine**, *Landscape with Shepherds – The Ponte Molle*, 1645. This is the Milvian Bridge, site of the great battle painted by Giulio Romano, Raphael, Rubens and Le Brun (ill. 108), among others: here in 312 Maxentius, who had imposed himself as emperor since 306, was defeated by Constantine and drowned. Claude's painting evokes memories of long-distant violence in an idyllic rural scene. Unusually, the place seems to be topographically accurate, but the buildings, which appear elsewhere as well, are added, as is the characteristic group of trees.

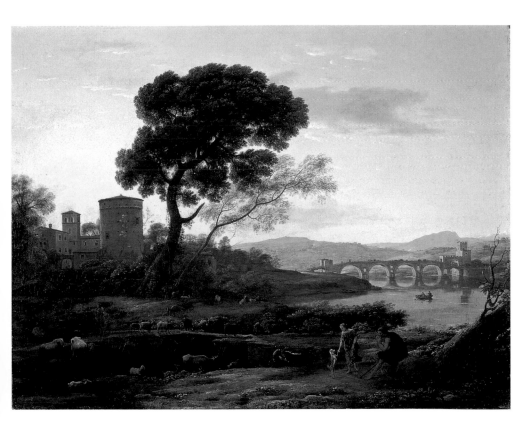

60 **Claude Lorraine**,
The Enchanted Castle, 1664.
This painting belongs to a pair
devoted to the story of Cupid
and Psyche (Apuleius, *The Golden
Ass* 5: 1–3) ordered by Claude's
most important late patron, Prince
Lorenzo Onofrio Colonna. Psyche
sits outside the castle of Cupid,
probably meditating her wicked
sisters' suggestion that her lover is
really a monster whom she should
kill. This reading is corroborated
by the companion painting, in which
Psyche tries to drown herself after
she has failed in her attempt and
Cupid has left her. The present
title comes from a late 18th-
century engraving.

Claude's conception of infinity is inseparable from his
treatment of light. The eye is drawn away into luminous
backgrounds, sometimes even into the brilliance of the setting
sun. In this respect Claude reverses the practice of the history
painter, who must place his narrative subject in the foreground
and give it the strongest illumination in the picture. Claude
prefers back lighting as a general principle, although he will give
the foreground and any figures there whatever lights they require.
It is not just that trees are more picturesque when silhouetted
against the sky, but that light coming through their crowns animates
them with an incomparable sense of life and movement. The
ultimate reason for Claude's use of *contre-jour* lighting, however,
is that the hospitable space of the foreground is meant to allow
us into the picture, but then lead us to the contemplation of the
boundless – and brighter – space beyond. There could not be a
simpler and more direct expression of that transcendent presence
in nature which I suggested at the outset was the true concern
of landscape painting.

Claude's compositions do almost always contain small figures that belong to the repertoire of history painting, and some of them are from the same stories used by Poussin. But although Poussin became increasingly concerned with landscape in his later work, the core of his invention was always the story. With Claude on the other hand, the idea of the painting arises as a specifically landscape invention, to which the the subject appears to be added at some later point to confer additional layers of meaning. His subjects are not arbitrary, but they do not suggest any sustained philosophical meditation. They are more likely to evoke heroic or tragic or providential events set in a distant past; the tone is elegiac, and often nostalgic. It is the mood of someone contemplating from a distance events that have a poetic resonance beyond rational analysis, like nature itself. This is the sensibility that lies behind subjects like *The Enchanted Castle* (1664) [60], which avoids any of the obvious motifs from the story of Psyche, or *The Origin of Coral* (1674) [63], in which mysterious solemnity is enhanced by the dramatic nocturnal setting.

Claude's subject-matter evolves in step with his general development. His earlier works – before the mid-1640s – are populated with shepherds [57] and picturesque sea-port figures. He also adopts common landscape subjects like the Flight into Egypt. Mythological and literary subjects are at first employed with little concern for historical or archaeological accuracy. The *Ulysses returning Chryseis to her Father* (c. 1644) [61], for example, is filled with such blatant anachronisms in the buildings, costumes and especially the ships, that it has to be interpreted as deliberate fantasy rather than carelessness. After this time, however, Claude becomes both more careful in his choice of subject-matter and more rigorous in the avoidance of anachronism. His mythological subjects – especially stories associated with Apollo and episodes from Virgil, like *Landscape with Ascanius killing the Stag of Silvia* (1682) [62] – and his Old Testament stories, such as *Jacob, Laban and his Daughters* (1676) [64] or *The Expulsion of Hagar* (1668) [65], become increasingly charged with a sense of their consequences.

Claude's landscapes thus borrow idealization and invention from the tradition of history painting while reversing its priorities and subordinating narrative subjects to a more general sense of the poetic, or indeed of the numinous. The most mysterious quality of his art is the way in which acute sensibility to nature coincides with a consummate understanding of the inherent geometry of pictorial space, and correspondingly that a constructed and ideal space can evoke the dwelling of the

61 **Claude Lorraine**, *Ulysses returning Chryseis to her Father*, c. 1644. The subject is from *Iliad* 1: 430–487. Agamemnon has finally agreed to give back the daughter of the priest of Apollo whom he had seized from a town near Troy to be his concubine. Ulysses is sent to escort the girl home, and is seen here unloading cattle for an expiatory sacrifice to the offended divinity.

While his friend Poussin was scrupulous about archaeological accuracy, Claude deliberately combines modern ships and costume with a fantastic architectural setting which includes many structures that might have been built in the 16th or 17th centuries.

mind in the natural world. In the drawings themselves one can witness the moment of transition, when some observed detail or phenomenon is transformed into an artificial thing of ink and wash. Most of these studies belong to the third and fourth decades of the artist's life and represent the progressive translation of nature into Claude's distinctive painterly language. In the end, his mastery was such that he could create landscapes with something like the autonomy of a composer writing music.

Poussin and Claude have always been held in high regard in England, but their work has never been quite at home in France. The difference is that Claude's work seems to have faded from French consciousness during his own lifetime (philosophical and impersonal serenity was not the dominant tone of the culture developing in Paris), while Poussin's became the object of an academic cult which, as we shall see, did not mean that his example was actually followed. Part of the reason for this

62 **Claude Lorraine**, *Landscape with Ascanius killing the Stag of Silvia*, 1682. Claude's last painting tells a tragic story. Aeneas and his companions have landed in Italy and begun to establish friendly relations with the Latins, when Aeneas' son Ascanius, possessed by the Fury Allecto, unwittingly kills a tame stag and provokes bloody war between the two peoples (*Aeneid* 7: 475–510). The stag had sacred associations in Antiquity, and the Christians in turn had adopted it as a symbol of Christ. In Claude's painting the idyllic peace of the scene is about to be shattered by an act of wanton violence which will be echoed in the deaths of countless men.

disconnection lies in problems specific to the history painting tradition, but part of it can be attributed to the importance of landscape in the work of these two great artists.

The course of seventeenth-century art in general raised landscape to a rank not far behind history painting, and yet it never evolved into a vital expression of the French mind during this period. In Paris itself, landscape was initially a common but minor genre, a speciality of Northerners. In the middle years of the century it became a standard part of interior decoration, especially in the *cabinets* of great houses [93], but scarcely had any autonomous existence. It remained the province of Flemings like Jacques Fouquières (1580/90–1659), who combined observation of nature with picturesque formulas inherited from Mannerism. Philippe de Champaigne had first come to Paris with this compatriot and learnt the art of landscape from him, but a more sober naturalism appeared in his own landscapes some decades later, such as the *Landscape with Christ healing the Deaf-mute* (1650s) [66] or *The Miracles of St Mary the Penitent* (1656) [4].

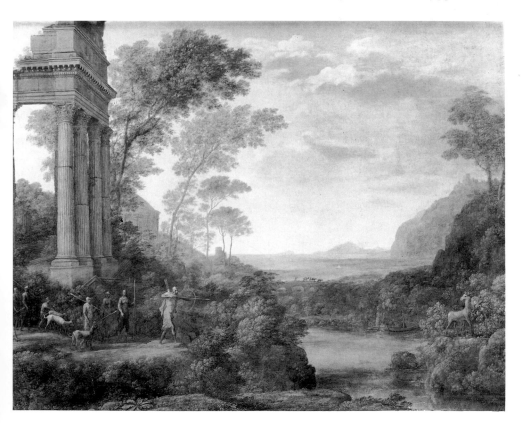

63 **Claude Lorraine**, *The Origin of Coral*, 1674. Perseus has slain the Gorgon Medusa. As he washes her blood from his hands, it falls into the water and turns to coral. Behind him is the winged horse Pegasus, also sprung from her blood. On the left, the nymphs dance around Medusa's head, the sight of which would turn mortal men to stone. The painting was done for Poussin's friend and patron Camillo Massimi (created a Cardinal by Clement X in 1670), and the Perseus group is from a much earlier Poussin drawing (c. 1627) in the Cardinal's collection. Both patron and artist must have intended this as a memento of Poussin, who had died almost ten years earlier.

64 Claude Lorraine, *Jacob, Laban and his Daughters*, 1676. Jacob, the son of Isaac, promises to work for seven years for his uncle Laban to earn the hand of Laban's daughter Rachel (Genesis 29), who will become the mother of Joseph. A beautiful late composition with a simplified foreground and a single clump of trees against the sky.

The latter shows some signs of Poussin's influence, but the fundamental concern of these pictures is to evoke a real place as testimony to the truth of the miracles they represent. The figures in the foreground, although small, are brightly lit, as are details of nature. The result is the very opposite of Claude: the parts are privileged above the whole, and local colour takes precedence over tonal unity. For Champaigne, the landscape has none of the numinous presence embodied in the wholeness of Claude's inventions; on the contrary, it is a created world whose beauty reflects the power of its creator, and whose truth bears witness to the miracles of Christ and the saints.

A similar taste is evident in such paintings as Laurent de La Hyre's *Landscape with a Flute Player* (c. 1650?) [67]. La Hyre combines naturalistic detail in his trees with Mannerist conventions in the vague blue background. There is no sense of the hospitable space created by Claude (instead, the foreground ledge is separated from a steep bank by the stream, and the course of the path into the distance is several times concealed), while the lateral lighting

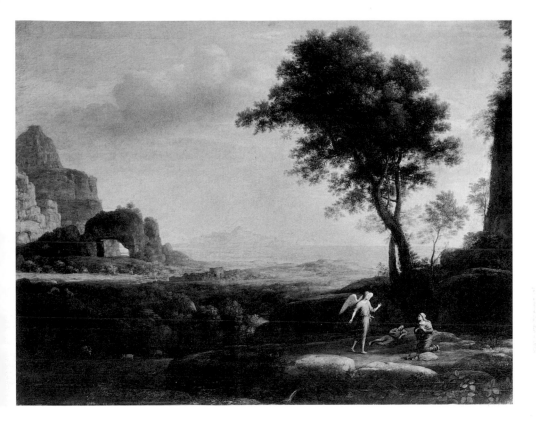

65 **Claude Lorraine**, *Landscape with Hagar, Ishmael and the Angel*, 1668. Abraham's wife Sarah was barren, and she invited him to have a child by her Egyptian handmaid, Hagar. A boy was born, Ishmael, father of the Arab people. Later, however, when Sarah miraculously bore Isaac, father of the people of Israel, in her old age, she had Abraham cast out Hagar and Ishmael. After nearly dying of thirst, they were rescued by an angel (Genesis 21: 9–21). This is the second of a pair of paintings, the only commission for which correspondence by Claude survives. The companion *Expulsion* (also Munich), he writes, represents the dawn, and this picture the afternoon.

of the scene preserves a rather literal greenness in the colour scheme. Elsewhere, La Hyre shows a greater concern for the picturesque and generally includes elements of ancient architecture, as we shall see in *The Death of the Children of Bethel* (1653) [86]. These works are really an intermediate genre, historical landscape, like many of Poussin's works at the time, and strong though low lighting from the side picks out the figures.

The decorative landscapes of the middle of the century, as practised by Henri Mauperché (1602/10–86) and Pierre Patel (c. 1605–76), combine elements from the Flemish tradition of Fouquières with what was clearly felt to be the 'Italian' taste of Claude. Patel, who was indeed rather significantly called 'the Claude Lorraine of France' by the 18th-century connoisseur Mariette, is the master of the *paysage composé* [93]. Fanciful Antique buildings are combined with picturesque landscapes of trees, rocks, bodies of water and a variety of little rustic figures. The emphasis is on the details, the lighting is lateral with the highest lights in the foregrounds, and the colour is at once literal

66 Philippe de Champaigne,
Landscape with Christ healing the Deaf-mute, 1650s. A deaf-mute is brought to Christ by the Sea of Galilee – which here, by deliberate transposition, becomes a river in a more densely wooded Northern landscape. Christ spits in his hand and touches the man's tongue, while looking heavenward and saying 'be opened'. The Gospel (Mark 7: 31–37) specifies that Christ took the man away from the multitude, whom we see appearing in the middle ground. The white swans symbolize the candour of the man's heart.

67 Laurent de La Hyre,
Landscape with a Flute Player, c. 1650? The flute player and a suggestion of indeterminate ruins give the foreground a classical air, while the background – significantly separated by the body of water – is lacking in any such connotations, (even the herdsman is clearly a modern peasant rather than a bucolic swain). The dead tree in the foreground similarly contrasts with the dense forest behind: the classical dream of nature and the contemporary experience are both appreciated, but do not quite coincide.

68 Sébastien Bourdon,
The Return of the Ark of the Covenant, 1659. This scene is the sequel to the events depicted in Poussin's *Plague at Ashdod* (ill. 39). The Philistines return the Ark, which contains the tables of the Law, and whose design had been dictated to Moses by God himself in minute detail. It is sent back on a cart drawn by two cows, without a driver (I Samuel 6: 1–15). The people of Israel are seen welcoming its return; the timber of the cart will be burned, and the cows offered as a sacrifice to the Lord.

and conventional. At the same time, Patel provides no convenient space in which the viewer can dwell; his foregrounds are frequently filled with water around which his figures are scattered on bridges, ledges and banks. These are pictures to be enjoyed as elements of an architectural interior, not spaces which allow themselves to be effectively entered by the imagination.

Of the generation of Le Brun, Sébastien Bourdon (1616–71) was the only painter in France to make a relatively original contribution to landscape. In such late paintings as *The Return of the Ark of the Covenant* (1659) [68] he imitated the geometrical strength of Poussin's composition; but because his own work had always relied more on painterly bravura than on Poussin's solid construction of volumes and spaces, the result is a moody, evocative landscape with very little depth, stratified into parallel horizontal lines.

In the second half of the century, the French seem to have preferred either more naturalistic landscapes in the Northern manner, as we have seen in the work of Philippe de Champaigne [66] or occasionally Laurent de La Hyre [67], or the sublime and 'romantic' landscapes of Gaspard Dughet [167, 168], the brother-in-law and pupil of Poussin, and like him a Roman resident. A little later, the Flemish-trained Francisque Millet returned for inspiration to the deep but muted sublimity of Poussin's late landscapes [169, 172]. Thus the art of landscape remained either Roman or Flemish, while as we shall see the tradition of history painting was imperfectly assimilated in France: in the end, neither Poussin nor Claude found a true successor in his own country.

Chapter 3 Vouet and Parisian Atticism

The careers of Poussin and of Claude have taken us, in the last chapter, well into the second half of the 17th century. We must now turn our attention once again to Paris and step back almost fifty years, to consider the stages by which the tradition of history painting was brought from Rome to Paris and adapted – more or less successfully – to local conditions. This process begins well before Poussin's own maturity, with the man he was to supersede in Louis XIII's favour in 1640, but whose importance and influence should not be underestimated.

Simon Vouet (1590–1649), who was a slightly older contemporary of Poussin, had achieved recognition from a very early age, and had been living in Rome, with a stipend from the French Crown, for most of the period that Poussin himself had spent in Paris. When the latter arrived in Rome in 1624, Vouet was a prominent member of the artistic community. He was elected Principe of the Academy of St Luke in the same year, retaining this position until his departure for Paris in 1627. It was at this time that he painted *St Jerome and the Angel* [69], which belonged to

69 **Simon Vouet**, *St Jerome and the Angel*, before 1627. This early work, painted in Rome, still shows the influence of Caravaggesque naturalism, although it is already combined with an unctuous fluency in the handling of paint which is characteristic of Vouet's mature style. The subject comes from an apocryphal letter of St Jerome in which the saint was supposed to have said that, waking or sleeping, he seemed always to hear the trumpet of the Last Judgment.

70 **Simon Vouet**, *Lot and his Daughters*, 1633. Lot and his family are warned by the angels of the Lord to leave Sodom before it is destroyed and not to look back; Lot's wife disobeys and is turned into a pillar of salt. Despairing of finding husbands of their own people, the daughters make their father drunk and lie with him without his knowledge (Genesis 20: 23–38).

Vouet has not been particularly scrupulous in his interpretation of the biblical account. On the other hand, there is a touch of classical learning in the attitude of the seated daughter, derived from the ancient relief then known as the *Nova nupta* (the new bride), which was later published in an engraving by François Perrier (reversed, as it is here) in 1645. The same relief – in Perrier's print – was the antique model for Rembrandt's *Bathsheba* (1654, Louvre).

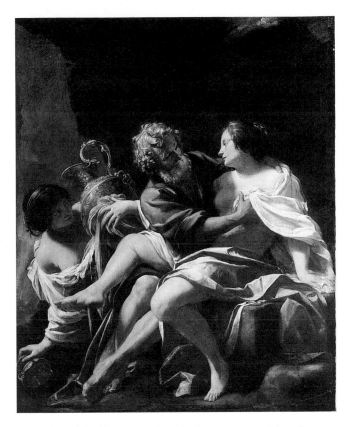

Pope Urban VIII. Vouet must have had some sense of the talent his slightly younger compatriot, for in 1626 he invited Poussin, as well as Valentin, to organize the celebrations for the feast day of the Academy's patron saint.

Vouet's return to Paris, at the order of the King, has always been considered a critical date in French art history, and with good reason. He brought back to France a coherent understanding of the method of history painting, as it had been recovered and systematized in the school of the Carracci. He practised and taught their system of drawing, based on close study of models, but subordinated to the creation of the artificial, general figures suitable for narrative paintings. He was in effect the first painter in France to teach a way out of the apparent dilemma between Mannerism and naturalism, and it is no wonder that the combination of vigour and fluency exemplified in works like *Lot and his Daughters* (1633) [70] should have proved enormously successful. His studio was a school as well as a highly efficient workshop in which the best students became the master's

collaborators, learning to paint in his style and helping him to carry out the many commissions that he received. Several of the most talented were offered daughters or nieces in marriage, thus bringing them permanently into the clan. Some of them were also set to the task of engraving the painted compositions, for Vouet, like Rubens, understood the enormous power of publication in extending and consolidating the influence of his work.

The example of Rubens, and his work, would have been familiar to Vouet as to all of Europe at that date, although he would not imitate the Flemish master's style. Shortly before Vouet's return, moreover, Rubens had sent to Paris the series of enormous allegorical compositions celebrating the life of the Queen Mother, Marie de Médicis (1622–25). This cycle had very little direct effect on French painters, but it marks a renewed interest in artistic matters in France, and thus Vouet's return was well timed. A new generation of sophisticated patrons would soon start to collect contemporary Italian work – perhaps the most spectacular being Louis Phélypeaux de La Vrillière (1599–1681), whose collection included 240 paintings at his death, and who bought or commissioned a series of large works by such artists as Guercino, Cortona, Reni, Maratta and Poussin for the magnificent gallery (begun in the mid-1630s) which was the centrepiece of his house in Paris. And this interest in Italian painting, as we shall see, was only part of a much broader movement of expansion and growth in every domain of French culture.

Vouet's role in this development, and his achievement, were considerable, and it is perhaps unfair that his limitations have often seemed more noticeable to posterity. They were in part personal, but must also be attributed to his historical circumstances. The precocious talent, the adventurous spirit, the entrepreneurial energy were all suited to a career that demanded active engagement with the social world. They are not the qualities most favourable to deep reflection or fundamental development. In this respect Vouet is like Le Brun (see Chapter 4), who was briefly his pupil. He did not have the substance to be a profoundly original artist, but he was ideally suited to playing the decisive role in importing a tradition.

Not surprisingly – for it suited his temperament – Vouet imported the version of the tradition current at the time of his departure from Rome. This was the moment, as we have already seen, when Domenichino's 'orthodox' and Classical understanding of the Carracci inheritance was losing ground to Lanfranco's broad and decorative manner, more suited to the large public

commissions of the Baroque (Lanfranco's work was designed to be seen from a considerable distance: he liked to say that the air did the painting for him). It was this style that Vouet brought back to Paris: founded indeed on the Carracci teaching, coherent and intelligible, but nevertheless accepting Lanfranco's preference for broad decorative effect over the serious expression of the subject. For the same reason the clear articulation of space, of attitudes, and of physical action is sacrificed to a general sense of movement. At worst, Vouet's pictures all seem to present the same cast of players: not the amateur histrions of the Mannerists, but a repertory troupe putting on whatever play is required of them, always competently but without much thought or conviction.

'There is hardly a church, a palace or an important house in Paris', wrote Félibien a few decades later, 'that is not adorned

71 **Simon Vouet**, *Saturn conquered by Love, Venus and Hope*, c. 1643–45. Saturn, as Father Time, is overcome by the somewhat incongruous combination of two divinities and a personification: Love as Cupid, Venus in the centre, and Hope (with her traditional anchor) on the right. The allegorical sense is given in the Latin inscription on Michel Dorigny's engraving (1646): Time is despoiled by those who are usually his victims. This large painting originally hung above the fireplace in the *cabinet* of the Hôtel de Bretonvilliers in Paris.

72 Michel Dorigny, *Susanna and the Elders*, c. 1655–60. The story of Susanna and the two lecherous elders is from the Old Testament Apocrypha. They spy on the girl as she bathes (the most popular episode for painters), and when she refuses them her favours, falsely accuse her of adultery with another man. At the eleventh hour the wise young Daniel saves Susanna's life and convicts the elders of lying by questioning them separately.

Dorigny's style is fluent and decorative (emphasizing the opposite movements of Susanna's arm and that of the elder), with scant regard for archaeological accuracy – the sphinx is meant to allude to the story's setting in Babylon.

with his works.' Time, changing taste and revolutionary vandalism have not been kind to Vouet. As with so many other French painters of the 17th century, particularly those who worked in France itself and produced decorative programmes for palaces and grand homes, his *œuvre* has largely disappeared. Galleries and *cabinets* have been demolished; of all the ensembles that Vouet executed for the royal residences of St-Germain-en-Laye, Fontainebleau and the Palais Royal, only fragments remain today. One of his masterpieces, the Chapel of the Hôtel Séguier in Paris, painted from floor to ceiling for the Chancellor in 1636, survived until the Revolution. The altarpiece (Lyons, Musée des Beaux-Arts) and some of the paintings from the side walls (Issy-les-Moulineaux, Le Havre) are all that remain today. The design of the vault, which must have been very impressive, is known only from engravings by Michel Dorigny (1616–65), who also engraved such surviving works by Vouet as *Saturn conquered by Love, Venus and Hope* (c. 1643–45) [71]. Dorigny was the last pupil to be brought into the artist's clan: Vouet, with little more than a year to live, married him to his youngest daughter, Jeanne-Angélique. On Vouet's death in 1649, Dorigny inherited the apartment and studio at the Louvre where he carried on his master's style well into the second half of the century with paintings such as *Susanna and the Elders* (c. 1655–60) [72], and where he too later died.

73 François Perrier,
The Sacrifice of Iphigenia, c. 1632–33.
The Greek fleet bound for Troy
is becalmed at Aulis and the
oracle demands that Agamemnon
sacrifice his daughter Iphigenia.
At the last minute the goddess
Diana (Artemis) brings a deer as a
sacrificial victim and steals the girl
away to become her priestess at
Tauris. The young Perrier's style,
showing the influence of his master
Lanfranco, is remarkably loose and
indifferent to anatomical accuracy
when compared to the provincial
realists like Tournier (ill. 17).

Of all the painters associated with Vouet, the most
independent personality before Eustache Le Sueur is no doubt
François Perrier (*c.* 1600–1649), who had begun his career in
Lyons before going to Rome. He became the pupil of Lanfranco,
for whom, as already noted (p. 52), he engraved Agostino
Carracci's *St Jerome*. He was in Paris between 1631 and 1635,
working with Vouet, but went back to Rome from 1635 to 1645
and devoted himself to making the engravings for two of the most
important archaeological compendia of the time, the *Segmenta
nobilium signorum...* of 1638 and the *Icones et segmenta...* of 1645,
in which he illustrated classical sculptures and fragments that
were to be seen in Rome. It was during the first of the periods
in Paris that he and Vouet had two pupils who were to become
important figures in the next generation: Pierre Mignard [154]

and Charles-Alphonse Dufresnoy [112]. (We shall meet them again in the next two chapters.) Perrier's style at this time demonstrates, even more clearly than Vouet's, the rather nerveless drawing that was the price of their Lanfranco-derived manner [73]. It is little wonder that the young Mignard and Dufresnoy felt the need to reach Rome as soon as they could. In contrast, after Perrier's next stay in Rome, during which taste evolved considerably and when he was personally occupied in the study of the Antique, his style became much more Classical and disciplined, as can be seen from the mythological subjects he painted at the Hôtel Lambert in Paris and elsewhere [74]. Unlike Vouet, Perrier joined the new Academy in 1648, although he too died in the following year.

Vouet's Roman manner was not the only stylistic import of his generation, although it was the most successful. Others, including Horace Le Blanc, Jacques Blanchard, and, to a lesser extent, Lubin Baugin, brought to France a style derived from Venetian models. Titian had already been a fundamental part of the Carracci synthesis, but the Venetians continued to exercise

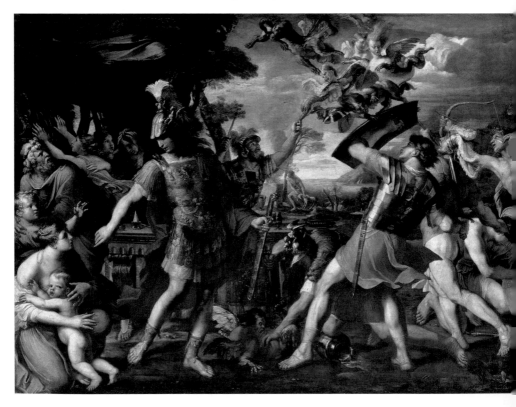

75 **Jacques Blanchard**, *Angelica and Medoro*, early 1630s? The episode, frequently illustrated, is from Ariosto's *Orlando Furioso*, Canto 19. Medoro, a young Saracen knight wounded and left for dead, is discovered by Angelica, princess of Cathay, who is living the life of a shepherdess. She heals him, they fall in love, and they carve each other's names on trees. The figures are reminiscent of the Second School of Fontainebleau and particularly of a painting of the same subject by Toussaint Dubreuil (Louvre), although Blanchard typically has a greater sense of the solidity of the body, and a greater sobriety in the attitudes, as well as a warmth of colour and feeling that derive from Venice.

a direct influence through both the great works of the 16th century and the more modest achievement of contemporary artists. Thus Horace Le Blanc (c. 1580–1637) worked in Venice with Titian's pupil Palma Giovane (1544–1628) and knew Lanfranco in Rome before returning in 1610 to Lyons, where he spent most of his life: the Consuls even created the position of Peintre Ordinaire to retain him in the city. Le Blanc's pupil Jacques Blanchard (1600–1638) spent eighteen months or so in Rome before travelling to Venice in 1626 for a further two years. Blanchard, called by the writer, cultural bureaucrat and promoter of contemporary French art and literature Charles Perrault (1628–1703) *le Titien de la France*, is in fact closer to contemporary

76 **Jacques Blanchard**, *Charity*, c. 1636–37. This work, painted towards the end of his short career, shows Blanchard responding to the more rigorous classical taste emerging in the later 1630s, at once in the composition of his figures and in the architectural setting, with its strong horizontals and verticals, and also in a new firmness of modelling. Charity is allegorized in the traditional way as a nursing mother accompanied by several infants.

Venetian painters – Palma was still alive when he was in Venice – and to those Genoese and others who had been drawn to Venice. Blanchard was chiefly a painter of devotional and allegorical pictures, and he was especially fond of subjects that allowed him to paint women (naked or clothed) and children [75, 76]. This 'neo-Venetian' style was not well suited to history painting, but it allowed Blanchard to reconnect with the Fontainebleau taste for compositions dominated by a few large nude figures, while avoiding the affected attitudes of Mannerism. His master Le Blanc similarly found in his *Martyrdom of St Sebastian* (1624) [77] the occasion for a large nude, but the *contrapposto* in this painting is extravagant compared to the more restrained and Classical style of Blanchard.

77 Horace Le Blanc, *The Martyrdom of St Sebastian*, 1624. Le Blanc painted this altarpiece for the church of the Capuchins in Rouen during a short stay in Paris. Sebastian, a Roman officer (his armour is visible in the foreground), was martyred after his conversion to Christianity. The saint's executioners are seen departing in the distance, although their arrows have miraculously failed to kill him. Angels bring him a martyr's crown in anticipation of his later death by flogging.

Lubin Baugin (c. 1612–63) was born in Pithiviers and began his training at Fontainebleau. He was received as a Master Painter in Paris in 1629, in the same year as Antoine Le Nain (unlike the three brothers, he did not take part in the foundation of the Academy in 1648, but became a member in 1653). This is probably the period of his still-life pictures [129], which will be discussed in the following chapter. Then he travelled to Rome, where he studied the work of Guido Reni – whose abundant production of religious paintings established the aesthetic of popular 'holy images' ever since – and the many small and sweet pictures of the Virgin and Child that he subsequently executed earned him in France the appellation *le petit Guide*. Baugin was, however, also influenced by both earlier and contemporary painters whose work was closer to 'Lombard' or Venetian painting: Correggio and Barocci as well as both Sacchi and Cortona. After his return to France in 1641, he seems, like Blanchard, to have rediscovered Fontainebleau as a source of inspiration for large figure compositions. Most characteristic are two paintings of the dead Christ (one in the Louvre and one at Orléans [78]), primarily conceived as religious meditations. The huge white figures which dominate them force us to contemplate the suffering of the Saviour, but they are oddly boneless and lacking in structure when compared to any contemporary work by an artist properly trained in the Carracci tradition.

There is no doubt of Vouet's superiority over his rivals. He was a fluent and talented decorator, capable of executing whatever

was asked of him. Blanchard is at times more touching and often conveys a greater sense of the substance of the body, but he is far less universal. Even Vouet's relative superficiality, as I have suggested, must have helped him to succeed in a Paris that could still take Lallemant [8] and Vignon [9] seriously. But in the very years of Vouet's triumph, certain artists and patrons were beginning to feel dissatisfied and to long for more demanding standards. For French culture was changing rapidly in the years that followed Vouet's return. The evolution of the French language itself sets a paradigm followed by the visual arts.

In the 16th century, the Pléïade group of writers (including the poets Ronsard and Du Bellay) had believed that their most urgent task was to expand the scope of French, especially in its

79 **Philippe de Champaigne**, *Portrait of Cardinal Richelieu*, 1633–40. Armand Jean du Plessis de Richelieu (1585–1642), created Cardinal in 1622 and Duke in 1631, was the Prime Minister of Louis XIII and the effective power in France from the early 1620s until his death. He was ruthlessly dedicated to the centralization of state authority and the elimination of any rival claims to power. He wears the order of the Holy Spirit (appointed in 1633) and is shown standing like a statesman rather than sitting as was usual for a man of the Church. Champaigne characteristically combines the opulence of Flemish colour with imposing stillness.

80 **Jacques Stella**, *The Liberality of Titus*, c. 1637–38, from the Cabinet du Roi in the Château de Richelieu. Louis XIII appears as the Roman Emperor Titus, accompanied by Richelieu. The dancing figures in the foreground celebrate the generosity of their ruler, and at the same time echo a motif that ran through the other works that hung in the room: the paintings by Mantegna and others from the *studiolo* of Isabella d'Este in Ferrara, and the *Bacchanals* commissioned from Poussin (ill. 42).

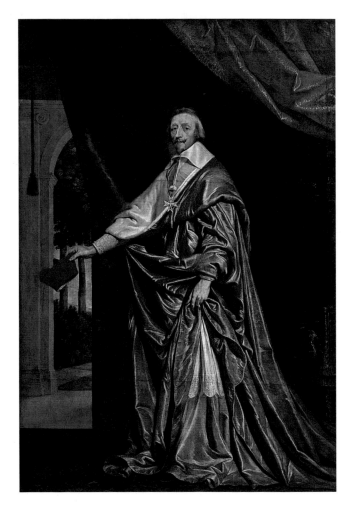

vocabulary, in order to raise it to the stature of Latin, Greek and indeed Italian. As a result, the language of Rabelais or Montaigne has a wealth and unpredictability that are akin to Shakespeare's English. In the hands of lesser authors, however, and by the beginning of the 17th century, French writing had sunk under the weight of pedantry and affectation. The great achievement of the new century was a severe pruning of the language, banishing neologisms and barbarisms, classing words according to their levels of connotation, and purifying the grammar. Convoluted

and pretentious style – known in ancient rhetorical theory as 'Asian' – was banished in favour of the clear and correct style known as 'Attic'. As in history painting, the rule of literary Classicism was the economical expression of the subject: only what is well conceived, as the poet and critic Nicolas Boileau (1636–1711) later wrote, can be clearly articulated.

The 1630s are a crucial decade for this reorientation of French culture. A group of literary friends had been meeting informally in Paris at the house of Valentin Conrart since 1629 or 1630; in 1634 they became the Académie Française under the patronage of Richelieu. In 1637 René Descartes published his *Discourse on Method*, choosing to compose his manifesto of *a priori* reason in French rather than Latin; and in the same year Pierre Corneille produced the first great play of the French theatre, *Le Cid*. In 1640 the Imprimerie Royale was founded, with a brief to produce beautiful and scholarly editions of important books; in the same year Corneille produced *Horace*. The whole period of transformation took place over some thirty years, so that by the 1660s the speakers and writers of French could feel confident that their language was the equal in purity and eloquence of Augustan Latin.

Richelieu himself, who played such an important role in this process, also promoted a greater rigour in painting, preferring Philippe de Champaigne to Vouet. Champaigne, who was born in Brussels, had first come to Paris in 1621 and established himself permanently there in 1629. Like Pourbus (p. 24), he combined a Flemish richness and attention to material with a classicizing simplicity which was to develop much further in the course of his career. The Cardinal employed him as early as 1630 on the Gallery of Famous Men at the Palais Cardinal in Paris (today – completely rebuilt – the Palais Royal), and later pressed him to move his family to the Château de Richelieu in order to devote himself fully to its decoration. Champaigne refused to leave Paris, but nonetheless painted the Cardinal on several occasions [79]. Portraits were in fact, as we shall see, Champaigne's real strength; his Flemish naturalism equipped him for the characterization of individuals better than for the artifice of history painting.

By the middle of the 1630s, however, Richelieu had learnt of Poussin's work in Rome and commissioned the series of *Bacchanals* which has already been mentioned (p. 61). The Cardinal would have had first-hand reports of Poussin's painting and of his growing prominence in Rome from the artist's close friend, Jacques Stella (1597–1657) [120], who was back in Paris

81 **Nicolas Poussin and Jean Le Maire**, *Theseus finds his Father's Sword*, c. 1636–37. When Aegeus, King of Athens, had lain with Aethra, daughter of King Pittheus of Troezen, he left his sword and a pair of sandals under a heavy stone, telling Aethra that if she bore a son strong enough to lift the stone, she should send him with these tokens to Athens. The adult Theseus duly meets the challenge, and eventualy becomes king of Athens. In this collaborative work – as the 18th-century connoisseur Mariette recognized – Le Maire painted the architecture and landscape, while his friend Poussin added the figures.

by 1634 and whose own Classical style appealed to Richelieu. Indeed Stella had been invited to work for the King of Spain, but Richelieu ordered him to stay in France, granting him an apartment in the Louvre and a stipend. When Poussin's paintings were installed with the Este pictures in the Cabinet du Roi at the Château de Richelieu, Stella's *Liberality of Titus* [80] (in which the Emperor is represented with the features of Louis XIII and accompanied by Cardinal Richelieu) was hung over the fireplace, completing the ensemble.

Jean Le Maire (1598–1659), best known as a painter of mythologies in antique architectural settings and another of Poussin's friends in Rome [81], was also back in Paris by 1638, and became keeper of the King's pictures at the Louvre and the Tuileries in that year or the following one. Le Maire's appointment was the work of Richelieu's able associate François Sublet de Noyers (c. 1588–1645), the Secretary of State for War. In 1638, at the Cardinal's insistence, Sublet had been given the additional portfolio of Surintendant des Bâtiments du Roi, which entailed responsibility for all of the royal houses (most of which needed considerable restoration) and their contents. Sublet was thus effectively in charge of the royal collections and also of official art patronage. Through Sublet, Richelieu began to establish closer relations with Poussin. Sublet's two cousins, Paul Fréart de Chantelou and Roland Fréart de Chambray, had first met Poussin in Rome in 1635; that was the beginning of Chantelou's long friendship with Poussin – who was already working on a commission for him, *The Gathering of the Manna* [43], by 1637 –

and of Chambray's career as a writer and art theorist. Sublet
wrote to Poussin inviting him to come to Paris in 1639, and when
he failed to obtain a commitment, sent the two brothers to Rome,
eventually resorting to veiled threats if the painter failed to heed
his King's command.

Something of what Richelieu and Sublet had in mind in pursuing
Poussin at the height of Vouet's success may be imagined from the
writings of Fréart de Chambray, the author, among other things,
of the French translations of Palladio's *Four Books of Architecture*
(1650) and of Leonardo's collected notes on painting, the *Trattato*

82 **Simon Vouet**, *The Presentation
in the Temple*, 1640–41. Simeon
takes Christ in his arms and thanks
the Lord that he has lived to see
the birth of the Messiah, while
the prophetess Anna kneels
behind the Virgin and Joseph,
holding the offering of doves in
a basket, looks on (Luke 2: 22–39).
In this composition, commissioned
by Richelieu for the Jesuit church
of St-Louis in Paris, Vouet has
created an impressive sense of
movement, but it is easy to see
how the new generation could
regard his visual rhetoric as
pompous and lacking in substance.

di pittura (published for the first time in simultaneous Italian and French editions in Paris in 1651). In 1662 he published a book that is of great interest in spite of certain eccentricities, *L'Idée de la perfection de la peinture* (*An Idea of the Perfection of Painting*, translated by John Evelyn, London, 1668). In this treatise, Chambray defends the standards represented by Raphael and Poussin against unnamed contemporary painters referred to only as 'libertins de la peinture'– 'libertines of painting' (the primary connotations of the word, at this time, were of religious unbelief rather than of personal immorality). Painting, he says, should appeal to the eye of the mind, and not merely to the eye of the body. He deplores the 'Cabale des Curieux', the 'gang' or 'conspiracy' of art-lovers or would-be connoisseurs who speak about painting without understanding it, and he quotes a farrago of contemporary art jargon, including a number of Italianisms. Although Chambray was writing some two decades after Poussin's visit to France, the expressions he cites so contemptuously evoke less the leading styles of contemporary painting around 1660 than the work of Vouet and Blanchard that he would have seen in his youth: 'freshness and *vaghezza* [i.e. grace] of colouring', 'freedom of the brush' and 'bold touch'. We may suppose that like Chambray, if less vehemently, Sublet and Richelieu also admired an art based, as they saw it, on solid principles rather than on superficial virtuosity and fanciful phrases.

Poussin was warmly greeted on his arrival in Paris – Richelieu is said to have embraced him and the King made a snide comment to the effect that this was quite a trick to play on Vouet. He was appointed, as we have seen, First Painter of the King, generously remunerated, and given what Bellori called a 'palazzetto' in the Tuileries gardens for his dwelling. We have already seen, however, that Poussin's stay in Paris was not a success (p. 63). He was put to work that he was unsuited for and prevented from doing what he knew how to do better than anyone. Apart from the ill-fated Grande Galerie at the Louvre – where the ambitious cycle of Hercules was never completed – one of the most interesting commissions he received was for the church of the Jesuit Novitiate. Sublet de Noyers ordered the high altarpiece from Poussin, depicting *The Miracle of St Francis Xavier* (Paris, Louvre), and two lesser altarpieces from his rival Vouet and his friend Stella. If the Louvre Gallery was uncongenial because it meant managing a team of painters instead of painting himself, the Novitiate must have reminded him disagreeably of being set up in a public contest with Valentin many years before. Poussin was obliged to paint a colossal

picture, once again far larger than he would ever normally contemplate, and felt he did not have time to do it properly. Vouet and his friends lost no time in criticizing the work. Vouet's own painting has since disappeared, and probably the most influential of the three was Stella's extremely sober painting of *Christ among the Doctors* (1642) [83], which at first sight appears to be standing quietly on the sidelines of the confrontation between the two masters.

On closer examination, however, Stella's composition seems deliberately conceived as a reply to a painting by Vouet of very

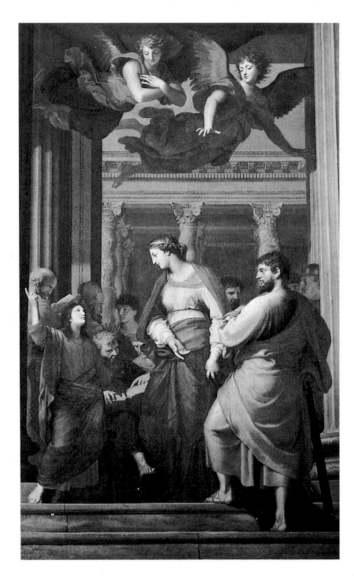

83 **Jacques Stella**, *Christ among the Doctors*, 1642. The subject is the single event recorded in the life of Christ between his infancy and the beginning of his teaching; it is only attested in the Gospel of Luke (2: 40–52). When Jesus was twelve, he went up to Jerusalem with his family. On the way back, Mary and Joseph thought they had lost their son, but returned to find him debating with the learned men in the Temple, and astonishing them with his wisdom and knowledge of scripture.

84 **Simon Vouet**, *The Assumption of the Virgin*, 1644. The Virgin, three days after her death, is assumed into heaven before the eyes of the apostles. Vouet painted this altarpiece for the Oratory of the Queen Mother and Regent, Anne of Austria, at the Palais Royal. It is a work to be seen in a small space, and is therefore very finely executed, but also shows the artist responding to the shift of taste towards Classicism.

similar format and recent date, *The Presentation in the Temple* of 1640–41 [82], commissioned by Richelieu for the Jesuit church of St-Louis (now St-Paul-St-Louis). Adopting the same basic elements, Stella offers Vouet a lesson in Classical composition: first of all avoid too many figures, especially ones that are half cut off by others, with their backs to us and otherwise superfluous – and avoid altogether figures truncated by the sides of the painting; establish a solid sense of the ground – if there must be a staircase, extend the steps across the painting – and ensure that the principal figures are actually and visibly standing (there is hardly a foot in sight in Vouet's picture); also make the figures stand up properly, instead of forever bending and leaning (a trick Vouet

borrowed from Veronese); avoid the eternal Baroque diagonal; arrange the figures in the foreground and parallel to the picture plane; ensure the architecture of the temple is archaeologically plausible; centre the angels; and finally and above all, consider the subject, think of the most economical way to tell the story, and concentrate on substantial expression, not a flurry of empty attitudes and gestures.

The implications of Stella's painting were serious: Vouet's style, which had seemed the harmonious remedy to Mannerist excess, was now implicitly condemned as 'Asian' by the standards of the new 'Atticism', as Jacques Thuillier was to call the French Classicism of this time. Vouet must have taken this confrontation seriously, because his next important altarpiece, the *Assumption of the Virgin* painted for Anne of Austria at the Palais Royal in 1644 [84], is considerably more Classical in style, and among other things includes two feet conspicuously planted on the ground.

85 **Laurent de La Hyre**, *Pope Nicholas V visiting the Tomb of St Francis of Assisi*, 1630. This work shows La Hyre experimenting, like many of his contemporaries, with Caravaggesque naturalism as an alternative to Mannerism. It was made for the Capuchins of the Marais in Paris, and shows the Pope, in 1449, finding the body of St Francis to be perfectly preserved and standing upright, his eyes half-open and gazing heavenwards. The Pope lifts the hem of Francis' habit, and sees the stigmata on his feet, the blood still fresh and red. La Hyre included his own self-portrait, in the centre, in the person of the Pope's secretary (directly above the Pope's head).

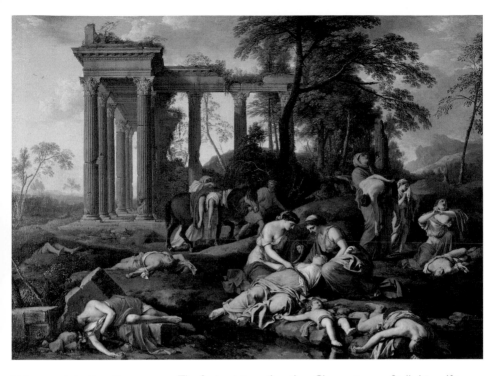

86 Laurent de La Hyre, *The Death of the Children of Bethel*, 1653. Elisha was mocked for his baldness by children near the city of Bethel; he cursed them, whereupon two she-bears came out from the wood and killed forty-two of the children (II Kings 2: 23–24). The story does not appear to have inspired any other painters, but La Hyre finds in it the tragic pathos associated with the subject of the children of Niobe. The work was commissioned by Claude Héliot, a Jesuit-educated collector who had travelled to Italy and learnt to paint, and presumably specified the subject.

The figures represent La Hyre's mature classical type (the one on the lower left is particularly beautiful) and they are set in a landscape both structured and made solemn by the impressive Antique ruins.

The first painter other than Champaigne or Stella himself to embody this new style was Laurent de La Hyre (1606–56). He had never been a pupil of, or even influenced by, Vouet, and so did not have to shake off what Roger de Piles later described as 'une manière si adhérente' – a manner that 'clings' to you. In fact, after early training by his father, La Hyre spent some time studying by himself at Fontainebleau, then a few months with Lallemant before setting out on an independent career. Like other artists of 'Parisian Atticism', and unlike almost all other important French artists both before and since, La Hyre never went to Italy. He worked hard and consistently in Paris, scrupulous in his methods and materials, and taking care to sign and date almost every painting, thus sparing historians much confusion, and also preserving many of his works from disappearing into anonymity. His paintings are appealing in their integrity and impressive in their variety, range and development.

As early as 1630, La Hyre's *Pope Nicholas V visiting the Tomb of St Francis of Assisi* [85] was painted in a style at once more naturalistic and more soberly balanced than anything that Vouet was doing. Later works like the *St Peter healing with his Shadow* (1635, Paris, Louvre) show an emerging Classical sensibility,

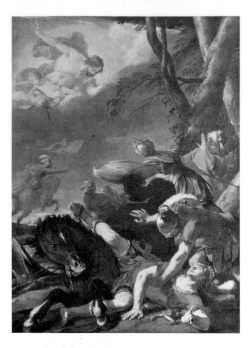

87 Laurent de La Hyre,
The Conversion of St Paul, 1637.
Saul, as he was then known,
was on his way to Damascus to
persecute the Christian community
when he was stricken from his
horse, temporarily blinded, and
ordered by Christ to become his
apostle. This spectacular scene
of conversion (Acts 9: 1–9) was
the *May* of 1637.

88 Laurent de La Hyre,
*Allegory of the Regency of Anne
of Austria*, 1648. The allegorical
figure standing in for the Queen
Mother, Anne of Austria, bears
the palm of victory and the orb
of dominion with the French fleur-
de-lys; she is crowned by a winged
figure of Virtue and celebrated by
a flying trumpet-bearing figure of
Fame. A boy, perhaps symbolizing
the young king Louis XIV, sets fire
to a pile of arms representing
discord.

although Mannerist uncertainties remain. In *The Conversion of St Paul* (1637) [87] La Hyre experiments with Baroque animation. Both of these were the *Mays* (in the spelling of the time) of their respective years, which, as will be explained below (p. 115), is evidence of the considerable prestige he already enjoyed. By the time of Poussin's stay in Paris, La Hyre had adopted the Greek profile that is also noticeable in Stella's work. In 1648 La Hyre was a founding member of the Academy and in the same year he painted the *Allegory of the Regency of Anne of Austria* [88] in honour of the new institution's patroness.

La Hyre's work reaches its maturity during the last fifteen years of his life, when his Classical forms are handled with increasing fluency, and important subjects are presented in impressive settings of landscape and architecture, as in his late masterpiece *The Death of the Children of Bethel* (1653) [86]. The inherently violent subject of this picture has been distilled into a scene of still and almost silent mourning. His last important painting is a rigorously Classical and lucid interpretation of that most Baroque of subjects – one that inherently dramatizes the tension between the material and spiritual worlds – the Supper at Emmaus [89]. For a man approaching the end of his life – although aged only fifty – it is a moving testament.

89 **Laurent de La Hyre**,
The Supper at Emmaus, 1656.
The story of Christ's mysterious
appearance to two of the apostles
after his resurrection is told in
Luke 24: 13–32. The apostles
journey all day with the stranger,
and it is only when he breaks
bread at supper that they recognize
him. Caravaggio, Rembrandt and
other Baroque artists generally
treat this subject as a nocturne,
dramatizing the tension between
the divine and the material world.
La Hyre chooses to set it in the
late afternoon, evoking a gentler
experience of revelation.

La Hyre was a successful and respected painter in his time;
his subsequent reputation suffered from the faint and heavily
qualified praise of Félibien and Roger de Piles towards the end
of the century. A closer reading of Félibien's biography reveals
approval of La Hyre's composition, architecture, perspective and
colour, but reservations about the treatment of the figure, which
he finds bloodless and nerveless ('insipid' is the most damning
epithet used), and which he explains by the fact that the artist
had not studied either the nude or the great masters sufficiently.
Unfair though the conclusions may be, there is at least some truth
in the observation: La Hyre had indeed not practised the tradition
as described here; he did not draw figure studies from nature
and seek general or synthetic forms. He had started with the
Mannerist figures of Fontainebleau and gradually fleshed these
out with experience of nature and superior artistic models.
Félibien was right to see this method as inherently flawed,

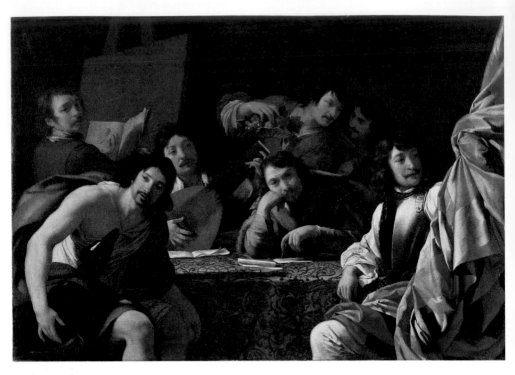

90 **Eustache Le Sueur**,
A Gathering of Friends, c. 1640.
The man in the middle with the
compass is probably Anne de
Chambré, Treasurer of War. The
others are his friends: the famous
lutenist Denis Gaultier; Le Sueur
himself in the left background, with
his easel (see ill. 2); an unidentified
officer in the foreground; and
another unidentified man as a
hunter with his dog (Adonis or
Meleager?) on the left.

Each is associated with his
particular inclination, but each
is also an allegory of the senses:
sight (the painter); hearing (the
lutenist); taste (the servant with
fruits); smell (the hunter with his
dog); and touch (the soldier holding
the standard) – all surrounding the
geometer, who stands for reason,
or for the 'common sense' with
which Descartes had begun his
Discourse on Method a few years
earlier (1637).

although ungenerous in not recognizing La Hyre's undoubted
poetic achievement.

The same critics took a very different view of La Hyre's
contemporary Eustache Le Sueur (1616–55), whose posthumous
reputation was for a time greatly inflated and then suffered a
nearly complete collapse, before being recently restored to a
more appropriate level. Le Sueur was one of the last and most
talented of Vouet's pupils: he was introduced to the tradition of
history painting at an early age, even if in the facile and decorative
version that he would have to struggle to outgrow. He probably
joined the studio between 1635 and 1637, and his earliest works
are painted for Vouet and in his style. A more personal
composition is the *Gathering of Friends* (c. 1640), which includes
the artist's self-portrait at about the age of twenty-four [2, 90].

By the middle of the 1640s Le Sueur had begun to find his
own style and was already in demand, working concurrently on
two projects: a series of paintings narrating the life of St Bruno,
the founder of the Carthusian order (canonized in 1623), and in
a very different vein the ceiling of the Cabinet de l'Amour at the
Hôtel Lambert in Paris [92]. The St Bruno cycle is very uneven,
because many of the pictures were left to assistants; but autograph

works like *St Bruno at Prayer* (c. 1645–46) [91] reveal an extraordinary departure from the formulaic attitudes and conventional draperies of Vouet's style. In the St Bruno picture, a solitary figure is set in an interior otherwise only defined by the geometry of architecture. The draperies, carefully planned in the preparatory drawings, are deliberately free of Vouet's mannerisms. The whole composition is designed to convey the intensity and urgency of Bruno's turning to God in a moment of crisis, and to anticipate his decision to withdraw from the world.

In a lighter vein, Le Sueur took part during these years in a project which is to some extent a microcosm of the state of painting in Paris at the time: the Cabinet de l'Amour. The *cabinet* was the French equivalent of the Italian *studiolo*: a private work-

91 **Eustache Le Sueur**, *St Bruno at Prayer*, c. 1645–46. The young Bruno has just witnessed the miraculous and terrifying revelation that his friend the Canon Raymond Diocres – reputed for his saintly life – was in fact corrupt, and is damned. This is the beginning of Bruno's turning away from the world and adopting a religious life.

room off the bedroom or *chambre*, which was frequently the
setting for a collection of art works and curiosities. The Cabinet
de l'Amour followed the characteristic French format of painted
timber panelling on the walls and ceiling, inset with paintings on
canvas. Le Sueur narrated the story of Love in the personification
of Cupid, the son of Venus, on the ceiling [92]; on the upper level
of the walls was a series of paintings based on the story of Aeneas,
also the son of Venus – and thus Cupid's earthly brother – by
Perrier [74], Berthollet Flémalle (1614–75), Juste d'Egmont
(1601–74) and others. On the lower part of the wall was a series
of poetic Classical landscapes by Pierre Patel [93] and others, and
below that a row of ornamental panels. Le Sueur's decorations
are light in manner and in content, but he achieves harmonious
simplicity and strives to find a rational solution to the perspectival

problems involved in painting scenes taking place over our heads. Le Sueur was a friend of the geometer Girard Desargues (1591–1661) and of Abraham Bosse (1602–76), who was soon to start teaching perspective at the Academy.

At only thirty years of age, however, Le Sueur was still a young man and the work is relatively small and modest. It was in the following years, until his premature death at the age of thirty-eight in 1655, that his style matured through the study of Raphael and Poussin. His enormous *St Paul at Ephesus* (1649) [94] clearly refers to Raphael's Cartoon of *St Paul at Athens*. The painting was a *May*, about which a word must now be said.

From 1630 until 1707, members of the Paris Goldsmiths' Guild annually commissioned a large painting – for many years on a subject drawn from the Acts of the Apostles – which they presented to the Cathedral of Notre-Dame in May, the month of the Virgin; altogether seventy-six paintings were presented, and the nave was once hung with them. The commissions were often given to relatively young men at the point at which they were beginning to enter their maturity, and a *May* was an exceptional and timely opportunity to show off their abilities. Although the series is now dispersed, and many of the paintings are lost or in a bad state of repair, it is of great historical interest, allowing us to follow not only the reputation of individual artists, but the evolution of artistic taste.

We have already mentioned two *Mays* by La Hyre (p. 110); the *May* of 1642, *St Peter preaching* [95], was by Charles Poërson

94 **Eustache Le Sueur**, *St Paul at Ephesus*, 1649. This enormous painting takes as its subject the account of Paul preaching at Ephesus, where he cured the sick, cast out evil spirits, made many converts, and, in the scene shown here, inspired magicians to bring their books and burn them (Acts 19: 19). Like the other *Mays*, it originally hung in the nave of Notre-Dame.

95 **Charles Poërson**, *St Peter preaching in Jerusalem*, 1642. The subject is again from the Acts of the Apostles (11: 2–18): St Peter defends the universal message of Christianity against the Jews, and his dramatic gestures evoke the supernatural vision that he begins by describing. The spiral columns allude to those in Old St Peter's in Rome that were thought to have been brought from the Temple in Jerusalem by Constantine (and which had recently inspired the twisted columns of the Baldacchino in St Peter's).

The work was designed as a *May* for Notre-Dame. The version illustrated is either the *modello* (a fully developed study for a large work made for the patron's approval) or a *ricordo* (a reduced version made after the completion of the painting, for the painter or the private collection of the patron). Poërson is still working in the style of his master Vouet (cf. ill. 71).

96 **Charles Poërson**, *The Annunciation*, 1652. This painting was made as a design for a tapestry, in a series begun by Philippe de Champaigne in 1638. Poërson has evolved towards a more classical style, although the picture is filled with surface animation suitable for the medium of tapestry.

(c. 1609–67), who was a pupil of Vouet, and whose style was still very closely derived from that of his master (ten years later, his *Annunciation* (1652) [96] shows that he has been thoroughly converted to Atticism). The *May* of 1643 was by Sébastien Bourdon, in a more Baroque manner, and will be discussed below [102]. That of 1644, by Michel Corneille the Elder (1602–64), a former pupil of Vouet, *The Sacrifice at Lystra* [97], anticipated Le Sueur in drawing its inspiration from Raphael's Cartoon of the same subject, and confirms that a whole generation of younger painters was responding to the example of Poussin and Stella by returning to Raphael.

Le Sueur's *May* [94] is stiff and graceless, hardly surprising in so enormous a picture, especially when the artist was accustomed to a much smaller scale (Félibien found the oil study more appealing). But this composition is followed, in the last five years of his life,

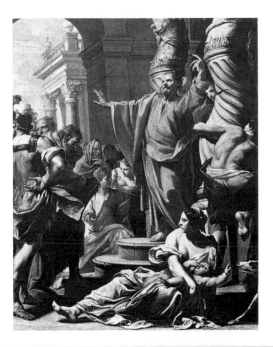

by Le Sueur's best paintings, including the *Deposition* (c. 1651) [98] and *Christ in the House of Mary and Martha* (c. 1653) [99]. These pictures have in common a great refinement in the types, geometrically meticulous treatment of spatial composition, and a particular sensitivity to the subject, especially to what the Comte de Caylus later called (in a lecture or *conférence* at the Academy in 1747) 'les passions douces' – mild emotional states, epitomized in the figure of Mary Magdalene listening attentively to the words of Christ. This tendency to specialization in the range of expression is a limitation in a history painter, but Le Sueur's strength lies in the quality of belief that he brings to the subjects that he does paint.

One of Le Sueur's last commissions was for a series of six enormous cartoons for tapestries for the church of St-Gervais, telling the story of the martyrs SS. Gervasius and Protasius. Le Sueur was able to finish one before he died (Paris, Louvre), leaving a second to be completed by his brother-in-law Thomas Goussé

97 **Michel Corneille the Elder**, *The Sacrifice at Lystra*, 1644. The subject is, as usual for a *May*, from the Acts of the Apostles (14: 8–18). Paul and Barnabas, having healed a crippled man, are taken for Jupiter and Mercury by the inhabitants of Lystra, who attempt to offer sacrifice to them. Corneille refers directly to Raphael's treatment of the same subject in the Cartoons for the Vatican tapestries. He was a pupil of Vouet and married one of the latter's nieces in 1636, but was nonetheless among the founders of the Academy (which had frozen out Vouet) in 1648.

98 **Eustache Le Sueur**,
The Deposition, c. 1651. In this
altarpiece commissioned for a
private funerary chapel at St-
Gervais in Paris the emphasis is
clearly on the Holy Shroud in the
foreground, which will bear the
imprint of Christ's body and
become a celebrated relic. Below
the *Deposition*, on the front of the
altar, Le Sueur painted the related
theme of Christ with St Veronica,
whose veil was indelibly marked
with Christ's features.

from his designs (Lyons, Musée des Beaux-Arts). The painter
who was initially appointed to complete the series, Sébastien
Bourdon (whom we have already encountered in Rome, p. 76),
was in many ways the opposite of Le Sueur – gifted with great
facility, not particularly scrupulous about stylistic matters, and
showing little evidence of belief in the sense discussed above.
As a result, perhaps, after delivering the third painting for St-
Gervais he was dismissed and the remainder of the commission
was transferred to Philippe de Champaigne.

Bourdon was an exact contemporary of Le Sueur, born in 1616
in the south of France, at Montpellier. He travelled to Paris very
early, then went to Rome at around the age of eighteen, in 1634.
He must almost at once have set about pastiching better-known

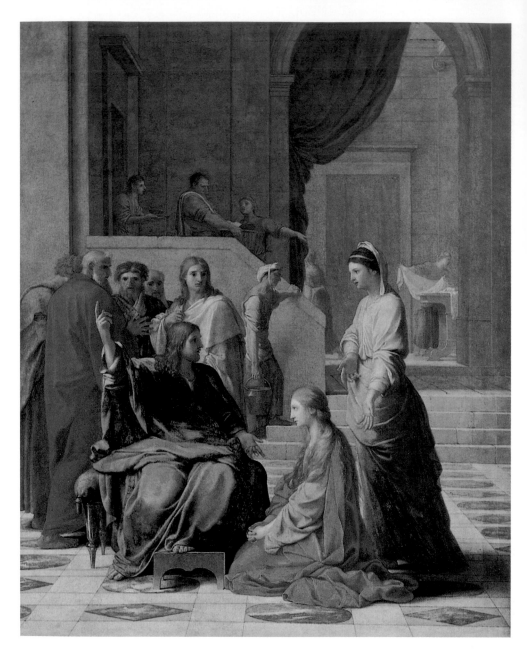

99 **Eustache Le Sueur**, *Christ in the House of Mary and Martha*, c. 1653.
Martha, on the right, reproves her sister Mary for being idle while she busies herself
with the household chores, but Jesus praises Mary for listening to his teaching
(Luke 10: 38–42). Le Sueur's picture is visibly influenced by Poussin and Raphael,
but distinctive in the simplicity of its composition and in its sensibility, concentrating
on *les passions douces*.

100 Sébastien Bourdon, *Gypsies and Soldiers, c. 1640–43.* This is a good example of Bourdon's *bambocciate*, one of the styles that the versatile young artist brought back from Rome: trivial scenes, but beautifully painted and popular with collectors. Bourdon produced many of these pictures, with the same set of characters and of compositional elements assembled in different combinations.

101 Sébastien Bourdon, *The Sacrifice of Iphigenia, c. 1640–45.* The other style that Bourdon brought back, and with which he must have hoped to make his mark in Paris, was a theatrical synthesis of contemporary Italian Baroque tendencies. The subject here is the sacrifice of Iphigenia to Diana (cf. ill. 73), but Bourdon has the girl carried away out of the smoke by the goddess, while the deer has already taken her place on the altar. In spite of Ovid's text (*Metamorphoses* 12: 24–38), he has made it even more evident than Perrier that the goddess' intervention is visible to all.

artists, if it is true that Claude started the *Liber veritatis* in 1637 after the incident described in the previous chapter. But Bourdon worked fast. He quickly assimilated two new styles which he duly imported to France on his return in 1638. One was a form of naturalism which had superseded the earlier formula of Bartolommeo Manfredi (the *methodus Manfrediana*, as Sandrart had called it), namely the new genre scenes known as *Bambocciate* (p. 26). Bourdon excelled in these pictures, which he used as the vehicle for displaying his mastery of painterly effects, including an extensive repertoire of costume and still–life details [100]. This was a highly commercial type of painting, a luxury product free from the constraints of subject, invention and expression.

At the same time, Bourdon also had a manner for serious subjects: an up-to-date version of the Baroque, influenced by Cortona, who was then at the height of his success as a painter,

102 **Sébastien Bourdon**,
The Crucifixion of St Peter, 1643. This, a *May*, was Bourdon's last important Baroque work, showing that he was still trying to impose himself with this style even after Poussin's stay in Paris had confirmed the growing classicism of many other younger artists. St Peter had chosen to be crucified upside-down, out of humility (the subject is traditional, not scriptural); in Rome, Bourdon would have seen such celebrated versions of the subject as those of Michelangelo and Caravaggio.

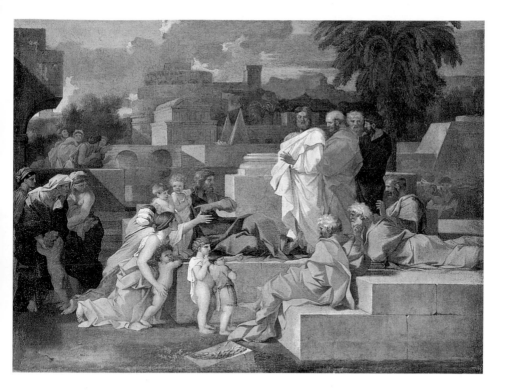

103 **Sébastien Bourdon**,
Christ and the Children, late 1640s?
Bourdon here finally abandons
his Baroque style and adopts a
Poussinesque geometrical style,
in time to be a founder member
the new Academy in 1648. The
composition, the arbitrarily
geometric setting, and the attitudes
of the figures – like the one on the
right lying down – are, however,
all extremely peculiar and would
have puzzled Poussin.

and by the Genoese Giovanni Benedetto Castiglione (*c*. 1610–65).
This formula can be seen in *The Sacrifice of Iphigenia* (*c*. 1640–45)
[101]. When he obtained the commission for the *May* of 1643,
seemingly ignoring Poussin's recent visit or the effect it had had
on many of his contemporaries, he painted a dramatically Baroque
Crucifixion of St Peter [102]. But Atticism caught up with him a few
years later and, characteristically, by the later years of the decade
he was painting in a version of Poussin's style, well illustrated
by his *Christ and the Children* (late 1640s?) [103], with its oddly
geometrical stage-setting. Bourdon's work does not demonstrate
a profound affinity with Poussin, although he spoke thoughtfully
about the latter's painting in lectures he gave as one of the
Rectors of the Academy.

The last of the important figures of this generation to return
from Rome was also the last to go there: Charles Le Brun had
accompanied Poussin on his journey back to Rome in 1642, and
returned to Paris in 1646. He was too young to have played any
part in the development of Parisian Atticism, but was instrumental
in establishing the new Academy of Painting and Sculpture, which
will be the subject of the next chapter.

Chapter 4 The Academy and Charles Le Brun

Most of the artists discussed so far did not belong to the Paris Guild of Painters, generally known as the Maîtrise. Guilds were a medieval institution and a vital part of the prosperity of the great cities that arose in Europe during that time, regulating craft standards and employment in each artisanal field, and even providing, through their mutual structure, a form of social security. In the early 17th century, the Paris Maîtrise still tightly controlled the practice of painting, making it hard for newcomers to be admitted, and jealously enforcing their monopoly: it was actually illegal for a non-guild painter to work in the city. Artists of any standing could, however, escape its jurisdiction by holding a royal appointment and being granted lodgings in a royal palace, usually at the Louvre. Less established individuals could also evade the guild's authority by staying in the grounds of a religious institution, like the monastery of St-Germain-des-Prés, or in one of the colleges of the Latin Quarter. Thus Philippe de Champaigne and Poussin met when they were both living at the Collège de Laon in 1622.

The Maîtrise was angry with the number of royal appointments made during the period of expansion and renewal of the 1630s and 1640s. It took advantage, like everyone else, of the comparative weakness of central power during the Regency that followed the death of Louis XIII in 1643, and attempted, in 1647, to have the number of appointments severely limited. The response of the artists was to propose the formation of a Royal Academy of Painting and Sculpture, the members of which would be collectively exempted from the guild regulations. The proposal was supported by Chancellor Séguier and the Queen Mother, Anne of Austria, and the new Academy was officially inaugurated by a decree of the Council of State at the end of January 1648. Vouet was not invited to join. The founders were his stylistic and commercial rivals, and they knew that if the former Principe of the Academy of St Luke in Rome were included he would accept nothing less than leadership. They may also have assumed, as Vouet was gravely ill during the months of January and February

104 **Charles Le Brun**, *Portrait of Chancellor Séguier*, 1661. Chancellor Séguier, the highest legal officer in the State, had recognized Le Brun's talent while he was still very young, lodged him in his own house, and personally funded his studies in Rome. Here he is seen in ceremonial robes taking part in the official entry into Paris of Louis XIV and his new wife, the Infanta Maria Teresa (Marie-Thérèse), in 1661. In the same year he became Protector of the Academy.

of 1648, that his death would soon obviate the problem. By the time he had recovered, all of the offices in the new institution had been filled. Inevitably affronted by this exclusion, Vouet sided with the Maîtrise (until his death in 1649), which did its best to undermine the Academy for the next fifteen years or so. A temporary accommodation and *jonction* or amalgamation of the Academy and the Maîtrise took place in 1651, but collapsed in 1655; its only interest for us is that it explains why several artists who had not joined the Academy in 1648 became members during this period. By the time of Pierre Mignard's return to Paris in 1657, normal hostilities had been resumed, and were only brought to an end, as we shall see, by Colbert in 1663.

As well as being a professional association, the Academy was meant to be a place of theoretical debate and especially of practical instruction: as the foundation of history painting was the study of the nude, life classes would be held, supervised by members of the Academy, who would pose the model and correct the drawings of the students. There would also be instruction in anatomy and perspective. Thus drawing and theory were the province of the Academy, while the craft of painting continued to be taught in the studios of particular artists on the old model of apprenticeship (it is not often realized that painting and other technical or 'studio' subjects were only brought into the academic curriculum following a reform of the Paris École des Beaux-Arts in the second half of the 19th century).

The first entry in the minute-book of the new Academy is by the young Charles Le Brun (1619–90), accounting for the money he has advanced to purchase furniture and the register itself. At twenty-nine years of age, he was the leader of an Academy whose founding members were mostly considerably older than himself: Philippe de Champaigne, the Le Nain brothers, La Hyre, Stella, Charles Errard; even Le Sueur and Bourdon were three years his senior. He would not have held this rank without exceptional ability as an artist; but his initiative in taking charge of the practicalities of setting up the Academy is a small sign of his other great talent, for administration and the management of complex projects.

Le Brun was born in Paris, the son of a sculptor. He showed precocious talent and was sent to study first with Perrier and then with Vouet. When he was still very young, Chancellor Séguier was shown a drawing he had made of Louis XIII on horseback and brought him to live in his own house, where Vouet was at the time painting a gallery. It is said that Séguier asked Vouet to give his protégé some piece of work in this gallery, but that Vouet set

105 **Charles Le Brun**, *Hercules and the Horses of Diomedes*, *c.* 1640. In this early work, painted for Cardinal Richelieu, Le Brun already displays his taste for violent subjects. Hercules, as one of his twelve labours, had to capture the flesh-eating horses of the cruel King Diomedes. He fed the tyrant to the beasts, after which they ceased their unnatural habits. Hercules' destruction of monsters was regularly understood as an allegory of the ruler's overcoming violence, sedition or vice: in this case *Hercules admirandus* was taken as an anagram of *Armandus Richeleus* (Armand de Richelieu).

Le Brun to menial tasks. Shortly after this he was introduced to Richelieu, for whom he painted *Hercules and the Horses of Diomedes* (*c.* 1640) [105]. Poussin is supposed to have admired this picture, although it can hardly have been to his taste: the love of violence it betrays is characteristic of Le Brun's artistic temperament, but antithetical to that of Poussin. Nonetheless, Le Brun travelled back to Rome with Poussin in 1642, and spent the next four years studying there on a stipend from Séguier. Le Brun's gratitude to his first patron was to be attested in a sumptuous equestrian portrait (1661) [104].

Returning to Paris in 1646, Le Brun had little in common with the leaders of Parisian Atticism. He had gone from a training in

106 **Charles Le Brun**, *Moses striking the Rock*, 1648–50. The subject had been painted by Poussin, whom Le Brun imitates in this early work, made not long after his return from Rome. The subject comes from Exodus 17: 1–7: the people of Israel (fed with manna in the preceding episode) are thirsty; the Lord commands Moses to strike a rock with his staff, and water pours forth.

Vouet's manner straight to Rome, and must have thought there was something slightly provincial about the style La Hyre and Le Sueur had developed without leaving Paris. He was also completely out of sympathy with the quietism inherent in their work. On the other hand, his direct experience of Poussin's methods, and close study of the Raphael that the others knew only from prints, must have lent him authority; he could produce solid and superficially Poussinesque works like *Moses striking the Rock* (1648–50) [106] which must have seemed impressively modern. Le Brun's example probably encouraged his contemporaries to pursue their study of Raphael and of Poussin, even if they did not imitate his own style, which was (especially before Versailles) a Pandora's Box of vigorous but incompatible elements, taken from Raphael, Giulio Romano, Poussin, Cortona, Guido Reni and Rubens. *The Penitent Magdalene* (c. 1657) [107] is a histrionic interpretation of Guido Reni's ecstatic upturned gaze, while *The Battle of Constantine and Maxentius* (c. 1660–61) [108], commissioned by Richelieu's successor as Prime Minister, Cardinal Mazarin (1602–61), shows both Le Brun's love of violent action and the overwhelming influence of Rubens. (The latter had copied

the prototype of cavalry-battles-on-a-bridge, Leonardo's great but unfinished *Battle of Anghiari*, before attempting his own *Battle of the Amazons* of 1615 and *Defeat of Maxentius* of 1622.) Le Brun was commissioned to paint two *Mays*, *The Stoning of St Stephen* (1647) and *The Crucifixion of St Andrew* (1651), both still in Notre Dame. At the same time he painted a number of devotional subjects, such as the *Holy Family* known as *Le Silence* (1655) [109].

Although he had taken a leading role in establishing the Academy, Le Brun's pre-eminence was not yet definitively established. For a few years he was actually eclipsed by a rival, Charles Errard, both within the Academy and in official favour. Errard (d. 1689) was born in Nantes between 1606 and 1609, the son of a painter, and was in Rome from 1627 until 1637 or 1638, supported, like Vouet earlier, by a royal stipend. It seems

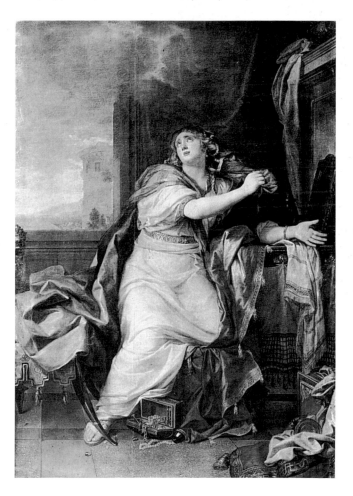

107 **Charles Le Brun**,
The Penitent Magdalene, c. 1657.
Unlike La Tour and Champaigne,
who show Mary Magdalene in a
state of penitent meditation (ills.
32, 125), Le Brun depicts a harlot
seized with anguish in the midst of
sin and surrounded by the symbols
of luxury and vanity. The picture
was painted for the Carmelite
convent in the Faubourg St-Jacques
(next door to Port-Royal).

108 **Charles Le Brun**, *The Battle of Constantine and Maxentius*, c. 1660–61. Giulio Romano had painted the battle (see ill. 59) in the Vatican *Stanze*, and Le Brun made a copy; Mazarin admired that and requested an original version, but died before it was finished.

109 **Charles Le Brun**, *Holy Family* ('*Le Silence*'), 1655. The influence of Raphael is combined with a very French naturalism: St Elizabeth on the left restrains her infant son John who reaches out to the sleeping Christ, and the Virgin motions him to be quiet. St Anne moves forward like an old nurse to prevent the child from being disturbed. The effect is enhanced by the cat keeping warm under the brazier on the right.

110 **Charles Errard**, *Rinaldo leaving Armida*, c. 1640. The Christian knight Rinaldo has come to his senses and is about to leave the beautiful witch Armida, who has fainted and lies on the shore. The story is from Tasso's *Jerusalem Delivered*.

that he was on friendly terms with Poussin and that he met Fréart de Chambray during the latter's visit to Rome in 1635–36. Chambray evidently saw in Errard an artist who matched his own high standards of probity, and introduced him to his cousin Sublet de Noyers, the new Surintendant, around the end of 1638; and Sublet sent him back to Rome almost immediately with further funding and letters of recommendation. There he took part, among other things, in an important commission for the Maréchal and Duc de La Ferté-Senneterre, for which he painted the large canvas of *Rinaldo leaving Armida* (c. 1640) [110]. Errard returned to Paris at the end of 1643, was given a royal appointment, and was commissioned to paint the *May* of 1645 (now lost).

Errard's career appeared to suffer an important setback in 1643, when Mazarin engineered Sublet de Noyers' fall from grace. As it turned out, however, Sublet's right-hand man in the arts portfolio, Antoine de Ratabon, who had formed a high regard for Errard, retained his powerful position and continued to support him. Errard took part in the founding of the Academy, as we have seen, and became one of the two joint Treasurers in 1651. In 1655, Ratabon took the role of Director for himself, and in 1656 he became Surintendant des Bâtiments; Le Brun was Chancellor of the Academy (more will be said about these functions below) and Errard became one of the four Rectors. Thanks to Ratabon's support, Errard increasingly managed the affairs of the Academy

111 **Charles Errard**, realized by Noël Coypel, ceiling of the Grande Chambre in the Parlement, Rennes, c. 1661–62. Errard and Coypel's ceiling is filled with moral allegories appropriate to a hall of justice (the protection of innocence, the suppression of calumny, the unmasking of fraud). This ensemble was very nearly the last of many French art works to be destroyed by mob violence, when the Parlement was set alight in a fishermen's riot in 1994. A long and costly restoration has recently been completed. (The ceiling is so large that a number of individual photographs have to be combined to obtain an overall view.)

as his substitute. Le Brun, angry at this state of affairs, finally handed back the seals (which he held as Chancellor) to Ratabon and withdrew from the Academy for some months apparently at the end of 1660 and the beginning of 1661.

At the same time, official favour meant that Errard was given, during the course of the 1650s, substantial commissions for the royal and ministerial apartments at the Louvre and at St-Germain-en-Laye, Fontainebleau and elsewhere. The very extent of this work meant that Errard, like Poussin at the Louvre, was mainly occupied in preparing designs executed by assistants. Incredible as it may seem, almost nothing survives today: once again a whole section of French art history is simply missing, and it is very hard to form an idea of the quality of Errard's achievement. The *Rinaldo leaving Armida* [110] already mentioned is a very big and rather disappointing painting, characterized by an almost complete lack of expression. The only substantial example of Errard's mature style is the ceiling of the Parlement at Rennes [111], painted by his pupil Noël Coypel around 1661–62 after his designs. It is elegant and refined, but once again principally concerned with form: in fact it is quite likely that Le Brun's preoccupation with expression began as a way of demonstrating the superiority of his own painting to that of Errard (recalling of course that this had also been the argument of Domenichino's superiority over Guido Reni: see p. 51).

It was at this time, too, that another rival appeared on the scene: Pierre Mignard (1612–95), who together with his lifelong friend Charles-Alphonse Dufresnoy (1611–68) had returned from Rome to Paris by 1657. Mignard was eight years older than

Le Brun, and already an established artist by the time the latter came to Rome as a student. Dufresnoy was also a painter, but perhaps already better known as the author of a Latin poem on the art of painting, *De arte graphica* (eventually published in 1668). They had certainly met, for Le Brun had painted Dufresnoy's portrait [112]. Unwilling to take a back seat to the younger man, Mignard refused to join the Academy, choosing instead to lend his support to the continuing attacks of the Maîtrise. Caylus later wrote that he spent 'the first five years of his stay in Paris fomenting disputes, and encouraging demands by the Maîtrise, in the hope of tiring and disheartening' the protectors of the Academy.

Le Brun, meanwhile, had not been idle. He painted a number of important easel pictures during these years, as well as executing the ambitious Galerie d'Hercule at the Hôtel Lambert (c. 1650) [113]. He still enjoyed the favour of his first patron, Chancellor Séguier, and began in 1658 to work for another of Mazarin's ministers, the Surintendant des Finances, Nicolas Fouquet (1615–80), who was responsible for the kingdom's taxation and all other

113 **Charles Le Brun** (engraved by Louis Desplaces), *The Battle of the Lapiths and Centaurs*, ceiling of the Galerie d'Hercule, Hôtel Lambert, Paris, c. 1650. Hercules, the symbol of virtue, is shown fighting with centaurs, who as usual in ancient and modern art represent bestial instinct and violence. The head of the fleeing centaur on the right is taken from that of a terrified follower of Heliodorus which Le Brun had copied from Raphael's fresco in the Vatican.

financial matters. The Surintendant, like Mazarin himself, had grown enormously rich from the administration of his office, and in the late 1650s he spent a great deal of money building himself the most beautiful and modern château in France, at Vaux-le-Vicomte. Fouquet assembled an exceptional team of architects and artists – Louis Le Vau designed the château itself, André Le Nôtre the gardens, and Le Brun the interior decorations. La Fontaine celebrated the house and garden in verse. When the château was almost complete, on 16 August 1661, Fouquet held the celebrated and disastrous Fête de Vaux, a splendid celebration in honour of Louis XIV, which included an opera-ballet with libretto by Molière and music by Jean-Baptiste Lully. The young King, married only the year before, was lavishly entertained in a setting far more glamorous than any of his own rather ramshackle and half-renovated palaces.

Fouquet's extravagant gesture was particularly ill-timed. Mazarin had died in March of the same year, leaving a colossal fortune. The King had tolerated his corruption (and that of his administration) out of gratitude, presumably, for Mazarin's achievement in successfully governing the kingdom during his childhood and youth; but now the late minister's subordinate was made to pay for both of them. Fouquet was arrested and eventually condemned to life imprisonment (according to a persistent tradition, he could not be sent into exile, the more usual punishment for someone of his station, because he knew the identity of the Man in the Iron Mask, the most closely guarded state secret in France). The trial was partly the work of another of Mazarin's officials, Jean-Baptiste Colbert (1619–83) [114], who

was to become the right-hand man of Louis XIV. They were utterly different men, the personality of each aptly symbolized by his chosen emblem: Fouquet's nimble, audacious squirrel and Colbert's cold, gliding serpent (*coluber* in Latin). Colbert did not have Fouquet's aesthetic sensibility, but he could appreciate professional competence, and he took the arts seriously as a means of promoting the image of the State. What he saw at Vaux was a team of remarkably able men, whom he was quick to take into the King's service: and the one who most impressed Colbert was Charles Le Brun, in whom he must have recognized an energy and determination very like his own.

The Fête at Vaux was thus in many ways a catalytic event: it allowed the young King – who on Mazarin's death had announced his intention of governing personally – to assert his authority in a spectacular way; it was the occasion of Colbert's rise to power; and for Le Brun, who might have expected to suffer in his patron's fall, it turned out to be the opportunity to reassert his leadership of contemporary French art in a decisive way.

For the last years of his life, Mazarin himself had been Protector of the Academy, and Chancellor Séguier Vice-Protector; in 1661 Séguier became Protector (it was at this time that Le Brun painted the equestrian portrait already mentioned [104]). A few months later, a delegation from the Academy went to Fontainebleau to ask him to name his own successor as Vice-Protector. Ratabon, the Director, wanted the position for himself, but as he broached the subject, Séguier interrupted him before all present and said, 'yes, these gentlemen have asked for Monsieur Colbert, and I am quite willing'. Le Brun had met Séguier privately the night before and proposed this nomination. Ratabon was stupefied; he had been publicly disgraced, and although he was reappointed as Director later that year, his power was eclipsed. Le Brun was unambiguously restored as the leader of the Academy; he was ennobled in 1662, and created a Knight of the Order of St Michael in 1663. He arranged a public reconciliation with Errard, who was in due course sent off in 1666 as the Director of the newly founded 'Académie de France à Rome', with responsibility for the supervision of students sent there to further their studies. Colbert meanwhile gave the Academy a new constitution at the end of 1663, which helped to clarify the various responsibilities: the Director was to be elected annually, while the Chancellorship (held by Le Brun) was a life appointment, as was the post of Secretary. In fact, as we shall see, Le Brun kept the Directorship nominal or vacant for the next twenty years, until he finally added

114 **Claude Lefebvre**, *Portrait of Jean-Baptiste Colbert*, 1663. Colbert is shown in the year when he decreed that artists working on royal commissions had to be members of the Academy; he is wearing the robes and order of the Holy Spirit, of which he was Treasurer. Lefebvre was one of the leading portraitists of the first half of Louis' reign, introducing a more spontaneous and natural style than such earlier painters as Charles and Henri Beaubrun (ill. 118). This was his *morceau de réception* at the Academy in 1666.

it to his other responsibilities in 1683. In 1664, he was officially appointed First Painter of the King (once again an appointment for life). He had enjoyed this rank in practice since 1662, but must have felt uneasy about claiming a position that was in principle still occupied by Poussin himself (who died in November 1665).

In addition to helping restore Le Brun's authority and reforming the constitution of the Academy, Colbert promulgated an edict in 1663 compelling all artists who worked for royal commissions to join the Academy. It is an indication of the powerful connections that Mignard had by then established that he and Dufresnoy were able to decline the invitation which was made to them in the most courteous terms by Le Brun (as with Errard, Le Brun was concerned to find a face-saving accommodation). In general, however, the decree had the desired effect. Several recalcitrants, including Mignard's own brother Nicolas (1606–68), suddenly remembered that they had always held the Academy in high regard and had long

aspired to be members. In the following year, 1664, Colbert cemented his control over arts policy in general by acquiring the office of Surintendant des Bâtiments du Roi, which had until then nominally still belonged to Ratabon, although Colbert had effectively taken control for over two years. As in every other department of his administration, he then set about establishing new industries, granting monopolies and privileges, and rationalizing the management of existing institutions. Already in 1662 he had established the Manufacture des Gobelins in Paris as a factory that would produce all the furniture, tapestries and decorative objects for the adornment of the royal palaces; as director he appointed Le Brun in 1663.

Le Brun was ideally suited to the demanding tasks imposed on him. He was highly talented and artistically inventive, well educated, and extremely competent at managing complex tasks and difficult people. He took in his stride the endless interruptions and competing demands that had distressed Poussin; but he did not have anything like the latter's intellectual and artistic independence. In fact, just as Poussin needed freedom to develop his own painterly thinking, Le Brun needed the guidance of a patron to provide him with a subject. He could carry out any task required of him, from designing a table setting to painting an allegorical cycle; but he had very little ability to be autonomous.

Le Brun's single most famous easel painting is *The Queens of Persia before Alexander*, also known as *The Tent of Darius* [115], which he painted at Fontainebleau in 1660 or 1661. The King himself would regularly come into the studio after dinner to see how the picture was progressing, so an invaluable connection was established before the disaster at Vaux; Le Brun was in fact always to retain a personal relationship with Louis XIV, even in the difficult last years of his career. The *Queens* was treated by his supporters as something of an artistic event: the young André Félibien even composed a short publication (1663) to assist in the reading of the painting. Le Brun's composition shows the mother, wife and daughters of Darius kneeling before Alexander the Great, who has just defeated the Persian king. Their consternation is increased by the fact that, deceived by his red cloak, they have mistakenly begun to do obeisance to Alexander's companion, Hephaestion, and they are afraid of having offended their conqueror; but Alexander dismisses this mistake with magnanimity. It is clear from Félibien's text that Le Brun has deliberately conceived each of the principal figures as embodying a particular emotion or 'passion': fear, wonder, anxiety, etc. Le Brun himself later confirmed this in his important

115 **Charles Le Brun**, *The Queens of Persia before Alexander* (*The Tent of Darius*), *c.* 1660–61. The victorious Alexander stands with his general Hephaestion, whom Darius' mother, wife, daughters and retainers initially took for the conqueror. Most of those figures were conceived from the first as illustrating particular passions: the servant on the right in the top row is Wonder (*Étonnement*); below her is Fear (*Crainte*); of the two young women kneeling in the centre of the composition, the one on the right is Anxiety (*Inquiétude*) and the one on the left is Dejection (*Abattement*).

lecture at the Academy on the expression of the passions (probably given in two parts in April and May 1668), which he illustrated with several heads taken from the *Queens*, as well as other drawings. The lecture was not published until after his death, in 1698, but many of the illustrations Le Brun used had been reproduced in the 1693 and 1696 editions of *Les Sentimens des plus habiles peintres* [116], a work that will be mentioned again below.

In according this meticulous attention to the passions, Le Brun no doubt thought of his painting as a kind of manifesto; a demonstration of what real history painting should be. It was quite likely intended as an embodiment of Poussin's lesson that expression is the very essence of painting, and a rebuke to the decorative style of Errard. To many of Le Brun's contemporaries the *Queens* must indeed have seemed a homage to Poussin, and

most textbooks today still consider it highly Poussinesque. In fact, although Le Brun alludes to the composition of Poussin's *Coriolanus* (1650–55, Les Andelys), Poussin never painted anything remotely like this. He did not approach his paintings as an assemblage of passions, but proceeded from the significance of the event to its expression by all the means at his disposal. Rarely is it possible to name the 'passion' that one of Poussin's figures embodies, for the experience depicted is inseparable from the circumstances in which the figure finds itself. There is no such thing as 'wonder' in the abstract. Le Brun, on the other hand, conceives of the passions as a finite repertoire of emotional states, which can be put together in different combinations to narrate any given story. There is little doubt that he chose to lecture to the Academy on *The Gathering of the Manna* [43] because this was one of relatively few of Poussin's works to be amenable to analysis along these lines.

The difference therefore is twofold: for Poussin, in the first place, expression is always specific to the particular circumstances and grows out of the effort to express the subject, while for Le Brun it can be reduced to permutations of a set of elements. Secondly, much as for Aristotle in his theory of tragedy, the action in Poussin (including the significance of the event) takes precedence over and determines psychology. For Le Brun, on the other hand, the primary reality is psychological, and action is just a way of displaying interesting psychological states. The result is that the *Queens* displays little more than a collection of disparate facial movements, monotonous in their arrangement in rows, ultimately

116 After Charles Le Brun, examples of the passions, from Henry Testelin, *Les Sentimens des plus habiles peintres*, 1696. A large fold-out plate reproduces many of Le Brun's lecture drawings (reversed in engraving). The expressions are identified as (top to bottom, left to right): Astonishment, Contemplation, Sadness, Laughter; Terror, Fear, Anger, Contempt; Despair, Anxiety, Dejection, and Acute Pain. Most of the female heads can be found in the *Queens of Persia*, while the figure of Fear on the left is the fleeing Persian officer in the centre of the *Battle of Arbela* (ill. 117).

distracting the viewer from the moral spectacle of Alexander's generosity. The same criticisms can be made of the colossal pictures of the *Battles of Alexander* series which followed (1665–73) [117]. They are really enormous pastiches made up of elements from Giulio Romano, the Leonardo of *The Battle of Anghiari*, and Rubens, gratuitous mayhem alternating with textbook examples of 'passions'.

Le Brun's theory of the passions derives directly, although not always faithfully, from Descartes' *Traité des passions de l'âme*

117 **Charles Le Brun**, *The Battle of Arbela, c. 1668.* At Arbela in 331 BC Alexander the Great (the eagle of Zeus flying over his head) defeated Darius and won the Persian Empire. Le Brun is clearly thinking of Pietro da Cortona's treatment of the same subject, and is also trying to outdo the version by Guillaume Courtois which was given to the King by the Apostolic Nuncio in 1664.

(*The Passions of the Soul*), of 1649. Descartes's narrowly mechanical account of the passions encouraged Le Brun's tendency to think that emotional experience could be analysed into a repertoire of distinct psycho-physiological states, which could in turn be reduced to the mechanics of facial grimaces. This tendency was aggravated by the general tenor of Cartesian thought, in particular its separation of mental and physical events. Descartes explicitly rejected the medieval idea that the soul actually *animates* the body; he maintained that the body

functions in a purely physical way, and the passions themselves are initially a matter of corporeal action and reaction. In animals this is all there is; but in humans the passions are subsequently experienced as conscious states, or emotions, which gives us the freedom of deciding how to behave in response to any given stimulus. This mechanical view of the world, with its metaphysical dualism, is antithetical to Poussin's cosmology of mind immanent in nature, and makes nonsense of most of his subjects. It is difficult, more generally, to see how it can ultimately be reconciled at all

with the tradition of history painting, in which the mind must be made visible in the actions of the body. But Poussin, as has already been suggested, was in a sense the last painter of the Renaissance; a particularly deep generation gap divides him from an artist like Le Brun, who comes to maturity in the middle of the scientific revolution.

A broader context for Le Brun's treatment of psychology, however, is to be found in some of the dominant tendencies of contemporary French sensibility. The decades we are now

considering represent the culmination of the cultural reconstruction of France. The 1630s, 1640s and 1650s were the decades of growth; the 1660s and 1670s, with the catalyst of a new young King and an administration of exceptional efficacy, were the time of a glorious harvest. There are very few generations even in the history of great nations when every year brings the publication or performance of a masterpiece: to mention only a few, 1664 sees the first performances of Molière's *Tartuffe* and Racine's *Thébaïde*, and the first edition of La Rochefoucauld's *Maximes*; 1665, Molière's *Dom Juan*; 1666, Molière's *Misanthrope*; 1667, Racine's *Andromaque*; 1668, Molière's *L'Avare* and Books I–VI of La Fontaine's *Fables*; 1669, Racine's *Britannicus*; 1670, the posthumous edition of Pascal's *Pensées*, Molière's *Bourgeois gentilhomme*, and Racine's *Bérénice*; 1671 marks the beginning of Madame de Sévigné's famous correspondence with her daughter; 1672, Racine's *Bajazet*; 1673, Molière's *Le Malade imaginaire* and Racine's *Mithridate*; 1674, Racine's *Iphigénie* and Boileau's *Art poétique*; 1677, Racine's *Phèdre*; 1678, Madame de Lafayette's *La Princesse de Clèves*; 1678–79, Books VII–XI of La Fontaine's *Fables*.

Different as these works are in genre and register, they share an exquisite purity and incisiveness in their use of the French language, which becomes the instrument of an unprecedented sophistication in psychological analysis. Collectively, the permanent addition they have made to the European mind has been to articulate the modern idea of the self, or more precisely the awareness of the individual's alienation within a shell of personal interests, illusions and self-deception, which cuts him off from others, from the world and from God. The origin of this way of thinking (the forerunner of existentialism in the 20th century, with its ideas of 'bad faith', etc.) seems to lie in a fusion of two quite distinct currents: the enquiring humanism of Montaigne, and a pessimistic Christian reflection on the corruption of the human heart brought about by the Fall. This pessimism arose from the renewed seriousness of Christian thought in the 17th century, and thus the new sensibility has particular associations with the group which, in France, took the most radical view of the mystery of grace, namely the Jansenists.

The Jansenist movement arose in the early 17th century, taking its name from the Bishop of Ypres, Cornelius Jansen, known as Jansenius, who had defended the strictly Augustinian view that God grants the power to love him and thus to be saved – or grace – as he chooses, and that nothing we can do can compel him to grant it to us. This view was condemned by many in the Church

as dangerously close to the Calvinist doctrine of predestination. The Jesuits, particular enemies of the Jansenists, advanced an opposing view – known from the name of its author as Molinism – according to which God will in fact grant his grace to anyone who asks him sincerely. The Jesuit position was fiercely condemned by the Jansenists, though less by Jansenius himself than by a series of brilliant French polemicists, especially the Abbé de St-Cyran and then Antoine Arnauld, known as 'le Grand Arnauld'. The latter's sister, Mother Angélique Arnauld, had reformed the old Cistercian convent of Port-Royal, and moved it to the Faubourg St-Jacques, where it became the centre of the Jansenist movement, and where the nuns were joined by the 'Gentlemen of Port-Royal', who led a life of spiritual retreat in the grounds. Louis XIV was always extremely hostile to the Jansenists, and at the start of his personal reign attempted to force the nuns to sign a document, known as the formulaire, denouncing the alleged errors of Jansenius. They, of course, denied that the errors were to be found in his writings. Near the end of his reign, Louis finally destroyed the convent in 1710 and dispersed the surviving nuns.

The rigour of Jansenism appealed very strongly to some of the most outstanding minds of mid-17th-century France, and Jansenist sympathies or ideas have been detected in many of the authors mentioned: Pascal, Racine, La Rochefoucauld, Madame de Lafayette – in approximately descending order of direct affiliation. Two of these deal with the problem of the self explicitly. They were already considered a kind of pair by Jean de La Bruyère, writing later in the century, although they were as unlike each other as could be imagined: Blaise Pascal, the mathematician of genius turned Christian apologist, who was frail and ill and died young; and the Duc de La Rochefoucauld, who spent his youth in battles and conspiracies and acts of reckless bravery, and then devoted his retirement to moral reflection. La Rochefoucauld describes his *Maximes* as a 'portrait of man's heart', and sets out to prove that what he calls *amour-propre* – by which he means self-interest or egoism as well as vanity – is the 'corrupter of reason'. La Rochefoucauld's thought is not monolithic, but exists as it were in the form of hundreds of brilliant sparks; we are constantly involved, he believes, in a systematic self-deception which allows us to remain pleased with ourselves even though we are more often than not selfish, cowardly, avaricious, weak and frivolous.

Pascal died two years before the publication of the *Maximes*, leaving the manuscript of his *Pensées* to be published posthumously in 1670. He too sees the human mind as subject to constant

self-deception, influenced by desires, interests, habits and customs to the point that we no longer know what our real nature is: might not what we call nature be nothing but a first custom, he asks, just as we call custom a second nature? Pascal explicitly sets out to demolish the Stoic idea of virtue, which in his eyes grossly overestimates man's moral strength. He extends his enquiry to a critique of the mind's capacity to understand the world at all; what can it really apprehend, perched between the two chasms of the infinitely great and the infinitely small, newly revealed through the telescope and the microscope? The more he considers man's frailty – not so much his physical frailty as the inconstancy and weakness of his mind – the more he concludes that our condition is essentially wretched and unbearable without God; and yet there is a greatness in our capacity to recognize our own wretchedness.

Much more might be said about all of these ideas, but this brief sketch will give some sense of the intellectual environment in which painters were increasingly working. It should be added that the activity of the *précieuses*, women whose cult of refinement in language and manners was satirized by Molière in *Les Précieuses ridicules* (1659) and other comedies, also tended to encourage psychological introspection and the analysis of human passions and motives. It is not surprising therefore that painters tended to become more and more concerned with the psychological level of experience, even though this often entailed losing sight of the action and meaning at the heart of the subject. It cannot be too strongly emphasized that this development of self-consciousness is essentially foreign to Poussin, who is concerned, as we have already seen, with more impersonal and philosophical questions and with perennial scriptural and mythological subjects.

Nor is it surprising to find that some of the best pictures of the time are portraits. The portrait was also, for that matter, a literary genre: La Rochefoucauld, for example, composed a strikingly frank and lucid self-portrait, beginning with his own physical appearance and proceeding to his character. The reader can compare it with an alternative version by his old enemy Paul de Gondi, the Cardinal de Retz, who is in his turn the subject of a portrait by La Rochefoucauld. Such pen-portraits provide us with invaluable evidence of the mentality that lies behind the painted ones: the individual is carefully analysed, from the physical traits which provide clues about his essential nature or temperament, to the innate strengths and weaknesses of his character and the effects of education and experience on his development.

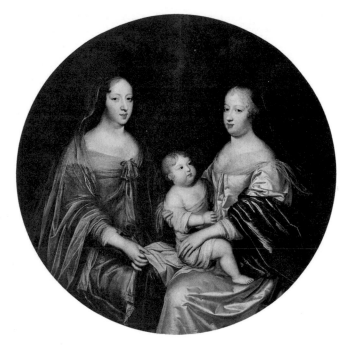

118 **Charles and Henri Beaubrun**, *Anne of Austria, Marie-Thérèse and the Grand Dauphin, c.* 1665. The Queen with her first-born son on her lap and her mother-in-law echo the iconography of the Virgin and Child with St Anne. The close resemblance between the two women is not a coincidence, for Louis XIV's wife Marie-Thérèse (the Spanish princess Maria Teresa) was the niece of the Queen Mother.

But written portraits are not solicited or paid for by their subjects. When a great man commissions his picture from a painter, he does not want to be anatomized in quite this pitiless way. He does of course want his character, like his physical features, to be perceptively delineated and immortalized, but not necessarily the whole of his character. At the same time he realizes, in the intellectual climate of the time, that he will look ridiculous if the painting is seen to be excessively flattering. It is a matter for the greatest tact, and calls for an understanding between artist and sitter. Both are aware of living in a time that is acutely conscious of hypocrisy – which etymologically is acting – when everyone had read books like Cureau de La Chambre's *L'Art de connaître les hommes* (1659; *The Art of knowing Men*), in which the author showed how to discern the real character of individuals under the masks they affect.

In the conventional society portraits of the mid-17th century, and especially in portraits of women, there is no attempt to lift the mask. The emphasis is on ivory-like smoothness in the faces and rich fabrics in the dress (with none of the painterly quality of a Van Dyck, however). The studio of the cousins Charles (1602–92) and Henri (1603–77) Beaubrun, whose collaboration was so close that their styles are indistinguishable, became a

virtual salon where the rich and the beautiful crowded to
have their portraits done. In their portrait of Louis XIV's mother
with his wife and child (c. 1665) [118], the two Queens are as
impassive as the fat little Dauphin. Claude Lefebvre (1632–75)
was one of the leading practitioners of the early decades of
Louis XIV's reign, as can be seen from his impressive, but very
official, portrait of Colbert (1663) [114]. A more personal and
intimate sense of the sitter appears in the work of non-specialists,

like Bourdon, whose *Man with Black Ribbons* (*c.* 1657) [119] combines elegance and melancholy in way that seems characteristic of the age, or Jacques Stella, in his fine *Self-portrait* (*c.* 1650) [120].

The outstanding portrait painter of the mid-century is, as we might expect, Philippe de Champaigne, whose powerful image of Cardinal Richelieu has already been mentioned [79]. From the mid-1640s, Champaigne became closely associated with the Jansenist movement, and his portraits, like no others, evoke the new consciousness of the self. His group portrait of the Lord Mayor and councillors of Paris (1648) [121] is particularly austere, but it well conveys the sobriety that characterized the city in this generation. Many of his sitters were actually Jansenists or supporters of Port-Royal, like Omer Talon (1649) [124]. Robert Arnauld d'Andilly (1667) [122] and Charles Coiffier (long mistaken for 'le Grand Arnauld' himself (1650) [123] are grave and

120 **Jacques Stella**, *Self-portrait*, *c.* 1650. Stella was a close friend of Poussin and a collector of his work, which makes the loss of their correspondence particularly regrettable. This self-portrait is very like Poussin's [33], and was probably painted shortly afterwards. Unlike Poussin's manifesto of the *peintre-philosophe*, however, Stella's image of himself is marked by sadness and the signs of illness.

121 **Philippe de Champaigne**, *The Échevins of the City of Paris*, 1648. In spite of its title, only the four figures on the right are *échevins* (aldermen). The figure kneeling to the left of the Crucifix is the *Prévôt des Marchands*, Jérôme de Féron; behind him are his executive officers. The pedestal supporting the Crucifix bears a relief of St Genevieve, patroness of Paris.

thoughtful patricians: the materiality of the body, never concealed behind the splendour of dress or settings, is the correlative of the weight of the mind and heart, for these people have learnt to be conscious of vanity and self-deception in their own thinking. Their supreme virtues seem to be discretion and sincerity, and a true humility which does not exclude a sense of dignity, for false modesty is also a form of hypocrisy.

One of Champaigne's most moving paintings is of his own daughter Catherine, who had become a nun at Port-Royal, praying with the Mother Superior of the convent after a

122 **Philippe de Champaigne**,
Portrait of Robert Arnauld d'Andilly,
1667. The sitter (1588–1674) was
the brother of Antoine Arnauld,
Mother Angélique and Mother
Agnès; his daughters all became
nuns at Port-Royal. In retreat there
after 1646, he translated Josephus
and Augustine's *Confessions*.

123 **Philippe de Champaigne**,
Portrait of Charles Coiffier, 1650.

124 **Philippe de Champaigne**, *Portrait of Omer Talon*, 1649. Omer Talon (1595–1652) was Advocate-General of the Parlement of Paris, a liberal-minded man and a friend of Port-Royal. He was the author of memoirs in which among other things he judged Mazarin severely. Champaigne combines grandeur and simplicity in this patrician image, while the refinement of the character is suggested in the delicacy of the hands. The statue of Justice glimpsed in the right background alludes both to Talon's profession and to his personal uprightness.

miraculous recovery from illness (1662) [126]. The painting is an *ex-voto*, painted as an act of thanksgiving for the fulfilment of his own prayer for his daughter's life. The quality of faith manifest in this work will not be seen again in the religious painting of the century, nor will its severe plainness. It was also for this daughter that Champaigne painted *The Penitent Magdalene* (1657) [125], a work that speaks both of his daughter's renunciation of the world and of his own sacrifice as a father. Indeed, Champaigne is the last painter of the period whose depiction of the world is intimately shaped by belief. The painters of the last quarter of the century are sometimes brilliant, but their work seems to be largely determined by external factors, such as artistic fashion or the desire to impress. This decline will be visible not only in history painting and in portraiture, but even in the more modest genre of still life.

125 **Philippe de Champaigne**, *The Penitent Magdalene*, 1657. This painting was made as a gift to his daughter (see ill. 126), probably on the occasion of her taking the veil at Port-Royal in 1657. As in La Tour's version of the same subject (ill. 32), the still-life elements are prominent. The skull is once again a reminder of mortality and of the vanity of sensual pleasures, while the jar recalls Mary's anointing of the feet of Christ, in itself an act of penitence, but also interpreted by Jesus himself as preparing for his own death.

126 **Philippe de Champaigne**, *Ex-voto*, 1662. Champaigne's daughter, Sister Catherine de Ste-Suzanne Champaigne, suffered a progressive paralysis from 1660 to 1661, but was miraculously cured after a novena (nine days of prayers). The artist painted her praying with the abbess, Mother Agnès Arnauld (who had just succeeded her sister, Mother Angélique, the reformer of the convent), and depicts the moment on 6 January 1662 when Mother Agnès experienced the revelation that their prayers had been heard: Sister Catherine was healed the following day.

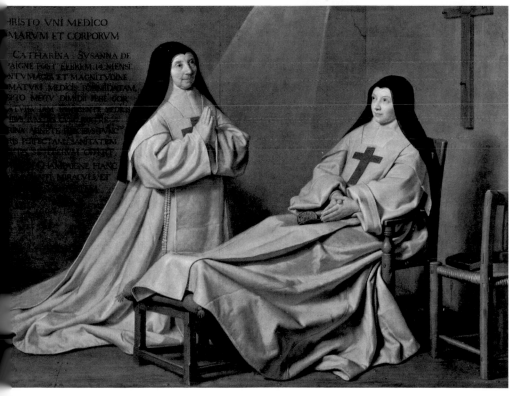

Like the portrait, still life must be understood in relation to contemporary developments in the sense of the world and of the self. Still life is in essence the painting of objects, or of things, of whatever nature, considered as objects. Thus trees and living plants are not still life; but plucked flowers and fruit – severed from their connection with a life outside ourselves – become, like dishes, glasses, loaves of bread, books, pipes and other items, objects of our attention. This way of looking at things can be related to the emerging epistemology of science. But it is also inseparable from the modern sense of the self: for to look at something as an object is at the same time to be aware of oneself as subject – in other words, to experience the thing as a collection of sense-perceptions, of affective responses, of memories and associations. The still life is a mirror of subjective experience; unlike landscape, which invites our imagination to enter into communion with a reality beyond the self, still life excludes the dimension of transcendence.

This is why the masterpieces of Dutch still life in the 17th century so consciously play on our sense-responses: a lemon, a few olives, a salted fish; bread and cheese; fruit and sweet biscuits and wine: in each case the painter, whose natural domain is sight, deliberately evokes smell, taste and touch. Appetite and sensation are awakened, but at a contemplative distance; the viewer can dwell on the vivid reality of the physical world, and yet see it assimilated into a harmonious composition of forms and sober colours.

The finest still lifes are such poetic meditations on the world of the senses. For those who required a more explicit intellectual structure, the elements of the painting could be organized into an evocation of the Five Senses; and for those who demanded a clear moral lesson, a few telling details could turn it into a *memento mori* – a reminder of mortality. In France, the genre was practised around the middle of the century by artists with Northern and mostly Protestant affiliations. Lubin Baugin, already mentioned (p. 99), painted a *Five Senses*, as did Jacques Linard (*c.* 1600–1645) and Sébastien Stoskopff (1597–1657), although the latter was also capable of compositions as simple as the *Basket of Glasses and Pâté* (1635–39) [127]. For other artists, including Philippe de Champaigne himself, the still life was above all the occasion for a *memento mori* [125].

Louise Moillon (1610–96) was not only one of the very rare women painters of the time, but something of a prodigy. As was so often the case with women artists, her father was also

127 **Sébastien Stoskopff,**
Basket of Glasses and Pâté,
1635–39. The artist demonstrates
his painterly virtuosity and at the
same time evokes in the viewer
echoes of the senses of touch, of
taste, and even of hearing. The
washed and empty glasses are
delicate, transparent, fragile and
inorganic in contrast to the pastry
and meat of the pâté, dotted with
its white lardoons. It is a freshly
cut portion, not yet tasted, just as
the glasses have not yet been filled.
Appetite is suggested as potential,
but not satisfied. There is a note
of *vanitas* in the letter used to
wrap the pâté.

a painter, although after his death she was trained by her father-in-law, François Garnier. Typically too, the family was Protestant, and Louise never abandoned her faith, even after Louis XIV revoked the Edict of Nantes in her old age, forcing French Protestants to choose between conversion and exile. The *Still Life with a Basket of Fruit and Asparagus* (1630) [128] was painted when she was only twenty years old. Later she sometimes included figures in her paintings, but her most memorable works are simple and sober reflections on the transformation of objects of appetite into the order of the aesthetic. The same could be said of Lubin Baugin's glass of wine and dish of wafers [129]. Immediacy is balanced by cool detachment. The sensibility, closely related to other aspects of French culture at this time, was to prove altogether too austere for the period that followed, and Moillon does not appear to have painted in the second half of her life.

The grand still life, or *pronkstilleven*, developed in Holland from the middle of the century, and was imitated in France in the second half of the century. Painters such as Jean-Baptiste

128 **Louise Moillon**, *Still Life with a Basket of Fruit and Asparagus*, 1630. Neither an intellectual puzzle nor a moral lesson, this expresses a chastely sensuous delight in the roundness and sweetness of summer fruit contrasted with spiky, savoury asparagus. Drops of dew on the table intensify the sense of freshness.

129 **Lubin Baugin**, *The Dessert of Wafers*, 1630s? The viewer's sensory memory, and the visual equivalents of taste and touch, are evoked in this very simple composition.

130 **Jean-Baptiste Monnoyer**, *Still Life with Flowers, Fruit and Objets d'art*, 1665. Monnoyer's *morceau de réception* at the Academy in 1665 celebrates the parallel abundance of nature and of human art.

Monnoyer (*c.* 1636–99) [130] who spent the last years of his life in London, his son-in-law and pupil Jean-Baptiste Blin de Fontenay (1653–1715), Meiffren Conte (*c.* 1630–1705), and François Desportes (1661–1743) began to make sumptuous decorative compositions, laden with massive urns, draperies and even animals. These pictures are no longer attentive studies of objects and of the sensations or reflections they awaken in the human subject. They are rather conceived as luxury objects in their own right, like any other extravagant piece of furniture. They are examples of the very different artistic sensibility that becomes increasingly prevalent throughout the reign of Louis XIV. The responsibility for this transformation must be laid partly at the feet of Colbert, whose mobilization of the arts around the figure of the Sun King will be subject of the next chapter.

Chapter 5 Versailles

Colbert believed that all departments of French life should be centrally organized and made to work as efficiently as possible for the economic and political growth of the nation. He not only took such initiatives as reorganizing the navy and the manufacturing industries and issuing new regulations for the government of overseas colonies, but equally reformed cultural institutions like the Académie Française. Finding that the latter had declined somewhat into a club for men of letters, he gave the Academicians new quarters and a handsome new clock, raised their fee for attendance, and made it clear, through Charles Perrault, his adjutant in cultural matters, that receipt of this payment would be conditional on punctual attendance and that he expected to see progress made on the long-awaited dictionary of the French language. Colbert founded several other important bodies, including the 'Petite Académie' in 1663, to compose inscriptions for royal buildings and medals (later known as the Académie des Inscriptions et Belles-Lettres) and the Académie des Sciences in 1666, as well as encouraging the new *Journal des Savants*, established in 1665 to record and review contemporary intellectual developments.

Similarly, in granting the Academy of Painting a new constitution at the end of 1663, Colbert had expressly stipulated that theoretical discussions should be held twice a month, with a view to identifying and codifying the true rules of art-making. The Academy was generously supported, and its appreciation is reflected in Nicolas Loir's *Allegory of the Foundation of the Academy* (1666) [131]. The early sessions were desultory, however, apparently consisting in some discussion of Leonardo's *Trattato*, which as we have already seen was published in Paris in 1651. Finally, at the beginning of 1667, when Colbert attended the annual prize ceremony, he proposed a new format for the *conférences*: the professors of the Academy should take it in turns, on the first Saturday of each month, to discuss a work from the royal collection, which would be brought into their

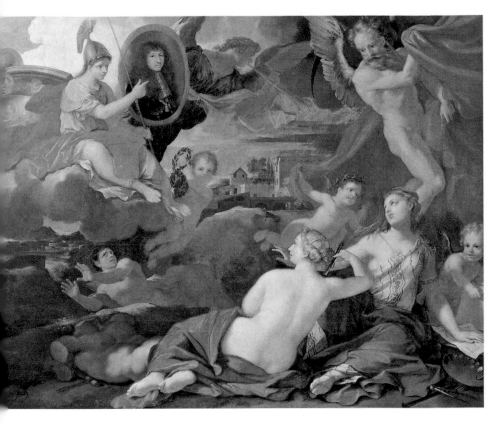

131 **Nicolas Loir**, *Allegory of the Foundation of the Academy* (also called *The Progress of the Arts in the Reign of Louis XIV*), 1666. Painting and Sculpture look up in gratitude and wonder at the portrait of the young Louis XIV, presented by Minerva, attended by Fame, while Time draws back the curtain that had covered the arts from sight and Ignorance flees in the background. This was Loir's *morceau de réception*, and reflects the new and explicit orientation towards the monarch himself.

room for the purpose. The formal lecture was to be followed by a general discussion, in which all should be free to express their views, until the assembly settled on the conclusions that were to be written down in the register as *préceptes*. Monsieur Le Brun, he added, should start on the first Saturday of the following month with Raphael's *St Michael slaying the Dragon*. Colbert's suggestions were orders, and regular theoretical discussion at last began in earnest.

The first year's *conférences* were published in 1669 by Félibien, in a most interesting and valuable book simply titled *L'Académie Royale de Peinture et de Sculpture* (published in English in 1740 as *Seven Conferences held in the King of France's Cabinet of Paintings*) and prefaced by a long essay in which the author, among other things, recalls lessons that he learned from Poussin twenty years earlier in Rome. The lectures themselves are not reproduced *verbatim* but paraphrased, and most of the subsequent discussion is summarized without naming the speakers. Nonetheless they reveal certain tensions between the partisans of line and colour,

the former taking Raphael as their champion and the latter Titian. Much of the trouble was provoked by an unnamed member of the audience, very likely to have been the young critic Roger de Piles, who was to publish his edition of Dufresnoy's *De arte graphica* in 1668, the year following the debates. His interventions, criticizing Raphael or praising Titian, were followed by animated argument and, apparently, by statements from Le Brun bringing the discussion to a close. The Academy was not pleased with Félibien's frank reporting of these debates – and no doubt even less with his comment that the first question stirred the Academicians from their slumbers – and he was not asked to write up the following years, for which we only possess a number of the opening lectures, and occasional accounts of the discussions which ensued.

The academic debates did not result in the distillation of effective and useful rules that Colbert had expected. The Secretary of the Academy, Henry Testelin (1616–95), eventually produced his *Tables de préceptes*, which were presented to the company from 1675 to 1679 before being published collectively in 1680 as *Les Sentimens des plus habiles peintres*, and then in a more ambitious edition with valuable essays and illustrations in 1693 and 1696 [116] (the tables alone were published in Cambridge in 1688 as *The Sentiments of the most Excellent Painters…*). Even a glance at Testelin's crowded diagrams, however, makes it clear that they were virtually unusable, their inadequate conceptual structure collapsing under the weight of detail. In content too, they are mostly a compilation of practical advice, much of it interesting, but with little attempt to resolve or even face the real differences that divided the Academy. The main outcome of the *conférences*, in fact, was the 'Querelle du coloris', the often heated debate between those artists and critics who considered that drawing and linear definition were the foundation of painting, and those who, on the contrary, attached the greatest importance to light, colour and tone, and the combination of colours to produce visual illusion.

The debate was underpinned by a real ambiguity in the Renaissance tradition. To put the matter simply, the original, or Florentine-Roman, branch of the tradition had inherited the early Renaissance concern for the clear definition of volumes in space. In this perspective, drawing or 'line' was clearly the fundamental tool of painting, and the guarantee of truth in art. The later Venetian branch, particularly represented by Titian, took the ability to picture the world as given, and was more concerned

with the unification of the painterly field through the harmony of colour and effects of light and shade, even though this involved sacrifices of objective definition. The first branch of the tradition is clearly objectivist in orientation, the second subjectivist; one is concerned with determining a world outside the subject, the other with evoking an experiential world, attaching particular importance to the unity of the moment of perception.

In the anti-Mannerist synthesis of the late 16th and early 17th centuries, both Raphael and Titian were regarded as essential sources for the style suitable for history painting. Nonetheless, it was clear that 'line' had to remain the basis of any pictorial language that was going to be devoted to narrative ends. 'Painterly' effects must be held in check. This synthesis was subsequently threatened by Baroque artists who, as we have seen, preferred grandiose decorative effect to the economy of narration. For the painters of the French Academy, the discussion soon turned from the Renaissance opposition of Raphael and Titian to the more contemporary dichotomy of Poussin and Rubens.

The division that first appeared in the *conférences* of 1667 was thus effectively between those who valued the integrity of the language of history painting above all else, and those who were less interested in narration than in visual experience. The 'Querelle' itself broke out openly in June 1671, when Philippe de Champaigne was mildly critical of Titian in a *conférence*, but concluded by admonishing young painters, in much stronger terms, against an excessive concern with colour for its own sake. Champaigne cited the example of Poussin, who had been a *coloriste* for a time in his youth before turning to more serious concerns. In November, one of the young painters in question, Gabriel Blanchard (1630–1704), son of Jacques, replied. His lecture, probably written by, or at least with the assistance of, Roger de Piles, presented an essentially scholastic line of reasoning attempting to prove that colour is the distinctive attribute of painting. In January of the following year, 1672, Jean-Baptiste de Champaigne (1631–81), the nephew of Philippe, attacked Blanchard's position, using a different set of scholastic arguments to show that colour was but an accident of painting, and line the substance. His lecture was followed, in the same session, by a considerably more articulate intervention by Le Brun himself, settling the argument in favour of drawing as the indispensable basis of the art of painting, but characteristically acknowledging the importance of colour in bringing a picture

to perfection. For in fact contrary to the view so often presented in both popular and even scholarly writing, Le Brun was not dogmatic or exclusive in matters of theory. He was concerned to maintain his authority in the institution, but his contributions to theoretical debate were generally intended to defuse arguments, and his personal theoretical interests were mainly in the area of expression.

The odd thing about the 'Querelle' is that the theoretical confrontation is not matched by any equivalent opposition in the order of practice. There is no brilliant school of colourists proposing an alternative to the official style of the Academy. Nor is there any actual suppression of those who can be identified as colourists in the debate, principally Blanchard and Charles de La Fosse (1636–1716). Each would be given at least as much work as the younger Champaigne in the decorations of Versailles [132–134]. Even more surprisingly, the official style of the Academy has very little in common with the art of its hero Poussin. The debate is from one point of view essentially futile and only kept going by the efforts of Roger de Piles, who continues to stir up controversy in his publications of 1673, 1677 (the year of the most bitter exchanges) and 1681. From another point of view, however, the 'Querelle du coloris' is both important and interesting, for it marks a deep crisis in the practice of history painting.

It is not simply, as may appear at first sight, that a younger generation of painters feels constrained by the standards of their elders, incapable of the sustained seriousness of Poussin, or tired of the solemnity of the Atticists. The Academicians find themselves in a fundamentally contradictory position, which can be stated in very plain terms: they have inherited a Classical theory of art, based on the example of Raphael and Poussin, and squarely aimed at history painting; while the large-scale commissions they are required to execute virtually compel them to adopt a Baroque style which sets decorative values above narrative economy. All that the *coloristes* are doing is aligning themselves with the reality of their circumstances and accepting that liveliness of effect or dashing painterly animation are their real priorities.

Charles Le Brun, on the other hand, is trying to maintain a balance between these opposing values. There is something particularly poignant in Roger de Piles' constant insistence on Rubens as a counter-example to the model of the Academy, when Le Brun's own style is actually much closer to Rubens than to Poussin. Le Brun seeks to reconcile the grand movement of

the one with the accuracy and discipline of the other, and like most such attempts at compromise, the result is ultimately unsatisfactory. At the same time a deep malaise becomes apparent in the treatment of the subject: many an anecdote recalls the Academicians' pedantic disputes over textual fidelity, but the sense of meaning at the heart of pictorial invention seems to have evaporated. The fact is that the vital underlying basis of belief was attacked from two sides. The progress of Cartesian rationalism and empirical science had severely undermined the possibility of poetic belief in the ancient gods, and had altered the quality of Christian belief itself (effectively, as Pascal complained, making God more remote from what science defined as the real world). At the same time, an increasingly exclusive focus on the glorification of the Sun King meant that no subject existed for itself: an ulterior layer of political reference is common in all ages, but in the France of Louis XIV the demands of official propaganda became so obtrusive that the ostensible subjects of pictures were reduced to insubstantial charades. When the gods themselves are only an allegorical retinue for the monarch (Rubens had set the example) they are not likely to be numinous entities in themselves.

These are the questions that became manifest in the art of Versailles, on which Le Brun and his team began to work around the same time as the debate about colour. Colbert had hoped to make a renovated Louvre the home of the monarchy, and Bernini had been invited to Paris in 1665 to prepare a design for the east façade; in the end his proposals were abandoned in favour of Claude Perrault's grand colonnade (1667–70). But Louis disliked Paris, which reminded him of the humiliations of the Fronde, and was happiest at his father's old hunting lodge at Versailles, the scene of his youthful love affair with Louise de La Vallière. Colbert tried to contain the King's increasingly ambitious plans to extend what became known as the Petit Château. Apart from anything else, it was built on a small hill and any significant enlargement would require raising the ground level all around at enormous expense. But Louis prevailed, and Versailles was transformed in three stages. In the first years of his reign, the architect Le Vau added large service wings in the east, matching what was by then the old-fashioned brick and stone construction of the original building, and made various improvements to the amenities. This stage became known as the Maison de Plaisance – a house of leisure. It was the scene of the extravagant entertainments of the early years of the Sun King, of which the first remained the most memorable: 'Les Plaisirs de l'Ile enchantée' – the Pleasures

132 **Charles de La Fosse**, *Alexander hunting Lions*, north wall of the Salon de Diane, Versailles, *c.* 1672. Alexander's passion for lion-hunting demonstrated his courage, and also symbolized his identification with Hercules, slayer of the Nemean Lion, and his appropriation of the royal lion-hunt from the near-eastern lands he had conquered. The white horse is Bucephalus, so spirited that it could only be tamed by Alexander himself. La Fosse's direct source for the lion-hunt theme is Rubens.

133 **Gabriel Blanchard**, *Diana*, central panel of the ceiling of the Salon de Diane, Versailles, *c.* 1672. Diana is seen against the moon, in a chariot drawn by deer. She is surrounded by the Horae (hours or seasons), some scattering flowers and dew, others apparently symbolizing the hours of work (with a clock) or sleep. The figures in the foreground bear symbols of the hunt (a net) and of navigation (anchor and tiller), activities that pertain to the goddess.

of the Enchanted Isle – in May 1665, in which the King himself performed the role of Roger from Ariosto's *Orlando furioso*, and which included a new play by Molière, music by Lully, astonishing special effects and breathtaking firework displays.

In the second stage, from 1668, the Maison de Plaisance was enclosed on three sides, again by Le Vau, in a more contemporary Classical style, leaving the entrance courtyard in the east – the Cour de Marbre – intact. Whether for sentimental reasons or more probably because they faced the rising sun, the King's personal rooms were to remain in this oldest part of the building. On the western side, they gave onto a great terrace overlooking the gardens: the western façade of the 'Enveloppe', as it was called, was thus articulated by the deep recess of a terrace at the first floor level, between two projecting pavilions. After 1678, at the height of Louis' power and military success, it was determined that Versailles should be the permanent home of the court and of the government. The final phase of enlargement, which continued for most of the remainder of Louis' long reign, involved not only the infilling of the terrace and the addition of two enormous wings on the garden front, but the erection of countless service buildings and several satellite châteaux or retreats in the vicinity of the main palace, notably the Grand Trianon and Marly. The character of Versailles, originally a place where the monarch could escape from the burdens of his duties, had thus gradually but inexorably

134 **Charles de La Fosse**,
Apollo in his Chariot, central panel
of the ceiling of the Salon d'Apollon,
Versailles. Apollo in his chariot is
accompanied by Flora, Ceres,
Bacchus and Saturn representing
the four seasons, an idea borrowed
from Poussin's painting of Phaeton
(Berlin). The figures of France,
Magnanimity and Magnificence,
however, belong to the sensibility
of the new generation.

changed. It became at once a symbol and an instrument of his
power, a theatre of royal pomp and a place where the formerly
troublesome nobility could be kept occupied with futilities and
thus emasculated once and for all.

Le Brun had, initially, three main projects at Versailles:
the Royal Apartments (not the King's personal rooms), the
staircase leading to those Apartments, known as the Escalier
des Ambassadeurs [137, 138], and the ceiling of the Chapel [140].
The Royal Apartments were painted by his assistants from 1671
to 1681 and they achieved, under his direction, an impressive
decorative ensemble. The paintings are confined to the ceilings,
most of which are divided into a central circular or square space
surrounded by four roughly semi-circular spaces. The rooms are
devoted to the seven planetary gods, in a scheme loosely based
on Pietro da Cortona's planetary rooms at the Pitti Palace in the
1640s. Cortona included only five of the planets, which he took
as symbolizing the successive phases of the ruler's adult life.
Le Brun does not follow Cortona's temporal scheme, but takes
all the planets as standing for virtues of the monarch, and follows

the medieval tradition of representing each divinity accompanied by his or her 'children' – celebrated individuals or representatives of occupations that reflect his influence. Thus Mercury (by the younger Champaigne) is accompanied by four history paintings representing princely patronage of the works of the mind, including Alexander the Great in conversation with the Gymnosophists of India and Ptolemy with scholars at the Library of Alexandria. Diana (the moon) presides over scenes of the hunt [132, 133], among other things, and Apollo over works of architecture and *exempla* of passion subdued by reason. This was a ceremonial suite in which Louis held court with an inimitable mixture of grandeur and – especially in his youth – of studied informality.

Le Brun allocated the rooms sometimes to single members of his team, and at other times to a pair or group whose work could be expected to fit together harmoniously. Thus in the Salon de Diane, Blanchard was given the centre of the ceiling [133] – where the subject seems suited to his manner – while two of the lateral scenes are by his fellow-*coloriste* Charles de La Fosse [132], the most explicitly Rubensian of the team (the match is not particularly happy in this case, because of the contrast between the cool colouring of Blanchard and the warm palette of La Fosse). The younger Champaigne had the Salon de Mercure all to himself, and Charles de La Fosse had the whole of the Salon d'Apollon

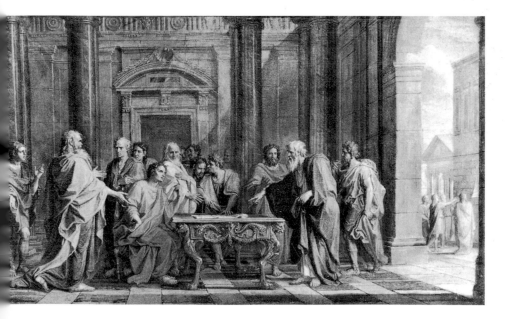

136 **Charles de La Fosse**,
The Rape of Proserpine, enlarged
in 1673. Proserpine, the daughter
of Ceres, is carried off by Pluto,
lord of the underworld; the figures
are a mix of Poussin and Bernini.
For its acceptance at the Academy
the painting was enlarged at the
right and bottom.

[134]. Much of the rest of the work was done by the less distinctive
figures Claude Audran (1639–84) and René-Antoine Houasse
(c. 1645–1710). Some scenes are more successful than others –
La Fosse's Apollo in the chariot of the sun is energetic and luminous
[134] – but while the decorative effect is undeniably impressive, the
iconography is generally wooden. We already know not to expect
the numinous, but when we find Apollo accompanied by allegorical
figures representing France, Magnanimity and Magnificence, we

are in the world of bureaucracy, not poetry. Of course this use of mythological figures is not entirely new; Rubens and the Baroque artists had already reduced the gods to the status of courtiers, accompanying monarchs and celebrating their virtues. If Le Brun goes further in this direction, it is in introducing such allegorical figures into a picture of which the god is ostensibly the main subject. The side paintings also vary in quality, although here Noël Coypel stands out for the Classical sobriety of *Solon defending the Justice of his Laws* in the original Salon de Jupiter [135], and La Fosse for the Rubenesque *brio* of his *Alexander hunting Lions* (*c.* 1672) in the Salon de Diane [132]. It was immediately after this that La Fosse enlarged his earlier and less exuberantly *coloriste* composition of *The Rape of Proserpine* [136] as his presentation piece for full membership of the Academy.

One of Le Brun's most brilliant inventions was the Escalier des Ambassadeurs, the grand staircase that was the official entrance to the Royal Apartments [137]. It was built from 1671, and painted in 1674–79, with ceiling panels glorifying the King, and walls decorated with elaborate *trompe-l'œil* colonnades and balconies on which Le Brun represented visitors from all the nations of the earth admiring the real court below them or the painted ceiling above [138]. The idea was partly inspired by the frescoes of the Sala Regia at the Quirinal Palace in Rome, painted by Agostino Tassi and Carlo Saraceni in 1616. Unfortunately we can only judge this great ensemble on the basis of the surviving drawings, cartoons, engravings, and modern reconstructions of the staircase itself, because Louis XV had it demolished in 1752; but from what we can see, it was an opportunity for Le Brun to display a considerable talent for naturalistic observation.

Le Brun's greatest achievement at Versailles survives, however: it is the ceiling of the Galerie des Glaces, the Hall of Mirrors built when it was decided, in 1678, to fill in the terrace overlooking the gardens in Le Vau's *Enveloppe*. It was clear that the painted decoration of this enormous room would be the biggest set piece at Versailles, and equally clear that its purpose would be to glorify the King. The only question was to find a suitable subject to attain this end. The theme of Apollo (for the Sun King) was rejected, then another plan for a series devoted to Hercules; finally it was decided that the King's achievements, from the beginning of his personal reign to the apogee of his success with the Peace of Nijmegen (1678), should be directly celebrated. Le Brun had to find a formula in which the particular episodes could be unmistakably evoked, and yet treated with discretion

137 Maquette of the Escalier des Ambassadeurs, Versailles, 1671–79. The staircase was designed by Le Brun (for the paintings) and Le Vau (for the architecture), and begun after the latter's death in 1670 by his associate François d'Orbay. The state entrance to the Royal Apartments, it was also used for grand receptions at court and for musical performances.

and grandeur. He adopted a combination of real and allegorical figures that recalls Rubens' series on the life of Marie de Médicis, but with important differences: the paintings are more sober, more economical in their narratives, and deal only with the King's public life and career [139].

The iconographic programme is relatively straightforward: at one end of the Galerie, Germany, Spain and Holland form an alliance in 1672; at the other end, after a series of French victories and conquests, Holland accepts peace in 1678 and breaks off her alliance with the other two powers. Louis' leading part in this story is emphasized by making his decision to govern alone (1661) the centrepiece of the whole ceiling. The dignity and seriousness that Le Brun manages to infuse into these subjects is remarkably successful in preventing us from dwelling on the incongruity of Louis' portrait, in Roman armour and full wig, appearing in scene after scene, accompanied by Hercules with his club, Mars, the Furies and various allegorical figures. If the message of the Galerie

138 After Charles Le Brun, *The Different Nations of Europe*, designed for the Escalier des Ambassadeurs, Versailles, before 1671. One of several scenes depicting visitors from all parts of the world admiring the court and the palace of Versailles. The man looking up at Le Brun's ceiling through his spectacles is a Spaniard.

(1679–84) was not clear enough to foreign visitors, the alternatives that the Sun King offered his neighbours were stated explicitly in the two Salons of War and Peace at either end (1684–86).

The Galerie itself had to be ready when the court returned from autumn in Fontainebleau at the end of 1684. When the King arrived, as planned, on 15 November, he found it brilliantly lit by a thousand candles in seventeen great silver chandeliers and twenty-six smaller crystal ones, with two long Savonnerie carpets covering the whole length of the floor, white damask curtains embroidered with his monogram, solid silver tables, and silver tubs with orange trees between the windows on one side and the mirrors on the other. The Galerie des Glaces displayed Le Brun's mastery not only of painting, but of every aspect of design, and even without the furnishings that have long disappeared, it has come to epitomize Le Brun's style in most people's minds. This has been in a way unfortunate for his reputation, because although as an artist he was limited in depth, he was gifted with enormous

breadth of ability. Had the Escalier des Ambassadeurs survived, it would have given a very different impression of his artistic personality. And had he been allowed to complete his third great project at Versailles, the Baroque strain in French academic art would have become unmistakably apparent.

From the beginning, Le Brun had expected to paint the ceiling of the new Chapel at Versailles, built in 1672. He worked on his

139 **Charles Le Brun**, *modello for The Conquest of the Franche-Comté for the Second Time in 1674* in the Galerie des Glaces, Versailles, c. 1679 (cf. ill. 178). The tripartite division of Charlemagne's Empire in the 9th century eventually left a number of tiny states between France and Germany, which Louis XIV proceeded to annex. The Franche-Comté was first conquered by the Grand Condé in 1668; after being retaken by the Spanish, it was again conquered by the French in 1674.

design for it [140] during the period of the Escalier (1674–79), and the central group of figures was almost immediately engraved by Nicolas Loir (1624–79). For the first time, Le Brun conceived an overtly Baroque composition on a vast scale: instead of the traditional French ceiling divided into compartments, he envisaged an open sky in the Italian manner, loosely based on Cortona's Barberini ceiling, but closely following Rubens in inspiration as in its theme, *The Fall of the Rebel Angels*. This was the subject of a celebrated painting by Rubens that entered the collection of the Duc de Richelieu (the Cardinal's great-nephew) around the time that Le Brun was originally elaborating his plan for the Chapel. Le Brun knew only too well that Rubens was held up as the

140 François Verdier after Charles Le Brun, *The Fall of the Rebel Angels*, for the ceiling of the Royal Chapel at Versailles, *c.* 1679. At one end of this great design God the Father is seen surrounded by angels with censers. The other half shows the rebel angels driven from heaven by St Michael.

supreme model by the *coloriste* party, and he evidently intended to meet the challenge by painting his own version of a work that was considered by some to be Rubens' masterpiece. His determination to emulate Rubens is confirmed by another important work that he carried out between 1679 and 1684: a *Descent from the Cross* [142] derived from Rubens' version of the subject in the Cathedral of Antwerp (1612). But the *coloristes*

were unrelenting: in 1681, when many would have been aware of Le Brun's intentions for the Chapel, Roger de Piles provocatively wrote that the Fall of the Rebel Angels was the most difficult subject a painter could undertake, that the Flemish master had surpassed himself in his treatment of it, and that the work itself was 'inimitable'. Le Brun must have hoped that the great ceiling would finally confound his critics, but he was to be frustrated in this ambition by events beyond his control. First the edifice itself was demolished to make way for a grander one: the present Chapel, designed by Jules Hardouin-Mansart (1646–1708) [176] with his son-in-law Robert de Cotte, was not begun until 1689, shortly before Le Brun's death, and only finished in 1703. Obstacles of a political order, however, would prove almost as intractable and even more painful.

Le Brun, as we have seen, had always been careful to secure his position at the Academy. He knew that every successful artist in his time in France – Racine was another example – was dogged by envious *cabales* who would consistently disparage his work and promote the superiority of some usually feeble rival. Within the Academy itself Le Brun, as Chancellor, had maintained control partly by preventing the Directorship (nominally and later effectively the senior office) from having any real authority. After his success in having Colbert made Vice-Protector in 1661, he was only too pleased to allow his old opponent Ratabon to continue as a powerless Director until the latter's death in 1670. After that, Le Brun managed to keep the post vacant until 1675. In that year, aware that opposition was growing, he had Errard sent back to Rome (after a short return to Paris) on a second posting as Director of the Academy of France there, and contrived to have him appointed at the same time Director of the Academy in Paris, conveniently *in absentia*. At the same time, he invited Colbert (Protector since Séguier's death in 1672) to name his own son, Colbert de Seignelay, as Vice-Protector.

As head of the Academy, Le Brun needed to ensure a favourable succession in the crucial position of Protector, but his precautions were in vain, for when Colbert died in 1683 he was followed by François-Michel Le Tellier, Marquis de Louvois (1641–91), the Minister for War. Louvois, the architect of France's military successes, had been Colbert's rival in his last years and had succeeded him as the first officer of the Crown. Le Brun well knew that Louvois was no friend of his, and preferred his rival Mignard. Faced with this crisis, and knowing how easily the Directorship could be rescued from its almost dead-letter status

and granted to Mignard or some other creature of the new minister, Le Brun took the strategic step of offering the Academy his resignation from all the offices he held. The Academy responded by begging him to stay, and offering him the Directorship as well. After pretending to demur, Le Brun accepted, and thus finally held the positions of Chancellor, Director and Rector as well as retaining the separate rank of First Painter of the King. A letter was sent to Errard in Rome advising him of the new arrangements.

Le Brun's defensive measures did succeed in preserving his authority at the Academy, but they could not prevent Louvois frustrating his real ambitions, in particular the Versailles Chapel ceiling. Le Brun tried to win Louvois's support for a modified version of the project, hoping to paint it in the Chapel of the Collège des Quatre Nations; but all to no avail. The remaining years of his life were dominated by a humiliating contest with Mignard for public esteem and royal favour: another of those gratuitous confrontations which Poussin had experienced early in his career and had chosen thenceforth to avoid.

141 **Pierre Mignard**, *The Virgin with a Bunch of Grapes*, c. 1640–50. Mignard was especially famous for young female figures of this type, which became known as 'Mignardes'. The bunch of grapes has a theological sense, anticipating the wine of the Eucharist; but Mignard would certainly have known of its painterly connotations as well (see ill. 158). Each grape has its own highlight and shadow, and yet the whole bunch forms an object that stands out against neighbouring areas of light and shade. Mignard's friend Dufresnoy had attributed this principle and this motif to Titian.

Pierre Mignard had returned to Paris by 1658 after an absence that corresponded to the whole of the fundamental period of development in French painting. His style was never as well rooted in the local tradition as Le Brun's, and had even less affinity with that of Poussin (who had incidentally not held him in high regard in Rome). His chief strength was in portraits, although these became increasingly mannered, and he was famous for paintings like the *Virgin with a Bunch of Grapes* (c. 1640–50) [141], which were known as 'Mignardes', for his very name meant something like 'sweet'. In general his style was tight and highly finished, more concerned with exquisite polish than with expression. Mignard's most important public commission was the dome of the Val-de-Grâce (1663–66) [143], on which he was probably assisted by Dufresnoy. This work was notable for being the first important example of fresco in France: all the great ceiling decorations of Versailles are in oil paint on canvas. Although Mignard's fresco was considered, especially by his supporters, as a great achievement, French taste was more attuned to the depth of colour and chiaroscuro that can be obtained with oils than to the flatness and lightness of fresco. No doubt for this reason, the dome was surreptitiously enhanced with oil pastels which soon faded, leaving later generations looking in vain for the charms spoken of by contemporaries. Mignard's pre-eminence in this unfamiliar and difficult art was celebrated in a poem by his friend Molière (whose portrait he painted around 1660 [144]), *La Gloire du Val-de-Grâce* (1669), in part intended as a rebuttal of the extravagant claims made for the genius of Le Brun in Charles Perrault's poem *La Peinture* (1668). A reply to Molière was duly composed, in burlesque verse, by Le Brun's pupil Elizabeth-Sophie Chéron (1648–1711).

In later years, protected by powerful aristocratic patrons, Mignard gained many important commissions, but always on the fringes of the world dominated by Le Brun and his associates: his refusal to join the Academy in 1663, although tolerated, had left him outside the institution designated as the instrument of royal artistic policy. From 1677 to 1682, he painted the Galerie d'Apollon and two adjacent salons for Monsieur, the King's brother, at St-Cloud (the château was destroyed in the Franco-Prussian War in 1870). This ensemble was admired by the King himself in 1678, not long before Le Brun began work on the Galerie des Glaces at Versailles. Jean Nocret (1615–72), who produced the *Allegorical Portrait of the Family of Louis XIV* (1670) [145] for Monsieur, had been the latter's First Painter, and there is a rather similar affectation in Mignard's late works, in spite of

142 **Charles Le Brun**, *The Descent from the Cross*, c. 1684. This altarpiece was commissioned by the Maréchal de Villeroy for his family chapel in the convent of Carmelite nuns of Lyons in 1679 (the importance of the female figures in the foreground, particularly the Virgin Mary and the ecstatic Magdalene, reaching out to take Christ's body in her arms, probably reflects this original destination). On completion, however, Louvois took possession of the work, intending it for the Chapel at Versailles.

Le Brun worked on this painting at the same time as the Galerie des Glaces. Like *The Fall of the Rebel Angels* (ill. 140), it clearly shows his debt to Rubens' treatment of the same subject (1612).

his much greater abilities. Around the same time, the King's older cousin and one of the greatest generals of his age, the Prince de Condé (1621–86) – the 'Grand Condé – commissioned a *Perseus and Andromeda* (1679) [146] from Mignard. The work is executed in a very self-conscious style with a highly finished surface (the contemporary term was *léché*, 'licked'). Mignard evidently valued this jewel-like effect, which was apparently also to the taste of a milieu that was, at least in literary matters, highly sophisticated. The Prince's circle included the Duc de La Rochefoucauld (whose portrait was painted by Mignard) and his close friend the novelist Madame de Lafayette. Condé seems to have commissioned a *Venus and Vulcan* (now lost) from Le Brun at the same time. Once again, the tendency to set up contests between artists seems inescapable.

After the death of Colbert, and with Le Brun's position significantly weakened, the rivalry became more overt, and Mignard was able to aim more directly at the favour of the King himself. In 1684 his *Christ carrying the Cross* [147] was given to Louis

144 **Pierre Mignard**, *Portrait of Molière*, c. 1660. Mignard had met the playwright Jean-Baptiste Poquelin, known as Molière (1622–73), in Avignon on his return to France. They remained close friends and Molière later wrote a poem, *La Gloire du Val-de-Grâce* (1669), celebrating Mignard's work and the beauty of fresco (most of the theoretical content of that work is derived from Dufresnoy's *De arte graphica*, published in 1668). This is one of Mignard's freshest and most spontaneous portraits.

by Colbert's son, Seignelay. The enormous contemporary success of this painting is hard to fathom except as the effect – as Guillet de Saint-Georges (see p. 186) says – of a conspiracy to promote Mignard in the King's eyes. In itself, the picture is a pastiche of second-generation Bolognese work, especially Albani and Guido; the attitudes are affected and expression is reduced to a disparate collection of sentimental episodes. Perhaps it was the precious finish that appealed to courtiers wearied by the solid but hardly exquisite painting of Le Brun's Galerie des Glaces [139]; or perhaps Mignard's supporters insisted on the pietistic tone of the work at a time when the King was known to be preparing to resume the persecution of Protestant 'heretics'. Religious hypocrisy became a powerful force in the later years of the Sun King's reign, and there are many stories of piety and zeal affected in order to curry favour with the monarch (thus a number of court ladies made sure they attended Mass whenever the King was present; one day the captain of the royal guard played a trick on them, by suddenly withdrawing his men, implying that the King would not come after all; the ladies all got up and left too, so that the King came in to find the Chapel sadly empty).

The King – faithful to his old friend but still unable to resist setting up a competition – invited Le Brun to make a painting for him on a subject of his choice to silence his critics – 'pour... clore la bouche à ces cabalistes'. Le Brun produced his *Raising of the Cross* (1685, Troyes, Musée des Beaux-Arts) in response to this request, and when he brought the picture to Versailles, the King insisted on interrupting a cabinet meeting to view it, making it clear that a new work by his First Painter was still a cultural event of moment. Three years later, Le Brun painted his own version of *Christ carrying the Cross* (1688) [148], which is more directly comparable to Mignard's: it is less mannered, the composition is stronger and the expressions better co-ordinated, so that there is, for example, a relationship between Christ and his mother. Nonetheless, it is hard to see much more in these works than the undignified if not indecent spectacle of two painters using episodes from the Passion of Christ in a struggle for royal approval. In such circumstances, the expression of the subject literally disintegrates into a search for psychological effects designed to impress the viewer. It is hardly surprising that paintings made in this way have never been highly regarded as examples of religious art. Le Brun's last work, *The Adoration of the Shepherds*, is more touching, precisely because it is less concerned to produce an effect and more concerned with its subject. Le Brun

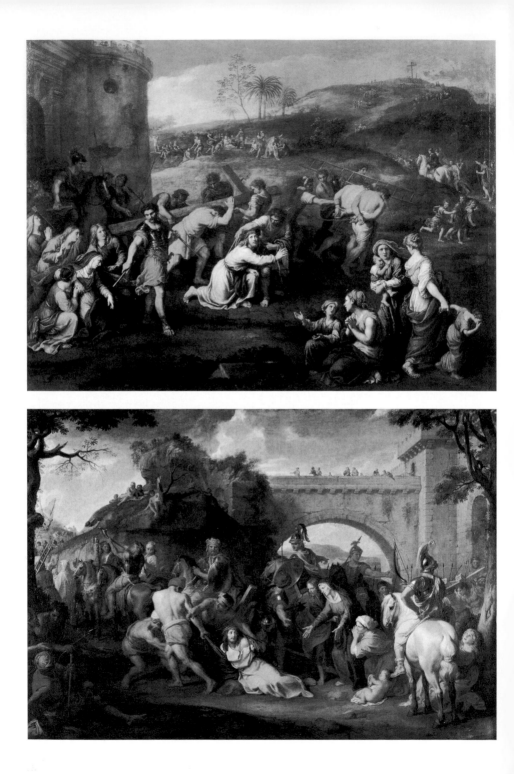

opposite, above
147 Pierre Mignard, *Christ carrying the Cross*, 1684. The figures in this strange painting all seem conceived separately, and the treatment of space and viewpoint is particularly arbitrary.

opposite, below
148 Charles Le Brun, *Christ carrying the Cross*, 1688. Painted as a reply to Mignard's picture (ill. 147), this is not only more coherent but more French. There are reminiscences of Poussin, and naturalistic elements that belong to the national sensibility.

above
149 Charles Le Brun, *The Adoration of the Shepherds*, 1689. This is the version made for Le Brun's wife not long before he died: although not a great religious artist, Le Brun depicts the central figures with simple directness and sincerity.

made two versions of this picture. The one for his wife is a reduced version that concentrates on the central event [149]. The original version for the King (Paris, Louvre) includes a whole outer layer of figures that add little and distract a great deal from the central focus. But the taste of the court was clearly not attuned to simplicity.

Meanwhile, with Louvois' support Mignard had finally succeeded in obtaining work within the palace of Versailles itself. In 1685 he painted the gallery of the Petit Appartement of the King (the personal rooms in the old part of the palace), which Louvois hastened to have engraved [150]. The paintings themselves were destroyed under Louis XV, but the engravings by Gérard Audran (1640–1703) reveal elaborate compositions teeming with mythological figures, including Apollo distributing rewards to the arts and sciences. Shortly afterwards, Mignard painted most of the King's direct legitimate heirs in *The Family of the Grand Dauphin* (1687) [151]. In spite of this success, Mignard remained apparently obsessed with proving that he could surpass Le Brun in every field. In 1689, he went so far as to paint his own version of the famous *Queens of Persia* [152]. It is a peculiar work, in which Le Brun's

150 **Pierre Mignard** (engraved by Gérard Audran), central scene of the ceiling of the Petite Galerie, Versailles, 1685. The central panel shows Minerva crowning a little boy, while Apollo distributes rewards to the arts and sciences, and Neptune with his trident points to figures bringing riches from over the seas. The Horae (cf. ill. 133) scatter flowers in celebration. The child, holding the lilies that are emblematic of the crown of France, no doubt represents the young Duke of Burgundy, the heir presumptive, born in 1682. Mignard's work in the Petite Galerie, destroyed under Louis XV, is only known through engravings.

logical if mechanical sequence of passions [115] is replaced, once again, by a set of conventional attitudes from the Bolognese repertoire. The figures are disconnected, and Alexander and his companion conspicuously lack *gravitas*. But I believe there is a rationale even for these faults. Mignard has tried to outdo Le Brun by relying on the one quality in which he indisputably surpassed him, namely *grace*. It was a commonplace in contemporary art theory that grace was the supreme but ineffable virtue of art, something that – like theological grace – was granted to the fortunate as a gift of heaven, but was not to be achieved by labour and application alone. Perhaps then, just as Le Brun used this subject to demonstrate his superiority to Errard in the crucial field of expression, Mignard wanted to show how the same work could be redone by an artist endowed with the highest of all gifts. But grace is a complement to other virtues, and is most effective where it is most discreet; too much deliberate 'grace' produces

151 **Pierre Mignard**, *The Family of the Grand Dauphin*, 1687. The Grand Dauphin was Louis XIV's eldest son and heir apparent until his death in 1711; Louis' grandson and heir presumptive, the Duke of Burgundy, the boy on the right, died in 1712 (one of his sons lived to be Louis XV); the boy in the foreground is the Duc d'Anjou, later Philip V of Spain.

affectation, which is its antithesis. As the Renaissance writer Baldassare Castiglione observed, true grace is inseparable from *sprezzatura*, a kind of 'carelessness'.

In February 1690, Le Brun died at his residence in the Gobelins. The Academicians suggested respectfully to Louvois that they should proceed, in accordance with the constitution, to elections for the offices left vacant by his disappearance, hinting that these should normally be filled by the most senior of their number. Louvois replied a few weeks later by brutally informing the company that Mignard was to assume all of Le Brun's positions; the Academicians could do nothing but express their unanimous 'joy' at this direction. In a single day, Mignard finally became a member of the Academy and was made Rector, Director and Chancellor.

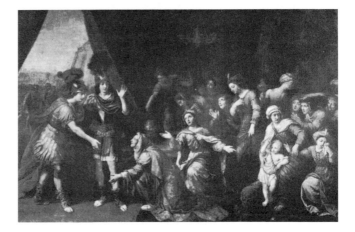

152 **Pierre Mignard**, *The Tent of Darius*, 1689. Le Brun's composition (ill. 115) is closely imitated, but his mechanical demonstration of the passions of the soul is abandoned in favour of the more sentimental and even neurotic sensibility of the *fin-de-siècle*. Hephaestion's attitude of embarassment at being taken for his commander is affected, while Alexander appears more solicitous than in Le Brun, but less magnanimous.

At the age of seventy-nine he had finally outlived his younger rival. He still considered himself capable of the most ambitious projects, and early in 1691 presented Louvois with a design for the dome of the newly completed church of the Invalides. But Mignard too was destined to outlive his all-powerful protector: Louvois died suddenly in July of the same year and the belated First Painter was frustrated in his hopes of accomplishing a final masterpiece.

Among the most important works of Mignard's last years were *Christ and the Woman of Samaria* (1690, Paris, Louvre), an *Ecce Homo* for the school of St-Cyr (1690, Rouen, Musée des Beaux-Arts) and several portraits, including the *Marquise de Seignelay as Thetis* (1691, London, National Gallery), in a style that recalls the *Perseus*. Another was of the founder of St-Cyr, the King's last mistress and morganatic wife [153]. Françoise d'Aubigné, Marquise de Maintenon, had an extraordinary life: the granddaughter of Agrippa d'Aubigné, the friend of Henri IV, she had lived in Martinique for a time as a child, and had been brought up a Protestant for some years. She was married to the poet Paul Scarron at seventeen and widowed at twenty-five; she had become the governess of Louis' children by his penultimate mistress, Madame de Montespan, before succeeding her. Madame de Maintenon had an excellent relationship with the Queen and married Louis secretly after her death in 1683. She founded the convent of St-Cyr in 1686 to provide an education for young ladies of good family but reduced means, as she herself had been. Mignard painted her portrait for the school in 1691, with an appropriate balance of sobriety – the Marquise's head is covered – and grandeur – the ermine lining of the robe is no doubt a royal allusion, since her marriage to the King was an open secret. Her expression is subdued, even sorrowful; she holds a book, no doubt a work of devotion, and the hourglass on the table is a *memento mori*, a reminder of mortality. This is in fact one of the last portraits of the period to be marked by a strong Christian sensibility.

If Mignard's portrait of Madame de Maintenon was a fitting memorial to the autumn of Versailles, his own *Self-portrait* (1690) [154] was at once a monument and an epitaph: a final expression of the rivalry that had consumed the second half of his life. It is a direct reply to the portrait of Le Brun painted by Largillière in 1686 [178] – although one that had to wait until Mignard had finally achieved the coveted honours. In Largillière's painting, the First Painter of the King sits in a grand but relaxed pose in front of a table laden with allusions to his life's work: Mignard's matches

the original point-for-point, except that his own attitude is more erect and brittle. There is one touching detail in this testament of enduring resentment, and that is the bust of the artist's daughter Catherine, on the lower left.

Catherine later gave this portrait to the Academy, but it is unlikely that the Academicians regarded it with much affection. They had not appreciated the imposition of their old enemy, and Mignard was frequently absent from their meetings. In 1695, when he died, the fact was recorded in the minutes in the driest and briefest of terms, following a reading of the accounts. Mignard had helped make Le Brun's last years miserable, but his own end – alienated from the affection and regard of his peers – was in its way equally distressing. The two First Painters of Louis XIV finished their careers in a petty and futile rivalry, while the court drifted around the magnificent gardens of Versailles and the régime of Louis XIV lost its way in religious bigotry and ruinous wars.

153 **Pierre Mignard**, *Portrait of Françoise d'Aubigné, Marquise de Maintenon*, 1691. The ladies of St-Cyr pressed their founder, Madame de Maintenon (1635–1719), to have her portrait painted by Mignard, who depicted her as S. Francesca Romana – a suitable choice, because the saint was a married woman who established a religious community of women in early 15th-century Rome. The hour-glass on the table is a *memento mori*.

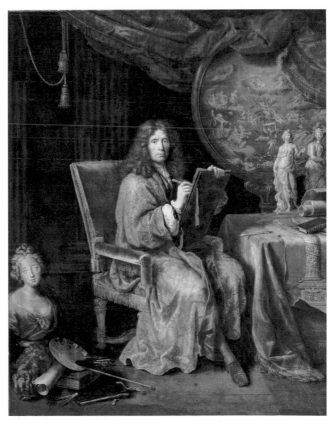

right
154 **Pierre Mignard**, *Self-portrait*, 1690. Following Largillière's portrait of Le Brun (ill. 178), Mignard has depicted himself in opulent surroundings, with reminders of some of his principal achievements: a miniature *ricordo* of the Val-de-Grâce dome painting (ill. 143) is visible in the background, as well as a design for a monumental column for the Place Royale (now Place des Vosges).

Chapter 6 The End of the *Grand Siècle*

When Mignard died in 1695, no replacement was appointed as First Painter of the King, and indeed the post remained vacant for twenty years; only under the Regency was Antoine Coypel finally named as the successor to the giants of the previous century. By the 1690s, the *Siècle de Louis-le-Grand*, in the title of Charles Perrault's celebratory and polemical volume (1687), was long past the glorious season of the 1660s and 1670s. The end of the 1680s and the early 1690s saw a few last fruits: La Bruyère's *Caractères* in 1688 is a fine work, but without the steely edge of La Rochefoucauld. There was also Racine's late return to theatre after a long silence with two plays, *Esther* (1689) and *Athalie* (1691), written to be performed by the girls of the convent of St-Cyr. In 1694 the *Dictionnaire* of the Académie Française was finally published, and the same year brought the last volume of La Fontaine's *Fables*. Apart from that, the end of the century was occupied by another pointless controversy, the 'Querelle des anciens et des modernes' – the Quarrel of the Ancients and Moderns – in which Perrault, among others, tried to argue that contemporary French writers had surpassed the authors of Antiquity. At the Academy, the *conférences* had gradually petered out. In 1682 the energetic Guillet de Saint-Georges (1624/25–1705) was appointed *historiographe*, and began to hold re-readings of the great debates of earlier years. From 1689 to 1693 he composed and read to the company a series of biographies of past Academicians. The tone was decidedly retrospective.

Meanwhile Louis grew ever more aggressive in foreign policy and at the same time, after Colbert's death in 1683 deprived him of better counsel, resolved that he could no longer tolerate heresy within his kingdom. Louvois was an enthusiastic partisan of this decision. The King had already in 1681 forbidden Protestants to hold government office, which had led to the departure from the Academy of its Secretary Henry Testelin, who chose to emigrate rather than renounce his beliefs. In 1685,

155 **Hyacinthe Rigaud**,
Portrait of Louis XIV, 1701. Louis (1638–1715), shown here in the splendour of his coronation robes, must have wanted a very impressive effigy of himself for his grandson, Philip V of Spain, to act as a reminder of the great power that stood behind the new King. At the same time, a sculpted relief of the figure of Justice on the pedestal of the column (cf. ill. 124) reminds the viewer of the legitimacy of Louis' claims.

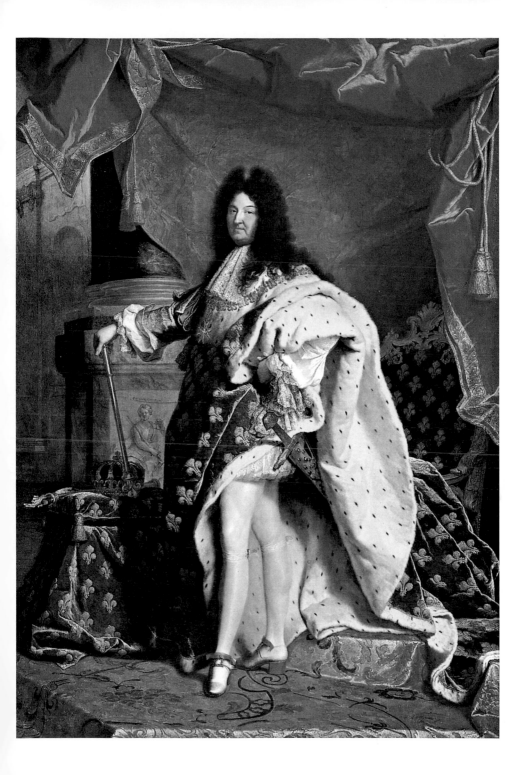

Louis revoked the Edict of Nantes, by which, as we saw, Henri IV had in 1598 guaranteed the freedom of the Huguenots. This momentous decision not only drove many thousands of skilled workers to emigrate from France, but also convinced the non-Catholic powers that the Catholics could never be trusted to accept religious freedom. Because of the Catholic sympathies of the Stuarts, the Revocation precipitated the fall of James II in England in the Glorious Revolution of 1688 and – a disastrous outcome for Louis – the accession to the British throne of James's son-in-law and Louis' arch-enemy since the 1670s, Prince William of Orange, Stadtholder of Holland, who reigned as William III of England conjointly with James's daughter Mary.

With the Protestant powers now ranged against him and undiminished ambitions – ultimately in regard to the throne of Spain, to which he had a claim through his marriage to the Infanta Maria Teresa (Marie-Thérèse) – Louis led France into a series of wars that nearly destroyed his kingdom. The War of the Grand Alliance (also known as the War of the League of Augsburg) lasted from 1689 until the exhausted belligerents made peace in 1697. When the epileptic Charles II of Spain died without an heir in 1700, and left the crown in his will to Louis' grandson, the Duc d'Anjou, the War of the Spanish Succession (1702–13) broke out, with William III's place at the head of the allies now taken by the Duke of Marlborough, together with Prince Eugene of Savoy and the Dutch Grand Pensionary Heinsius. France was brought to the very edge of ruin by 1709, when a series of military defeats was compounded by the 'great winter' in which most of the grain crops as well as fruit trees, birds and livestock were destroyed; this was followed by a terrible famine in 1710. Louis was forced to sue for peace, and was even prepared to renounce the throne of Spain. The allies – Heinsius in particular – made the fatal mistake of demanding not only that Louis cease to support his grandson as King of Spain, but that he actually overthrow him. The Sun King – famously saying that if he must fight, he would rather fight his enemies than his children – resorted to the unprecedented measure of appealing to the people of France to support him in a moment of national emergency. At this point Louis's fortune turned: Marlborough was recalled, and then the English withdrew from the war altogether, because dynastic events in Austria had made the Habsburg candidate for the Spanish crown as undesirable as the French. In the battle of Denain (1712), the old Maréchal de

Villars won a psychological victory over Prince Eugene, and the allies were compelled to negotiate more reasonable terms. The economic cost of these wars, however, was crippling; the solid silver furniture of the Royal Apartments had to be melted down for coin in 1689, and teaching at the Academy would have been suspended in 1694 if the members had not offered to supervise the life-class without remuneration.

Many of France's difficulties in the last decades of the century must be attributed to the isolation of the King at Versailles and to the unreal world of flatterers and hypocrites that evolved around his person. The deepest purpose of Versailles was not to entertain a monarch addicted to vanity or pleasure – Louis was hard-working and in many respects sagacious – but, as already noted, to manage a formerly unruly nobility by turning them into courtiers fully occupied with entertainments and trivial distinctions of rank and royal favour. Great *seigneurs* spent their time vying for the attention of the King, instead of engaging in conspiracies and rebellions, or living far away in the provinces and imagining that they were almost sovereign rulers of their ancestral lands. The courtier at Versailles – so different from Castiglione's humanist *cortegiano* – lived to please the monarch. The system was effective in achieving its ends, but it led in turn to another order of problems, an introverted culture which also naturally impinged on the integrity of the art of painting, and particularly on what remained in principle its highest genre.

The royal monopoly on meaning weighed heavily on the painters of the Academy; coincidentally, they were affected by another development also cited in the previous chapter: the inexorable advance first of rationalist philosophy and then of empirical science. A third factor now contributed to the erosion of belief in the traditional subject-matter of history painting. The Quarrel of the Ancients and Moderns and its sequel, the Quarrel of Homer (1714–15), were symptoms of a profound change in the attitude to the Antique. The passionate curiosity about all aspects of ancient civilization that had been common in Rome in Poussin's and Claude's time was a world away from the barely suppressed resentment of so many in late 17th-century Paris. For the Italians, from Dante to the 20th century, Antiquity has always been a reminder of past glory, while for the French it became a rival to be bettered, and even later French Neo-classicism is more concerned with either political ideology or eroticism than with a deep interest in the Antique

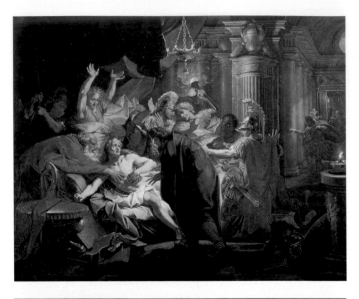

156 **Jean-Baptiste Corneille**, *The Death of Cato of Utica*, 1687. After the victory of Caesar at Thapsus (46 BC), Cato, unable to endure living under tyranny, committed suicide at Utica near Carthage. He disembowelled himself at daybreak, after re-reading Plato's *Phaedo*. The artist was the son of Michel Corneille the Elder (see ill. 97) and the younger brother of Michel Corneille II.

157 **Louis Boullogne the Younger**, *The Centurion at the Feet of Christ*, 1685. The subject of this huge *May* is from Matthew 8: 5–13. A centurion begs Christ to heal his servant; Jesus should not come to his house, he protests, because he is not worthy: he need only 'speak the word'. Christ says he has not found such faith among the Jews, and declares that the servant is cured.

(with the result that the Germans, in their turn, would later find in the same Antiquity a powerful ally in their resistance to French hegemony). One cannot, therefore, expect to encounter in the Paris of 1700 anything like the same urgent, attentive and yet personal response to the Antique that had animated artists and artlovers alike earlier in the century, and especially in Rome.

At the same time, convention obliged academic painters to draw their inspiration from Antiquity. The result – to vary the simile one last time – was like a troupe of actors performing a play whose meaning they do not understand. Unable to find any sense in the whole, they overact each episode and each part in an incoherent manner. This tendency is aggravated by Le Brun's reduction of expression to a repertoire of 'passions', each of which is in turn defined mechanistically as a combination of grimaces [116]. The disastrous consequences of this system can be seen in Jean-Baptiste Corneille (1649–95), only one of several minor painters of the time for whom expression comes to mean the unleashing of histrionics that we find in his *Death of Cato of Utica* (1687) [156]. If the expressions are less violent in Louis Boullogne the Younger's *May* of 1685, *The Centurion at the Feet of Christ* [157], they are no more convincing. The pictorial language is a sweetened, mannered version of Le Brun's idiom, all the figures looking vaguely absent, going through the motions of their parts with more attention to elegance than to significance. The blandness of Boullogne's picture may explain the paroxysms of Corneille's: authenticity of expression is sought in intensity rather than in lucidity.

But there were also artists for whom the ends of history painting, the emphasis on invention and the expression of the

158 **Nicolas de Largillière**, *Two Bunches of Grapes*, 1677. Although these grapes may have been painted partly as an exercise, they could not fail to recall the saying attributed to Titian that the bunch of grapes demonstrated how the painter was to make a single object out of a collection or group of small objects (cf. ill. 141).

subject, were no longer really important. The most significant example is Charles de La Fosse (above, p. 160), the contemporary and friend of the *coloriste* critic and controversialist Roger de Piles. The latter had consistently argued that composition was the most important part of painting, but he did not mean composition conceived as the articulation of the subject so much as a visual unity of masses, colour, light and shade. This effect of the *tout-ensemble* was something that appealed directly to the eye – to the corporeal eye, and not to what Fréart de Chambray had called in Platonic fashion *l'œil de l'esprit*, the eye of the mind. Roger de Piles had held up Rubens as an example of the way colour is used to achieve visual unity, and had criticized Raphael's work for lacking the same immediate and unmistakable appeal. He liked to quote a saying attributed to Titian (for his conception of art is ultimately Venetian): that the bunch of grapes shows us how the painter is to make a single, composite object out of a group of small objects. (Nicolas de Largillière could hardly have painted his *Two Bunches of Grapes* (1677) [158] without this in mind.) After a lifetime in opposition to the Academy, Roger de Piles ended up, rather surprisingly, as its official theoretician: for in 1699, the architect Jules Hardouin-Mansart became Surintendant des Bâtiments and Protector of the Academy and proceeded to appoint his friends Charles de La Fosse and Roger de Piles respectively Director and *Conseiller amateur* – effectively an honorary position for a theoretician who was not a practitioner.

Roger de Piles had been distracted from artistic controversies, for a time, by his career as a diplomat and later as a secret agent. He was caught by the Dutch in 1692 and held captive for five years until 1697, when he returned to France and received a royal pension. While in Holland, apart from passing the time in raising birds and teaching them tricks, he had acquired a greater understanding of Dutch art and became one of the first Frenchmen to appreciate Rembrandt. He had also gathered material for his collection of artists' biographies, the *Abrégé de la vie des peintres* (1699) – published in English in 1706 as *The Art of Painting and the Lives of the Painters* – and developed more ecumenical views on art theory in general. Roger de Piles inevitably owed much to Félibien's longer and more substantial biographical work, the *Entretiens sur les vies et sur les ouvrages des plus excellens peintres...* (*Conversations on the Lives and Works of the Most Excellent Painters...*), which had come out in five volumes from 1666 to 1688.

After his appointment to the Academy, Roger de Piles gave a series of lectures which appeared in the year before his death

as the *Cours de peinture par principes* (1708) – published in English
in 1743 as *The Principles of Painting* – in which he endeavoured
to reconcile his own interest in relative naturalism and the
optical appeal of pictures with the orthodox principles of the
Academy. The work ends with the notorious *Balance des peintres*,
in which the most prominent artists of the canon are 'weighed'
and given marks out of 20 for Composition, Drawing, Colour
and Expression. Sometimes rather unfairly cited as epitomizing
the dogmatic tendencies of the Academy, the *Balance* is really
an attempt (admittedly with a touch of provocation in the detail)
to achieve consensus between the partisans of line and those
of colour. Thus when we add up their different scores, we
find that Raphael and Rubens come equal first with 65 out of
a possible total of 80. The Carracci and Domenichino are given
58, Le Brun 56, Van Dyck 55, Poussin and Correggio 53, Titian
51 and Rembrandt 50.

The *coloriste* sympathies of Charles de La Fosse had not
prevented him taking an important part in the decoration of the
Royal Apartments under Le Brun's direction (1671–81) [132, 134].
His most successful contribution was the ceiling of Apollo in his
chariot, and this led to further commissions of a similarly Baroque
nature towards the end of his life. Thus in 1702 he painted the
dome of Hardouin-Mansart's church of the Invalides in fresco [159],

and in 1708 the apse of the new Royal Chapel at Versailles in oils [164] (once again the death of a protector, this time Hardouin-Mansart, deprived him of the commission for the whole ceiling). As large-scale decorations, they are competent and effective, although the conception is largely drawn from earlier formulations of the Baroque ceiling. Typically, the figures are all gathered around the edges of the space, while the heavenly infinity into which angels and saints soar in the Roman ceilings of Gaulli or Pozzo becomes, in La Fosse's hands, a glowing cloudy background. Thus the French solution seeks to evoke grandeur while avoiding excesses of ecstasy; but this measured approach to effect does not carry great conviction. Nor should we be surprised at the absence of any deep religious inspiration in these first years of the new century. The architecture of the Chapel itself – in the white stone known as *banc royal*, used in preference to the heavy coloured marble of the earlier interiors (interestingly, this was Louis' own choice) – looks forward to the lighter style of the following reign. And the most important intellectual figures of this generation, like Pierre Bayle, already belong to the century of the Enlightenment. His *Dictionnaire historique et critique* (1695–97) was one of its first books. For Bayle (a Protestant intellectual living in Rotterdam as a refugee from religious intolerance), as increasingly for thinking people in France, the great question was religious and intellectual freedom; and this duly led to thoughts of political freedom. Piety, spirituality and indeed imagination were sacrificed to more urgent priorities.

La Fosse's easel paintings are not much more memorable than his monumental decorations. Perhaps the most poetic is *Clytie changed into a Sunflower* (c. 1688) [160], part of a mythological series ordered for the Grand Trianon. *Bacchus and Ariadne* (1699) [161], on the other hand, shows the extent to which the artificial language of history painting, formerly anchored in the observation of nature, has become stale and mannered. The bodies have grown elongated and nerveless, with pretty, insipid faces; gestures and attitudes have been reduced to a collection of standard poses – the very affectations that the *philosophe* and critic Denis Diderot (1713–84) would later ridicule as the tricks of the dancing-master. Bodies no longer stand upright, and the ground on which they are set is sloped down to the front of the picture like the raked stages of the time, with the result that the figures seem to be standing on tip-toe. This is the origin of the mincing gait so common in paintings of this generation.

Sir Joshua Reynolds, addressing the Royal Academy in London more than half a century later, saw that this was not merely a fault

160 Charles de La Fosse,
Clytie changed into a Sunflower,
c. 1688. Clytie fell in love with
Apollo and sat all day watching
his course through the heavens,
until she was finally changed into
a sunflower (*Metamorphoses* 4:
256–270). This was part of a
commission of 1688 for twenty-
seven Ovidian subjects by different
artists for the Grand Trianon.

161 Charles de La Fosse,
Bacchus and Ariadne, 1699. Bacchus
encounters the abandoned Ariadne
on the island of Naxos and appears
to be introducing himself to her,
while she apologizes for the
yapping of her little dog. The
constellation Libra is in the sky
because September is the month
of the grape harvest, and Bacchus
is the god of wine. The painting
stood for Autumn in a series of
the four seasons for the Salon
de Musique at Marly.

of style, but a fundamental error of decorum: 'The neglect of separating modern fashions from the habits of nature, leads to that ridiculous style which has been practised by some painters, who have given to Grecian Heroes the airs and graces practised in the court of Lewis the Fourteenth; an absurdity almost as great as it would have been to have dressed them after the fashion of that court.' That painters were insensitive this failure of judgment is evidence of their alienation within a decaying tradition.

All of these faults are even more conspicuous in La Fosse's younger contemporary Antoine Coypel (1661–1722), the son of Noël Coypel. His *Rebecca at the Well* of 1701 [162] reworks one of Poussin's most celebrated compositions [47] – one particularly cited as an example of 'general expression' – and thus invites a comparison to which it is hardly equal. In place of the silent and solemn encounter that occupies the centre of Poussin's version, Coypel has imagined an awkwardly over-emphatic Eliezer and a simpering Rebecca. He makes us see that the great strength of Poussin is precisely in the parity he evokes between the man and the woman: the servant who is more than a servant, and the young woman who is more than a girl; two individuals who are elevated to dignity through the great event in which they are participants.

In recent years, labels in French museums and articles in exhibition catalogues would have the visitor believe that paintings like *Rebecca at the Well* were the heralds of a new sensibility. If so, we can hardly resist the conclusion that it is a less intelligent and a coarser sensibility, in which moral significance recedes in favour of the merely psychological; and in which the psychological itself is reduced, as we have seen, to a rather obvious level. The sentimentality of Coypel's blushing Rebecca is another characteristic of the new 'petit goût' – the 'little style' considered as an alternative to the 'great style' of Le Brun and his generation. Sentimentality can be cloying; it can also mask a kind of prurience, as in the later pictures of young girls who have gone astray by Jean-Baptiste Greuze (1725–1805), on whose shame and confusion the artist dwells a little too intrusively.

Antoine Coypel also applied himself to works on the largest scale. As far as one can judge from the surviving oil sketch [163], the ceiling he painted for the Duc d'Orléans, in the Galerie d'Enée at the Palais Royal (1703–5), must have been one of his most successful works. A few years earlier, Coypel had gained the commission – long desired by Le Brun – for the ceiling of the

162 **Antoine Coypel**, *Rebecca at the Well*, 1701. This painting was intended as a new interpretation of a great Poussinian subject, as was La Fosse's *Finding of Moses* (Louvre). The superficiality of the two pictures is less surprising when it is realized that they were commissioned for the Billiard Room at Versailles.

Chapel at Versailles [164]. The building's design, in the event, prohibited a large unified painting of the kind Le Brun had envisaged [140], and Coypel's main subject is very small in relation to the area of the ceiling. He had to work with other constraints too, for in a sense the layout of the Chapel illustrated in the most concrete fashion the absolute focus of all meaning on the monarch: while the royal tribune was naturally at the opposite end of the Chapel from the altar, so that the King faced

the Divinity, the rest of the congregation actually sat with their backs to the altar, facing the tribune. Not even God the Father could turn his back on the King, so instead of making him face La Fosse's Risen Christ in the apse, as might have been reasonable, Coypel has him apparently leaping through the heavens as though about to land in the royal box.

One painter stands out as a striking exception to the vogue of the 'petit goût', and that is Jean Jouvenet (1644–1717). He was born in Rouen, and worked with Le Brun in Paris from 1661. After Le Brun's death he concentrated on religious subjects, often executed on a very large scale, like his *Descent from the Cross* (1697) [165], inspired both by Rubens' painting of the same subject and by Le Brun's version (c. 1684) [142]. Jouvenet's most impressive works are four colossal paintings executed for the Priory of St-Martin-des-Champs in Paris (1697–1706): *The Miraculous Draught of Fishes* [166], *The Feast at the House of Simon* (Lyons, Musée des Beaux-Arts), *The Resurrection of Lazarus* (Paris, Louvre) and *Jesus driving the Moneychangers from the Temple* (also

166 **Jean Jouvenet**, *The Miraculous Draught of Fishes*, 1706. This striking and grand composition revitalizes the inherited idiom in the naturalism of the details of the setting and in the representation of movement and physical effort (the fisherman pulling on the rope at the right seems almost literally to be drawing the composition together).

opposite

165 **Jean Jouvenet**, *The Descent from the Cross*, 1697. Jouvenet looks for a new way of expressing the weight of Christ's body and the physical effort of taking it down from the cross, and comes up with the rather awkward solution of having it bent backwards over the figure of the man on the ladder (the equivalent figure in Le Brun's version, ill. 142, had only supported the legs). The prominence of the shroud in the foreground suggests that he is also thinking of Le Sueur (ill. 98), although his temperament is entirely different.

Lyons, Musée des Beaux-Arts). When they were shown to the King he was so pleased with them that he ordered copies to be made to serve as tapestry cartoons for the Gobelins. Jouvenet is not subtle, and the gestures are often too grandiloquent in the end, but these pictures were meant to be seen, as it has been recently pointed out, not in the bright light of a modern museum, but in church interiors, where the gloom would have mitigated their vehemence.

The difficulties we have identified in the French practice of history painting, and its subsequent decadence, were still not sufficient to redirect the energies of artists towards landscape as an alternative form of expression. The distinctive French contribution to landscape in this period is rather in the grand garden designs which reconstruct the environment surrounding the palaces of the time. Landscape-as-installation, the wilful and ingenious reshaping of nature, left little room for landscape as a painterly contemplation of the inherent life of nature. The great artist was André Le Nôtre (1613–1700), whose first masterpiece was the garden at Vaux-le-Vicomte, complementing the château built by Le Vau and decorated inside by Le Brun. Le Nôtre's most important work was of course the gardens at Versailles, whose real beauty is in the sense of expansiveness, of ease and serenity

167 **Gaspard Dughet**, *Storm: Elijah and the Angel*, late 1650s–early 1660s.
In both its style and its subject this picture is characteristic of Gaspard's love
of romantic and even sublime effects: the angel exhorts Elijah to 'go forth, and
stand upon the mount before the Lord. And behold, the Lord passed by, and a
great and strong wind rent the mountains and broke in pieces the rocks before
the Lord' (I Kings 19).

168 **Gaspard Dughet**, *Landscape with St Jerome*, 1639–40. Gaspard depicts Jerome in a wild natural setting, where craggy rocks block the eye's access to the left side of the picture, while the saint subsists, with his lion, on a narrow bank above a torrent. The old and dessicated but still living tree in the centre is a metaphor for the body of Jerome himself, worn by the ascetic life of a hermit.

induced in the visitor by vast bodies of water and long uninterrupted vistas. It is as though the purpose of these gardens were to evoke an inner world of space within the closed and isolated environment of the court.

While Le Nôtre was thus fashioning the lucid spaces of the Classical garden, his exact contemporary Gaspard Dughet (1613–75) – who never set foot in France – was turning away from the rational views of his master Poussin towards wilder and more sublime scenes [167, 168]. He did not go as far as Salvator Rosa (1615–73) in this direction, but replaced open prospects and glassy bodies of water with rugged scenery through which a path can be picked only with difficulty, while the ground often falls away in the distance and space extends indefinitely in various directions instead of being limited and defined by buildings or hills in Poussin's manner.

Several other painters, later in the century, also followed in Poussin's footsteps in varying degrees, but their careers and oeuvres remain poorly defined. The most original of them seems to have been Jean-François or Francisque Millet (1642–79), who was born in Flanders of a French father and Flemish mother, was admitted to the Academy in 1673, and died prematurely, at the zenith of the *grand siècle*. Of the few paintings that can be attributed to him, most show the influence of Poussin's later

169 **Francisque Millet**, *Classical Landscape*. Poetically Antique figures are set in a landscape that appears congenial, yet is dominated by a disturbing antinomy: on one side a severely classical building, and on the other a smoking volcano.

170 **Adam Frans van der Meulen**, *The Taking of Maastricht*, 1673. This celebrates one of the French victories during the war with Holland launched in 1672.

171 **Joseph Parrocel**, *The Passage of the Rhine*, 1699. Like so much of the late art of Louis XIV, this has a retrospective flavour, for the event took place in 1672, in happier times for the Sun King. The painting was made during the brief interval between the Wars of the Grand Alliance and of the Spanish Succession.

landscapes (he had made many copies of Poussin for the collector Everhard Jabach), like the *Classical Landscape* in Marseille [169] or the *Landscape with Mercury and Battus* (New York, Metropolitan Museum of Art). Others seem to be drawn from observations of particular places, like the London *Mountain Landscape with Lightning* [172], with its combination of Flemish naturalism and the sublime motifs of Alpine scenery and a bolt of lightning.

In spite of a few such individual achievements, landscape painting was still largely subordinated to decorative or documentary ends. Thus François Desportes, already mentioned as a painter of overladen still lifes (p. 154), also executed a series of *plein-air* oil studies of natural motifs between 1690 and 1700. These works are fresh and spontaneous (painting outdoors with oils did not become common until the 19th century), but were intended as no more than backgrounds for portraits of the royal hounds. Adam Frans van der Meulen (1632–90) travelled with the army and made careful landscape studies in preparation for his painted records of Louis' campaigns, such as *The Taking of Maastricht* (1673) [170]. The *provençal* Joseph Parrocel (1646–1704) too used landscape as the setting for pictures of battles [171],

172 **Francisque Millet**, *Mountain Landscape with Lightning*, c. 1675. Francisque's interest in the violent power of nature is confirmed in this study of an electric storm in an alpine setting. He would also have known, like Poussin, that to paint lightning was to demonstrate both virtuosity and classical erudition: Pliny had said that Apelles painted things that could not be represented in pictures, like lightning.

173 **Joseph Parrocel**, *St John the Baptist preaching*, 1693. This painting was the *May* of 1694. Parrocel came from one of the longest dynasties of painters in French history, active from the 16th to the 18th centuries. He was taught by his father and then his brother before living and working in Paris, then Rome and Venice. The influence of Venetian art is visible in his evident fondness for painterly effects of light and colour.

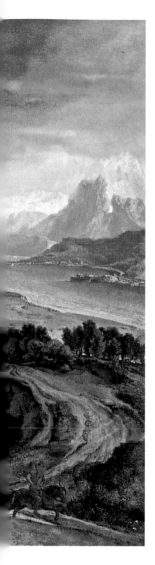

but also painted one of the last striking *Mays* – that of 1694,
St John the Baptist preaching [173].

It is not surprising to find that the portraits at the end of
the century are once again more interesting than the history
paintings of the same period. We have already argued that
the great originality of French 17th-century culture, for better
and for worse, lay in its psychological acuity, and that its
permanent heritage has been a certain understanding of the
self. The last literature of the period is overwhelmingly devoted
to portraits – La Bruyère's *Caractères* to the character types

of his time, and the Duc de Saint-Simon, in *Mémoires* that are considerably longer than Marcel Proust's *The Remembrance of Things Past*, to a catalogue of the actual individuals who populated the court of Louis XIV (the *Mémoires* were carefully prepared and drafted during the 1740s, but not fully published until 1829–30).

As we would expect, the portrait painters in the last decades of the 17th century and the first decades of the 18th embody a sophisticated awareness of the self and its manifestations. The artists and sitters of the end of the century are alike aware of the complexities of character and social role, of public perception and self-perception, of all the tricks of vanity, but now they no longer care to hide them from others or struggle against them in their own hearts. Instead they assume – or perhaps the word is indulge – them in a manner sometimes so extravagant that it is hard to take them seriously.

The first of the younger generation of portraitists – although received into the Academy in 1674 as a history painter – was François de Troy (1645–1730), a friend of Roger de Piles and sympathetic to the *coloristes*. He was the painter of the King's mistress, Madame de Montespan, and depicts her daughter-in-law

174 **François de Troy**, *The Astronomy Lesson of the Duchesse du Maine*, c. 1702–5. The sitter is the wife of the Duc du Maine, Louis XIV's eldest son by Madame de Montespan. The age of Louis XIV was giving way to the Enlightenment, and science was becoming fashionable among the ladies of the court. The Duchess's professor of astronomy is her friend Nicolas de Malézieu. In the doorway is the Abbé Genest – with his large nose – offering a magnifying glass to Malézieu, whose poor eyesight was well known. De Troy's painting is thus very much a private piece with personal references and jokes.

175 **Hyacinthe Rigaud**, *Double Portrait of the Artist's Mother, née Marie Serre*, 1695. Rigaud lost his father at the age of eight and was raised by his mother, who encouraged his vocation as a painter. In 1695 he travelled to the Roussillon to paint this portrait in order to have a bust carved by his friend the sculptor Antoine Coysevox (1706). Many years later he painted a self-portrait with his mother's features traced on the canvas lying before him on the easel.

in *The Astronomy Lesson of the Duchesse du Maine* (1702–5) [174]. In striking contrast to the official pomp of royal portraiture under Louis XIV, this picture pretends to interrupt the young princess and her tutor in the middle of a discussion. The work emphasizes intimacy of setting and the spontaneous, unaffected interest that connects the two main figures. It also presents itself clearly as a private image: not a public façade but a personal memento. De Troy had a long and successful career, and the dignity to which the portrait rose in this generation is attested by his directorship of the Academy (following La Fosse) from 1708 to 1711.

The greatest official portraitist of the end of the century, however, was Hyacinthe Rigaud (1659–1743). His early portrait of the architect Jules Hardouin-Mansart (1685) [176] still has some of the older sobriety of tone, although there is already a new and characteristic combination of opulence and casualness in the attire and bearing. The artist's double portrait of his mother (1695) [175] shows that he is capable of perfect simplicity and directness, but his most famous work is the monumental *Louis XIV* of 1701 [155]. The painting was commissioned as a gift for Louis' grandson, whom the King had just succeeded in imposing as King Philip V of Spain. As we have seen, Louis had felt compelled to enforce his claim even though it would inevitably re-ignite war with both his Anglo-Dutch enemies and his Austrian Habsburg rivals for the throne. Both pride and a certain fatalism seem to lie beneath the dignified stillness of the royal features.

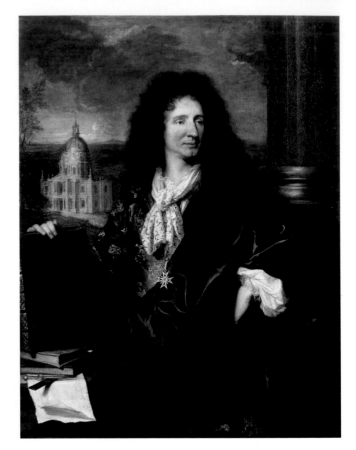

176 **Hyacinthe Rigaud**, *Portrait of Jules Hardouin-Mansart*, 1685. Hardouin-Mansart (1646–1708), the celebrated architect who completed Versailles and designed the Grand Trianon and the Invalides, among many other commissions, became Surintendant des Bâtiments du Roi in 1699. The church of the Invalides, the military hospital for Louis' veterans, can be seen in the background, although the structure was not actually finished until 1691, and finally consecrated in 1706 (for the painting in the dome, see ill. 159).

Rigaud's contemporary and friend, Nicolas de Largillière (1656–1746), although broadly part of the same stylistic development, is nonetheless quite a distinct personality: his style, largely derived from Van Dyck but without the latter's melancholy, is rich and glamorous rather than pompous. *A Young Man with his Tutor* [177] is one of his more sober and restrained pictures. Largillière's greatest portrait, as a study of an individual, is the painting of Le Brun which was his *morceau de réception* at the Academy in 1686 and which has already been mentioned in the previous chapter [178]. In countless others, Largillière seems content to take the sitter's own estimation of himself on trust. The enormous *Ex-voto to St Genevieve* (1695–96) [179] is the masterpiece of this genre. The Lord Mayor and councillors of Paris are seen thanking their patron saint for bringing an end to the drought of 1694, but appear much more concerned with their own importance than with any religious feeling. Although they

kneel before, and, in the Lord Mayor's case, point to the saint, they do not actually look at her. It is impossible not to contrast these smug and hard physionomies with Philippe de Champaigne's group portrait of the city council almost half a century earlier [121], and to feel that the later group share the coarser sensibility that we saw in Coypel's *Rebecca at the Well* [162]. It is perhaps partly because the anonymous sitter of *La Belle Strasbourgeoise* (1703) [180] is a provincial lady that she seems more natural and touching; her unusual hat becomes in a sense the symbol of this difference, but it is the fact that she looks out at us so unselfconsciously that makes this one of Largillière's most memorable pictures.

It is in the perspective of both the portrait and landscape traditions that we can appreciate the real originality of Jean-Antoine Watteau (1684–1721), the artist *par excellence* of the Regency years that followed Louis' death in 1715. Watteau does not attempt history subjects, nor does he paint the kind of figures that belong to history pictures. On the contrary, he astutely

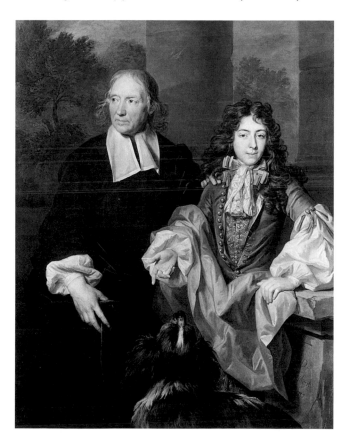

177 Nicolas de Largillière, *A Young Man with his Tutor,* 1685. The sitters in this portrait are unidentified, but they speak eloquently of the distance that separates the generation that matured before or around the beginning of Louis XIV's personal rule from the one that was growing up in the later years of his reign. The boy is vacant, overdressed, and falls easily into a conventional pose, while the older man, in clerical dress, looks pensively away. Largillière had lived in Antwerp and then spent some years in England in his youth working for Sir Peter Lely, so that he had many opportunities to assimilate the manner of Sir Anthony Van Dyck (evident here in the young man's finery and the dog's coat).

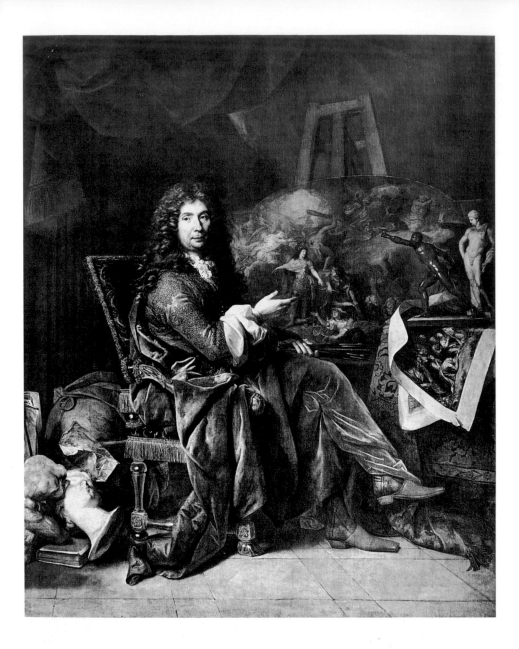

178 **Nicolas de Largillière**, *Portrait of Charles Le Brun*, 1686. When Largillière
presented himself to the Academy in 1683, and was assigned the portrait of
Le Brun as his *morceau de réception*, he realized that something grand, yet not
pompous, was expected. Le Brun is shown in a relaxed attitude surrounded by
reminders of his many achievements, especially an engraving of the *Queens of Persia*
(cf. ill. 115) and the *modello* for one of the most admired scenes in the Galerie des
Glaces, *The Conquest of the Franche-Comté* (ill. 139).

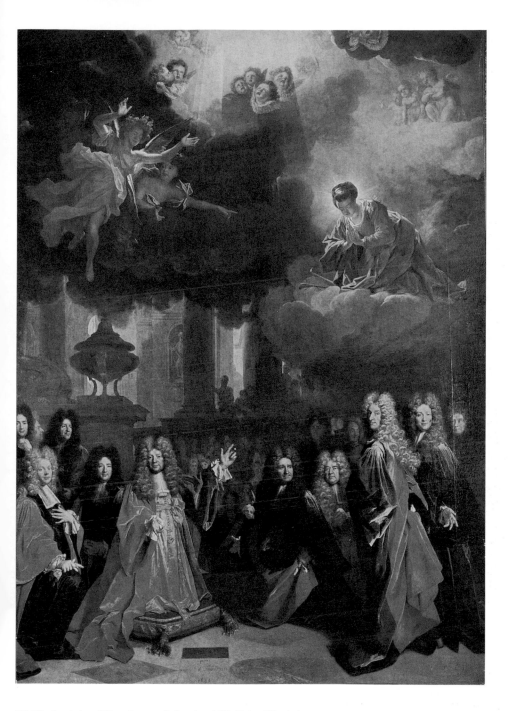

179 **Nicolas de Largillière**, *Ex-voto to St Genevieve*, 1695–96. Largillière's city
councillors give theatrical thanks to their patroness for the end of a drought.

draws on the more popular and spontaneously familiar genre
of portraiture. His most celebrated works, with a few exceptions,
incorporate depictions of real people, and his genius is to bring
into the light of consciousness much that had remained implicit
in the social portraiture of his time. The fact that so many of his
characters, like *Gilles* (1718–19) [181], are actors in *commedia
dell'arte* costume makes literal the 17th-century metaphor of life

180 **Nicolas de Largillière**, *La Belle Strasbourgeoise*, 1703. The lady is unidentified; the combination of striking frontality with the bold horizontal of the Alsatian hat, the contrast of elaborate costume and suggestively indefinite natural setting, and above all the sitter's direct yet gentle gaze all foster a quality of mystery that is seldom found in Largillière's work.

181 **Jean-Antoine Watteau**, *Gilles*, 1718–19. It has been suggested that this painting was made as a sign for a café opened by an actor and friend of Watteau's. *Gilles* has sometimes been known as *Pierrot*; both were clown figures, who eventually became confused in French versions of *commedia dell'arte*, in contrast to the clever Harlequin. The picture was later bought by Dominique Vivant Denon, author of the exquisitely Rococo short story *Point de lendemain* (1777), and entered the Louvre in 1869.

as theatre: in Watteau's world we are only ourselves by virtue of the play or dance or song in which we take part, and when the music stops, we are at a loss. The particular sub-genre that Watteau made his own, the *fête galante*, sets these figures in a landscape which is deliberately unlike either the Classical or naturalistic works seen before. Stylistically, he draws on the Flemish tradition of Rubens and Van Dyck to which he was heir, but his purpose is to create a subjective landscape, a crepuscular, nostalgic backdrop to his melancholy figures.

The uneasiness Watteau embodies had not been seen since the generation of Champaigne; it is this undertone of moral seriousness that makes him, in a certain sense, the last painter of the French 17th century. The fact that his contemporary François Le Moyne (1688–1737), the most important official painter of the next generation, actually committed suicide is symptomatic of a crisis. Le Moyne had painted a brilliant *Apotheosis of Hercules* in a single unified composition on the ceiling of the

182 **François Le Moyne,**
The Apotheosis of Hercules, ceiling
of the Salon de Marbre or Salon
d'Hercule, Versailles, 1733–36.
At the lower right, Hercules is
borne up to Olympus in a chariot
while Minerva, Bacchus, Mercury
and others look on. At the peak
of the composition, Hymen, the
god of marriage, brings Hebe, the
personification of youth that has
just reached maturity, to Jupiter,
who will give her to Hercules to
be his bride.

Salon de Marbre at Versailles (1733–36) [182]; on its completion,
he had been appointed First Painter of Louis XV, but apparently
became obsessed by the belief that he had equalled Le Brun's
achievement without receiving anything like the rewards
and recognition that his predecessor had enjoyed. Whatever
the facts of Le Moyne's mental condition may have been, his
feelings were not without foundation. The *Apotheosis* is a work
of enormous skill, but it suffers from the evacuation of belief in
Classical mythology which had already taken place under Louis
XIV, and lacks the alternative source of authority which Le Brun
found in the legend of the Sun King. And with no urgency of
meaning, his figures themselves are trite and vacant. There is no
renewal of that fundamental alchemy by which abstract painted
men and women are produced from the study of the live model.

It is only, as I have argued, in straining to find those attitudes
that will give expression to a subject that artists are compelled
to look at the body and to think about it with a renewed sense
of necessity. The subject must matter to the artist and to the
presumed viewers of the work; there must therefore be some
community of purpose and belief between them. All of these
conditions become increasingly elusive in the mass societies
that develop out of the industrial revolution. This is ultimately
why figure painting itself reached such a point of crisis in
the academic tradition of the 19th century. No matter how
assiduously academic artists looked at the model, they could
not renew the synthesis of experience and artificial form that
is the essence of figure painting; instead they were trapped
in superficial naturalism, which was then superficially tidied
up for the sake of decency. Everyone knows that the crisis of
the academic tradition was the context from which modernism
emerged, but the tradition itself is little understood, partly
because the modernist victors rewrote the popular history of art.
It may come as a surprise to many to realize that the 'academic
tradition' was never monolithic, never fully in harmony with its
own stated ideals, never free of opposition; and above all that
critical difficulties with the subject of painting go back to the
apogee of the French Academy in the *siècle de Louis XIV*.

Select Bibliography

General studies and surveys

Blunt, Anthony *Art and Architecture in France 1500–1700*. Harmondsworth: Penguin Books, 1953, 1973 (paperback edn), 1977

Changeux, Jean-Pierre *De Nicolò dell'Abate à Nicolas Poussin: aux sources du classicisme*. Meaux: Musée Bossuet, 1988

Chastel, André *L'Art français II: Les temps modernes 1430–1620*. Paris: Flammarion, 1994

—— *L'Art français III:Ancien régime 1620–1775*. Paris: Flammarion, 1994

Coquery, Emmanuel, ed. *Visages du Grand Siècle: le portrait français sous le règne de Louis XIV 1660–1715*. Paris: Somogy, 1997

Hilaire, Michel, et al. *Century of Splendour: Seventeenth-century French Painting in French Public Collections*. Paris: Réunion des Musées Nationaux, 1993

Mérot, Alain *La Peinture française au XVIIe siècle*. Paris: Gallimard, 1994

Rosenberg, Pierre *La Peinture française du XVIIe siècle dans les collections américaines*. Paris: Réunion des Musées Nationaux, 1982

—— et al. *Musée du Louvre: catalogue illustré des peintures: école française XVIIe et XVIIIe siècles*. Paris: Réunion des Musées Nationaux, 1974

Thuillier, Jacques *La Peinture française: XVIIe siècle* (2 vols). Geneva: Skira, 1963, 1992

—— *Au Temps du Roi Soleil, les Peintres de Louis XIV*. Lille: Palais des Beaux-Arts, 1968

Wine, Humphrey *The Seventeenth Century Paintings* [Catalogue]. London: National Gallery, 2001

Wright, Christopher *The French Painters of the Seventeenth Century*. London: Orbis, 1985

Specific artists – monographs and catalogues

BOURDON
Thuillier, Jacques *Sébastien Bourdon 1616–1671. Catalogue critique et chronologique de l'œuvre complet*. Paris: Réunion des Musées Nationaux, 2000

PHILIPPE DE CHAMPAIGNE
Dorival, Bernard *Philippe de Champaigne 1602–1674: la vie, l'œuvre et le catalogue raisonné de l'œuvre* (2 vols). Paris: Laget, 1976

Marin, Louis *Philippe de Champaigne ou la présence cachée*. Paris: Hazan, 1995

CLAUDE
Roethlisberger, Marcel *Claude Lorrain: The Paintings* (2 vols). New Haven: Yale University Press, 1961

—— *Claude Lorrain: The Drawings* (2 vols). Berkeley and Los Angeles: University of California Press, 1968

Russell, H. Diane, and Pierre Rosenberg *Claude Gellée, dit Le Lorrain 1600–1682*. Paris: Réunion des Musées Nationaux, 1983

Wine, Humphrey *Claude:The Poetic Landscape*. London: National Gallery, 1994

GASPARD DUGHET
Boisclair, Marie-Nicole *Gaspard Dughet: sa vie et son œuvre (1615–1675)*. Paris: Arthéna, 1986

LA HYRE
Rosenberg, Pierre, and Jacques Thuillier *Laurent de La Hyre 1606–1656*. Geneva: Skira, 1988

LA TOUR
Cuzin, Jean-Pierre, and Pierre Rosenberg *Georges de La Tour*. Paris: Réunion des Musées Nationaux, 1997

LE BRUN
Montagu, Jennifer *The Expression of the Passions: the origin and influence of Charles Le Brun's Conférence sur l'expression générale et particulière*. New Haven: Yale University Press, 1994

Thuillier, Jacques, and Jennifer Montagu *Charles Le Brun 1619–1690*, Château de Versailles, 1963

LE NAIN
—— and Michel Laclotte *Les Frères Le Nain*. Paris: Réunion des Musées Nationaux, 1978

LE SUEUR
Mérot, Alain *Eustache Le Sueur 1616–1655*. Paris: Arthéna, 1987

POUSSIN
Blunt, Anthony *Nicolas Poussin* (2 vols). Washington: National Gallery of Art, 1967

—— and Jacques Thuillier *Nicolas Poussin et son temps* (2 vols). Rouen: Musée des Beaux-Arts, 1961

Rosenberg, Pierre *Nicolas Poussin 1594–1665*. Paris: Réunion des Musées Nationaux, 1994

—— and L.-A. Pratt *Nicolas Poussin 1594–1665: Catalogue raisonné des dessins* (2 vols). Milan: Leonardo, 1994

Thuillier, Jacques *Nicolas Poussin*. Paris: Flammarion, 1974, 1994

—— *Nicolas Poussin* [biography]. Paris: Fayard, 1988

Verdi, Richard *Nicolas Poussin 1594–1665*. London, Royal Academy of Arts, 1995

VALENTIN
Mojana, Marina *Valentin de Boulogne*. Milan, Eikonos, 1989

VOUET
Thuillier, Jacques *Vouet*. Paris: Réunion des Musées Nationaux, 1990

Illustration List

Artists, titles and dates are given
in the captions.
All works are in oil on canvas unless
otherwise indicated.
Measurements are given in centimetres,
followed by inches (in brackets),
height preceding width.

1 The Earl of Plymouth (on loan to the
National Museum of Wales, Cardiff);
114 x 175 (44⁷⁄₈ x 68⁷⁄₈) **2** see 90
3 Musée du Louvre, Paris; 122 x 199
(48 x 73³⁄₈) **4** Musée du Louvre, Paris;
219 x 336 (86¼ x 132¼) **5** Collégiale
Notre-Dame, Les Andelys; 230 x 180
(90½ x 70⁷⁄₈) **6** Musée National du
Château, Fontainebleau; 97 x 107
(32¼ x 46⅛) **7** Musée National du
Château, Fontainebleau; 188 x 189
(74 x 74³⁄₈) **8** Musée des Beaux-Arts,
Lille; 189 x 315 (74³⁄₈ x 124) **9** St-
Gervais, Paris; 140 x 265 (65 x 103¼)
10 Musée du Louvre, Paris; 287 x 370
(113 x 145⅝) **11** Musée des Beaux-
Arts, Rennes; 310 x 259 (122 x 102)
12 Institutum Romanum Finlandiae,
Villa Lante, Rome; 330 x 245
(129⁷⁄₈ x 96½) **13** Vatican Museums,
Rome. Photo Alinari; 308 x 165
(121¼ x 65) **14** National Gallery,
London; 96 x 134 (37¾ x 52¾)
15 Musée du Louvre, Paris. Photo ©
RMN – Hervé Lewandowski; 176 x 210
(68¼ x 82¾) **16** Musée de Tessé,
Le Mans; 129 x 192 (50¾ x 75⅝)
17 Musée des Augustins, Toulouse;
237 x 183 (93¼ x 72) **18** Cathedral
of St-Etienne, Bourges; 189 x 152
(74³⁄₈ x 59⁷⁄₈) **19** Chapel of the Jesuit
College, Le Puy; 250 x 162 (98³⁄₈ x 63¾)
20 St-Michel, Dijon; 465 x 223
(183⅛ x 87¾) **21** Musée des Beaux-
Arts, Orléans; 102 x 152 (40⅛ x 59⁷⁄₈)
22 Musée des Beaux-Arts, Reims;
150 x 116 (59 x 45⅝) **23** Musée du
Louvre, Paris; 69 x 57 (27⅛ x 22½)
24 Musée du Louvre, Paris; 113 x 159
(44½ x 62½) **25** Musée du Louvre,
Paris; 117 x 137 (46⅛ x 53⁷⁄₈)
26 Kimbell Art Museum, Forth Worth;
97.8 x 156.2 (38½ x 61½) **27** Musée du
Louvre, Paris; 69.5 x 61.5 (27³⁄₈ x 24¼)
28 Musée départemental d'Art, Épinal;

145 x 97 (57⅛ x 38¼) **29** Musée du
Louvre, Paris; 167 x 131 (65¾ x 51⅝)
30 Musée du Louvre, Paris; 137 x 102
(53⁷⁄₈ x 40⅛) **31** Musée des Beaux-
Arts, Rennes; 76 x 91 (29⁷⁄₈ x 35⁷⁄₈)
32 Musée du Louvre, Paris; 128 x 94
(50³⁄₈ x 37) **33** Musée du Louvre,
Paris; 98 x 74 (38½ x 29¼)
34 The Minneapolis Institute of Arts,
The William Hood Dunwoody Fund;
148 x 198 (58¼ x 78) **35** Vatican
Museums, Rome; 320 x 186
(126 x 73¼) **36** Musée des Beaux-
Arts, Caen; 57 x 128 (22½ x 50³⁄₈)
37 Gemäldegalerie, Dresden; 131 x 181
(51⅝ x 71¼) **38** Musée Condé,
Chantilly; 148.5 x 174.5 (58½ x 68³⁄₈)
39 Musée du Louvre, Paris; 148 x 198
(58¼ x 78) **40** National Gallery,
London; 154.3 x 214 (60¾ x 84¼)
41 The Metropolitan Museum of Art,
New York. Harris Brisbane Dick
Fund, 1946 (46.160); 154.5 x 210
(60⁷⁄₈ x 82⅝) **42** National Gallery,
London; 134 x 145 (52¾ x 57⅛)
43 Musée du Louvre, Paris; 149 x 200
(58⅝ x 78¾) **44** Musée du Louvre,
Paris. © Photo RMN; 85 x 121
(33½ x 47⅝) **45** The Duke of Rutland,
Belvoir Castle, Grantham; 95.5 x 121
(37⅝ x 47⅝) **46** The Duke of
Sutherland, on loan to the National
Gallery of Scotland, Edinburgh;
117 x 178 (46⅛ x 70⅛) **47** Musée du
Louvre, Paris; 118 x 199 (46½ x 78¾)
48 Musée du Louvre, Paris; 101 x 150
(39¾ x 59) **49** Walker Art Gallery,
Liverpool; 116 x 178.5 (45⅝ x 70¼)
50 Musée du Louvre, Paris; 124 x 200
(48⅞ x 78¾) **51** Sudeley Castle,
Winchcombe; 97 x 131.5 (38¼ x 51¾)
52 The Metropolitan Museum of Art,
New York, Fletcher Fund, 1924
(24.45.1); 119 x 182.9 (46¾ x 72)
53 Musée du Louvre, Paris; 121 x 195
(47⅝ x 76¾) **54** Dulwich Picture
Gallery, London; 96.2 x 119.6
(37⅞ x 47⅛) **55** Ashmolean Museum,
Oxford; 150 x 204 (59 x 80¾)
56 Courtesy of the Fogg Art Museum,
Cambridge, Mass., Gift of Mrs Samuel
Sachs in memory of her husband,
Samuel Sachs, 1942.167. Photo Rick
Stafford © President and Fellows
of Harvard College; 123 x 179
(48⅜ x 70½) **57** Musée des Beaux-
Arts, Nancy. Photo G. Mangin; oil on
copper, 49 x 39 (19¼ x 15³⁄₈) **58** Musée
de Peinture et de Sculpture, Grenoble;

98 x 137 (38⅝ x 53⁷⁄₈) **59** Birmingham
Museum & Art Gallery; 74 x 97
(29⅛ x 32¼) **60** National Gallery,
London; 88.5 x 152.7 (34⅞ x 60⅛)
61 Musée du Louvre, Paris; 119 x 150
(46⅞ x 59) **62** Ashmolean Museum,
Oxford; 120 x 150 (47¼ x 59)
63 Collection of the Earl of Leicester,
Holkham Hall. Bridgeman Art Library;
100 x 127 (39³⁄₈ x 50) **64** Dulwich
Picture Gallery, London; 72 x 94.5
(28½ x 37¼) **65** Alte Pinakothek,
Munich; 107 x 140 (42⅛ x 55⅛)
66 University of Michigan Museum of
Art, Ann Arbor, 1960/2.93; 59.6 x 74.2
(23½ x 29½) **67** Musée des Beaux-
Arts, Lille; 106.5 x 131.5 (41⅞ x 51¾)
68 National Gallery, London; 108 x 134
(42½ x 52¾) **69** National Gallery of
Art, Washington, D.C.; 145 x 180
(57 x 70¾) **70** Musée des Beaux-Arts,
Strasbourg; 160 x 130 (63 x 51⅛)
71 Musée du Berry, Bourges; 187 x 142
(73⅝ x 55⁷⁄₈) **72** Musée du Château,
Annecy; 104 x 110 (41 x 43¼)
73 Musée des Beaux-Arts, Dijon;
213 x 154 (83⅞ x 60⅝) **74** Musée du
Louvre, Paris. Photo © RMN – Gérard
Blot; 155 x 218 (61 x 85⅞) **75** The
Metropolitan Museum of Art, New
York. Gift of George A. Hearn 1906
(06.1268); 121.5 x 176 (47⅞ x 69¼)
76 Toledo Museum of Art, Toledo, O.
Purchased with funds from the Libbey
Endowment, Gift of Edward Drummond
Libbey; 108 x 138.4 (42½ x 54½)
77 Musée des Beaux-Arts, Rouen;
222 x 160 (87⅜ x 63) **78** Musée des
Beaux-Arts, Orléans; 150 x 178
(59 x 70⅛) **79** National Gallery,
London; 259.5 x 178 (102⅛ x 70⅛)
80 Courtesy of the Fogg Art Museum,
Cambridge, Mass., Gift in part of Lewis
G. Nierman and Charles Nierman and
purchase in part from the Alpheus
Hyatt Purchasing Fund, 1972.362.
Photo David Mathews © President and
Fellows of Harvard College; 175 x 146
(68⁷⁄₈ x 57½) **81** Musée Condé,
Chantilly; 98.5 x 135 (38¾ x 53⅛)
82 Musée du Louvre, Paris; 393 x 250
(154¾ x 98³⁄₈) **83** Collégiale Notre-
Dame, Les Andelys; 380 x 200
(149⅝ x 78¾) **84** Musée St-Denis,
Reims; 195 x 129 (76¾ x 50¾)
85 Musée du Louvre, Paris; 221 x 164
(87 x 64⅝) **86** Musée des Beaux-Arts,
Arras. Photo C. Thériez; 104 x 140
(41 x 55⅛) **87** Notre-Dame, Paris;

340 × 220 (133⅞ × 86⅝) **88** Musée National du Château, Versailles; 225 × 162 (88⅝ × 63¾) **89** Musée de Peinture et de Sculpture, Grenoble; 162 × 175 (63¾ × 68⅞) **90** Musée du Louvre, Paris. Photo © RMN; 136 × 195 (53½ × 76¾) **91** Musée du Louvre, Paris; 193 × 130 (74¾ × 51⅛) **92** Musée du Louvre, Paris; 182 × 125 (71⅝ × 49¼) **93** Musée du Louvre, Paris; 73 × 150 (28¾ × 59) **94** Musée du Louvre, Paris; 394 × 328 (155⅛ × 129⅛) **95** Los Angeles County Museum of Art, Los Angeles, Gift of the Ahmanson Foundation. Photograph © 2004 Museum Associates/LACMA; 76 × 62 (29⅞ × 24⅜) **96** Musée des Beaux-Arts, Arras; 350 × 400 (137¾ × 157½) **97** Musée des Beaux-Arts, Arras; 340 × 260 (133⅞ × 102⅜) **98** Musée du Louvre, Paris; D 134 (52¾) **99** Alte Pinakothek, Munich; 162 × 130 (63¾ × 51⅛) **100** Musée Fabre, Montpellier; oil on wood, 37 × 52 (14⅝ × 20½) **101** Musée des Beaux-Arts, Orléans; 142 × 110 (55⅞ × 43¼) **102** Notre-Dame, Paris; 360 × 260 (141¾ × 102⅜) **103** Musée du Louvre, Paris; 50 × 61 (19⅝ × 24) **104** Musée du Louvre, Paris. Photo © RMN – Gérard Blot; 295 × 353 (116⅛ × 139) **105** Nottingham Art Gallery; 290 × 188 (114⅛ × 74) **106** Musée du Louvre, Paris. Photo © RMN – Gérard Blot; 114 × 153 (44⅞ × 60¼) **107** Musée du Louvre, Paris; 252 × 171 (99¼ × 67⅜) **108** Musée Municipal, Château-Gontier; 112 × 170 (44⅛ × 66⅞) **109** Musée du Louvre, Paris; 87 × 118 (34¼ × 46½) **110** Musée Municipal, Bouxwiller; 242 × 337 (95¼ × 132⅝) **111** Ministère de la culture et de la communication, Préfecture de la Region Bretagne. Photo G. Artur **112** Musée du Louvre, Paris. Photo © RMN – Hervé Lewandowski; 73 × 59 (26¾ × 23¼) **113** Bibliothèque Nationale, Paris; engraving **114** Musée National du Château, Versailles; 138 × 113 (54⅜ × 44½) **115** Châteaux de Versailles et de Trianon. Photo © RMN; 298 × 453 (117⅜ × 178⅜) **116** Henri Testelin, *Sentimens des plus habiles peintres*, 1696 **117** Musée du Louvre, Paris. Photo © RMN – D. Arnaudet/G. Blot; 470 × 1265 (185 × 498) **118** Musée Bernard d'Agesci, Niort; 103 × 90 (40½ × 35⅜) **119** Musée Fabre, Montpellier;

108.5 × 89.5 (42¾ × 35¼) **120** Musée des Beaux-Arts, Lyons; 83 × 67 (32⅝ × 26⅜) **121** Musée du Louvre, Paris; 200 × 271 (78¾ × 106¾) **122** Musée du Louvre, Paris; 82 × 64 (32¼ × 25¼) **123** Musée du Louvre, Paris; 91 × 72 (35⅞ × 28⅜) **124** National Gallery of Art, Washington, D.C., Samuel H. Kress Collection; 225 × 161.6 (88½ × 63⅝) **125** Musée des Beaux-Arts, Rennes; 128 × 96 (50⅜ × 37¾) **126** Musée du Louvre, Paris; 165 × 229 (65 × 90⅛) **127** Musée des Beaux-Arts, Strasbourg; 49.5 × 63.5 (19½ × 25) **128** The Art Institute of Chicago; oil on panel, 53.5 × 71.3 (21⅛ × 28⅛) **129** Musée du Louvre, Paris; 41 × 52 (16⅛ × 20½) **130** Musée Fabre, Montpellier; 146 × 190 (57½ × 74¾) **131** Musée National du Château, Versailles; 141 × 185.5 (55½ × 73) **132, 133** Châteaux de Versailles et de Trianon, Photo © RMN – Gérard Blot **134** Châteaux de Versailles et de Trianon. Photo © RMN – Blot/Lewandowski **135** Musée du Louvre, Paris; 50 × 87.5 (19⅝ × 34½) **136** Ecole Nationale Supérieure des Beaux-Arts, Paris; 115 × 181 (45¼ × 71¼) **137** Châteaux de Versailles et de Trianon. Photo © RMN – Mercator **138** Châteaux de Versailles et de Trianon. Photo © RMN – Gérard Blot; oil on wood, 58 × 71 (22⅞ × 28) **139** Châteaux de Versailles et de Trianon. Photo © RMN – Gérard Blot **140** Châteaux de Versailles et de Trianon. Photo © RMN – Gérard Blot; 163 × 134 (64⅛ × 52¾) **141** Musée du Louvre, Paris; 121 × 94 (47⅝ × 37) **142** Musée des Beaux-Arts, Rennes; 54.5 × 32.7 (21½ × 12⅞) **144** Musée Condé, Chantilly; H 55 (21⅝) **145** Musée National du Château, Versailles; 305 × 430 (120⅛ × 169¼) **146** Musée du Louvre, Paris; 150 × 198 (59 × 78) **147** Musée du Louvre, Paris; 150 × 198 (59 × 78) **148** Musée du Louvre, Paris; 153 × 214 (60¼ × 84¼) **149** Musée du Louvre, Paris. Photo © RMN – J. G. Berizzi; 91 × 117 (35⅞ × 46⅛) **150** Département des Estampes, Bibliothèque Nationale, Paris; engraving **151** Musée du Louvre, Paris; 232 × 304 (91⅜ × 119⅝) **152** The State Hermitage Museum, St Petersburg **153** Musée du Louvre, Paris; 130 × 96 (51⅛ × 37¾)

154 Musée du Louvre, Paris. Photo © RMN – R. G. Ojeda; 235 × 188 (92½ × 74) **155** Musée du Louvre, Paris; 277 × 194 (109 × 76⅜) **156** Musée des Beaux-Arts, Dijon; 131 × 163 (51⅝ × 64⅛) **157** Musée des Beaux Arts, Arras. Photo C. Thériez; 450 × 360 (177⅛ × 141¾) **158** Collection Frits Lugt, Institut Néerlandais, Paris; 25 × 34 (9⅞ × 13⅜) **159** Musée des Arts Décoratifs, Paris; D 102 (40⅛) **160** Musée National du Château, Versailles; 131 × 159 (51⅝ × 62⅝) **161** Musée des Beaux-Arts, Dijon; 242 × 185 (95¼ × 72⅞) **162** Musée du Louvre, Paris. Photo © RMN – Jean Schormans; 125 × 106 (49¼ × 41¾) **163** Musée des Beaux-Arts, Angers; 95 × 195 (37⅜ × 76¾) **164** Châteaux de Versailles et de Trianon. Photo © RMN – Gérard Blot **165** Musée du Louvre, Paris; 424 × 312 (167 × 123) **166** Musée du Louvre, Paris; 388 × 660 (152¾ × 259⅞) **167** National Gallery, London; 201 × 153 (79⅛ × 60¼) **168** Museum of Fine Arts, Boston; 122 × 179.5 (48 × 70⅝) **169** Musée des Beaux-Arts, Marseilles; 96 × 128 (37⅜ × 50⅜) **170** Musée du Louvre, Paris; 230 × 332 (90½ × 130¾) **171** Musée du Louvre, Paris; 234 × 164 (92⅛ × 64⅝) **172** National Gallery, London; 97 × 127 (38¼ × 50) **173** Musée des Beaux-Arts, Arras. Photo C. Thériez; 440 × 345 (173¼ × 135⅞) **174** Musée de l'Ile-de-France, Sceaux; 96 × 188 (37¾ × 74) **175** Musée du Louvre, Paris; 83 × 103 (32⅝ × 40½) **176** Musée du Louvre, Paris. Photo © RMN – Gérard Blot; 139 × 106 (54¾ × 41¾) **177** National Gallery of Art, Washington, D.C., Samuel H. Kress Collection; 146 × 115 (57½ × 45¼) **178** Musée du Louvre, Paris; 232 × 187 (91⅜ × 73⅝) **179** Panthéon, Paris; 500 × 350 (196⅞ × 137¾) **180** Musée des Beaux-Arts, Strasbourg; 138 × 106 (54¾ × 41¾) **181** Musée du Louvre, Paris. Photo Eileen Tweedy; 184.5 × 149.5 (72⅝ × 58⅞) **182** Châteaux de Versailles et de Trianon. Photo © RMN – Blot/Lewandowski; 1850 × 1700 (728⅜ × 669¼)

Index

Page numbers in *italic* refer to illustrations and captions